First Published in the United States of America, 2007

First Edition

Gingko Press, Inc.

5768 Paradise Drive, Suite J

Corte Madera, CA 94925, USA

Phone (415) 924 9615 / Fax (415) 924 9608

email: books@gingkopress.com

www.gingkopress.com

ISBN : 1-58423-224- 2

ISBN 13: 978-1-58423-224-7

Printed in Hong Kong

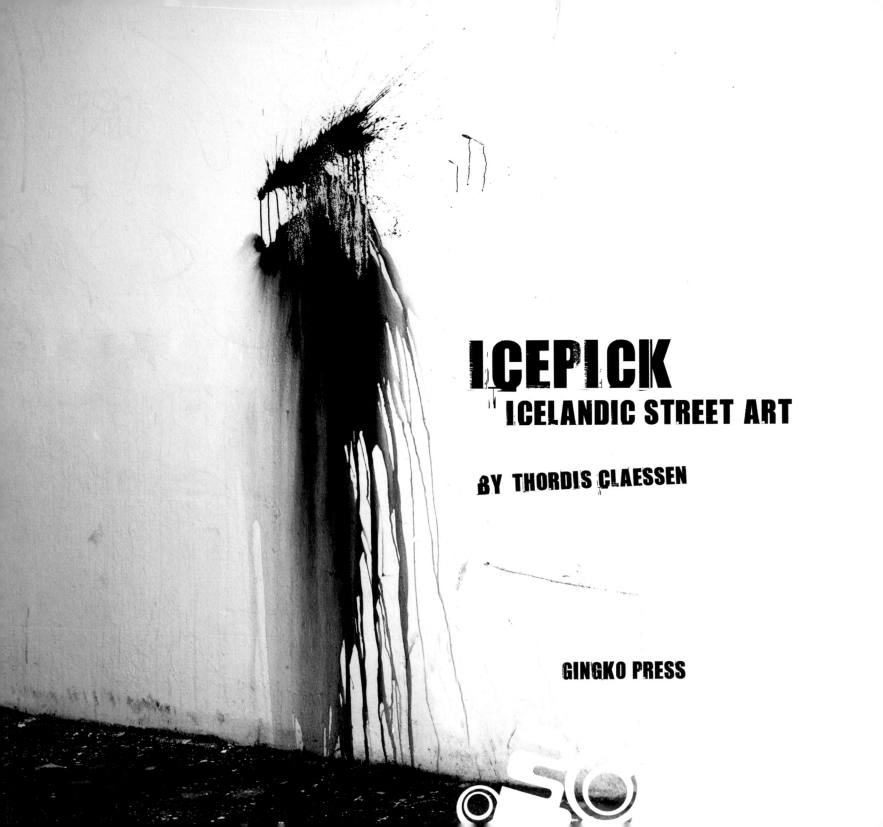

ICEPICK
ICELANDIC STREET ART

BY THORDIS CLAESSEN

GINGKO PRESS

ICEPICK

– A JUICY, REFRESHING EXPERIENCE OF ICELANDIC STREET ART AND GRAFFITI

DESIGNED – PHOTOGRAPHED AND ILLUSTRATED

BY

THORDIS CLAESSEN

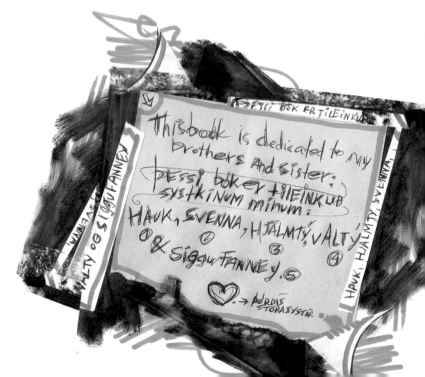

This book is dedicated to my brothers and sister:

þessi bók er tileinkuð systkinum mínum:

HAUK, SVENNA, HJÁLMTÝ, VALTÝ ① ② ③ ④

& SIGGU FANNEY. ⑤

♥ → þórdís STÓRASYSTIR

þessi bók ertileinkuð

VALTÝ OG SIGGU FANNEY

HAUK, HJÁLMTÝ, SVENNA,

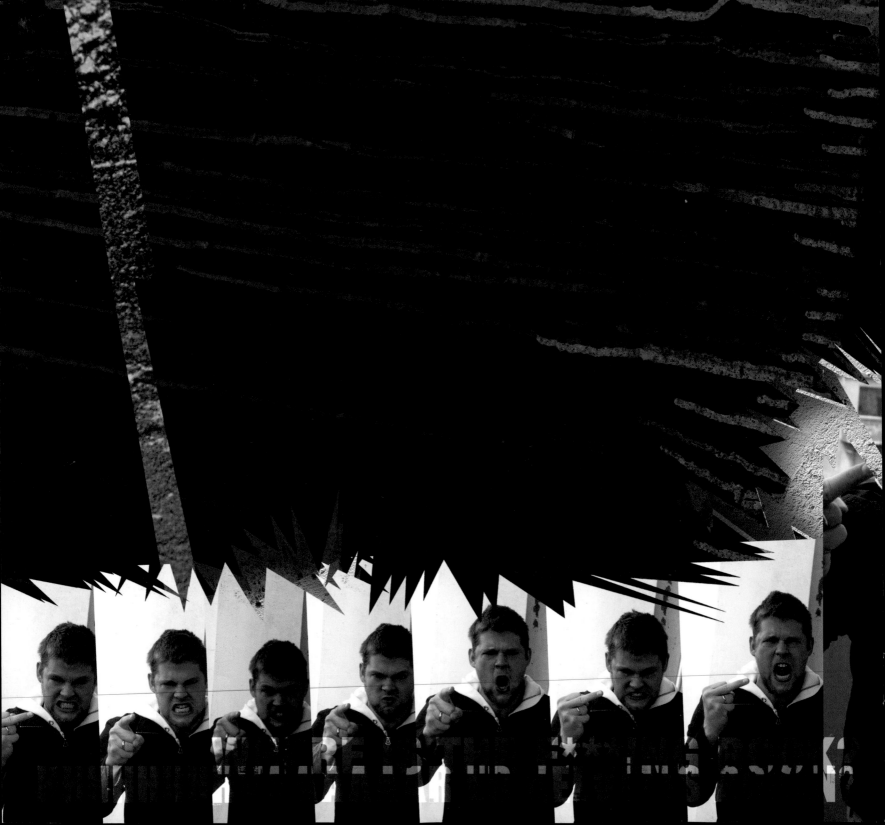

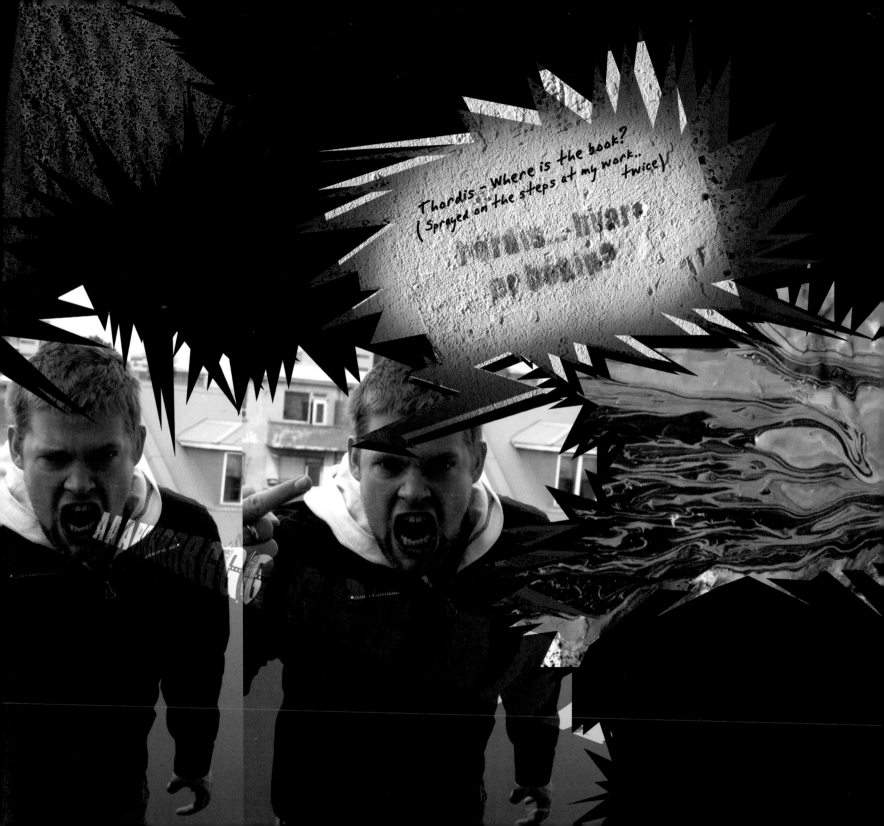

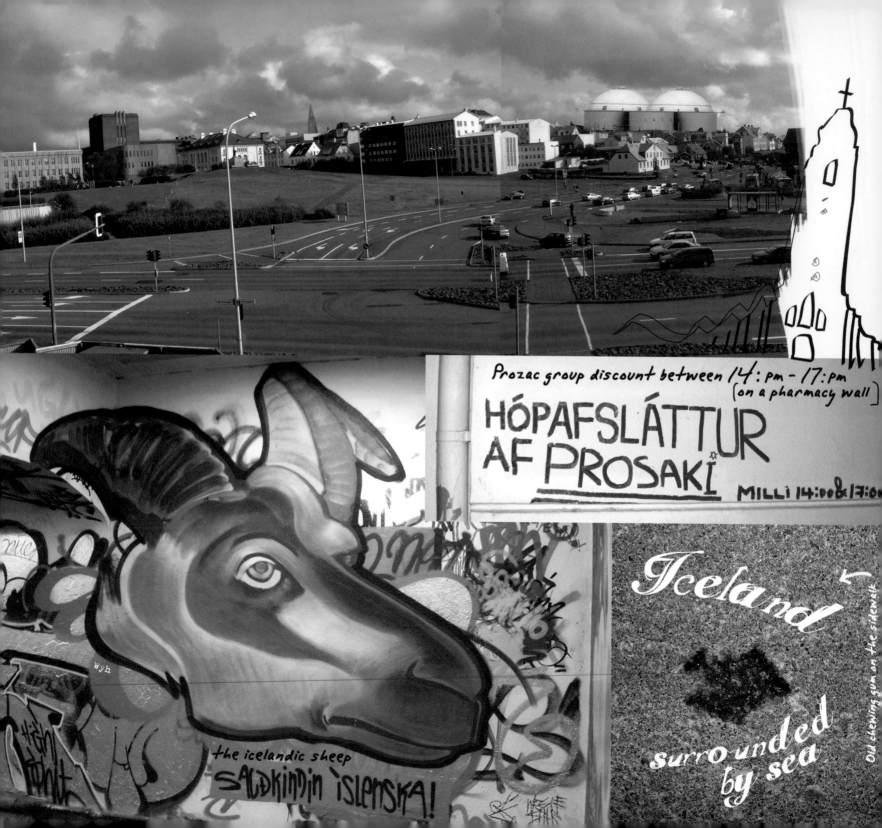

Prozac group discount between 14:pm – 17:pm
(on a pharmacy wall)

HÓPAFSLÁTTUR
AF PROSAKI

MILLI 14:00 & 17:00

Iceland

surrounded
by sea

Old chewing gum on the sidewalk

the icelandic sheep
SAUÐKINDIN ÍSLENSKA!

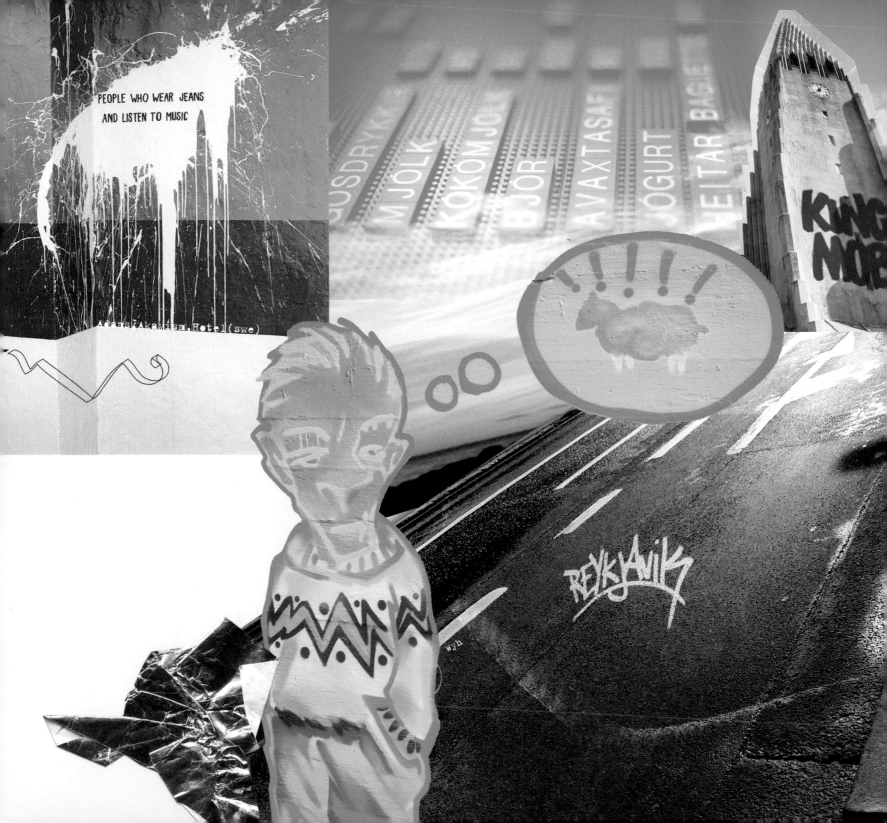

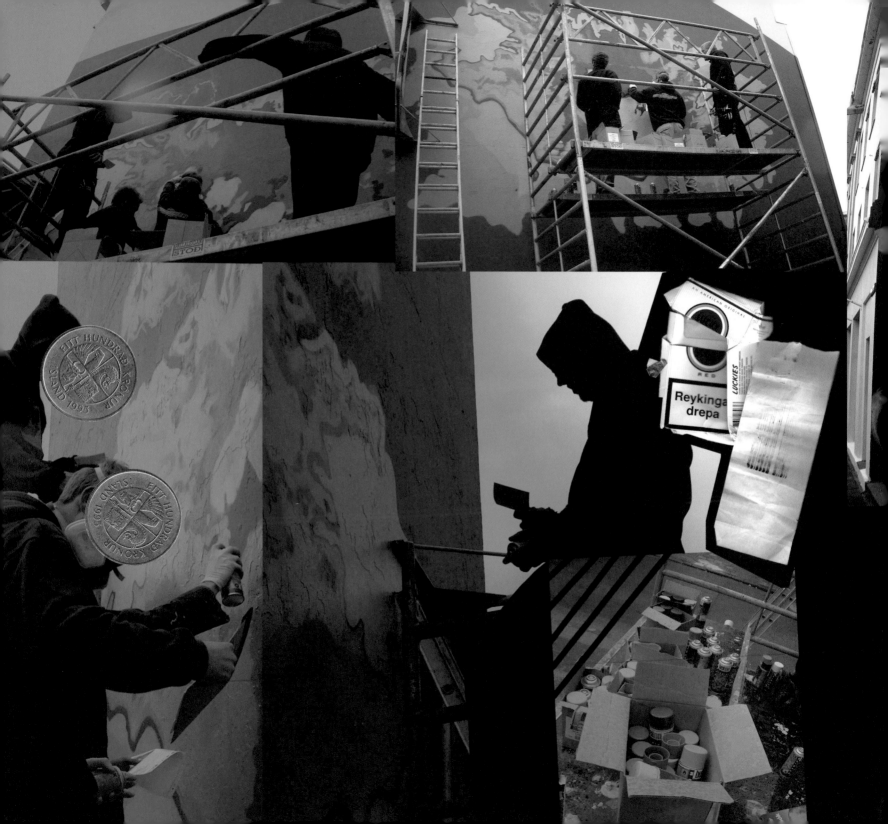

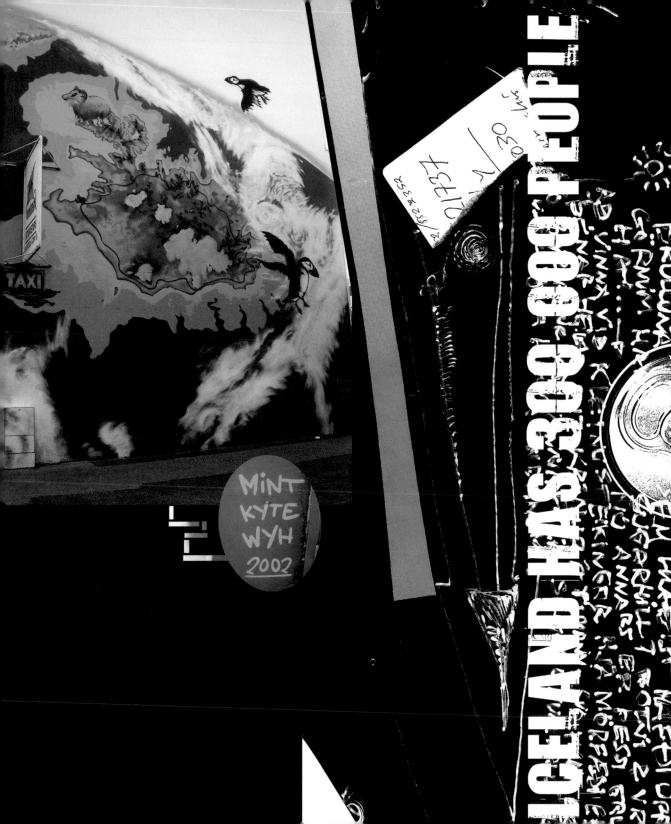

ICELAND HAS 300.000 PEOPLE

MiNT
KYTE
WYH
2002

TAXI

A dramatic death is what I desire, but will never get, because I have tuberculosis

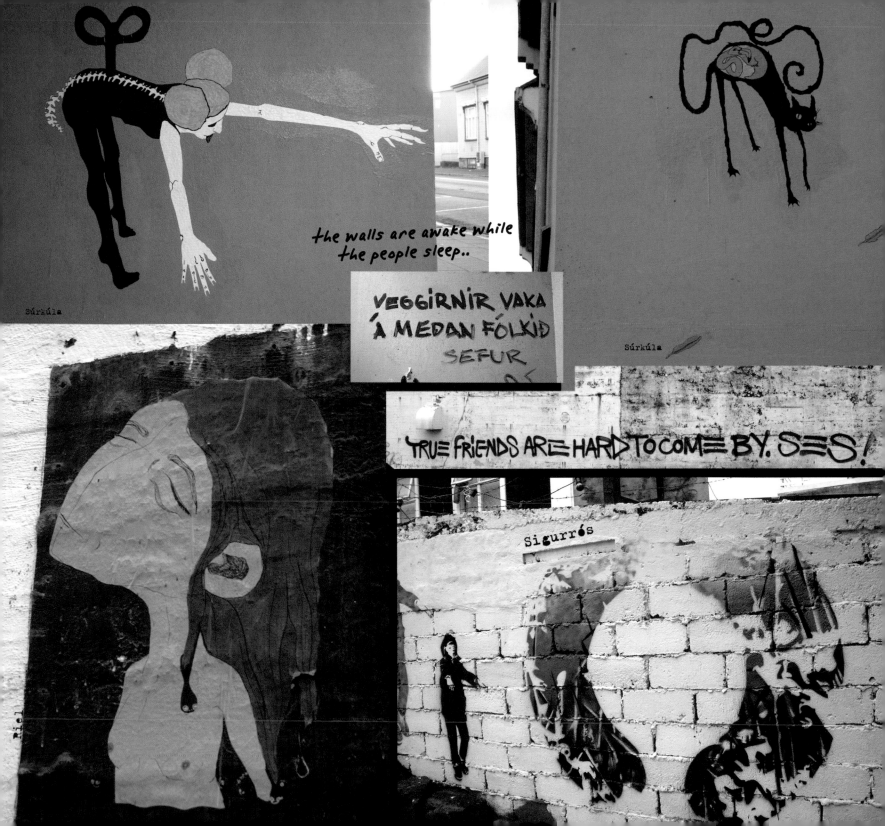

the walls are awake while the people sleep..

Súrkúla

VEGGIRNIR VAKA Á MEDAN FÓLKIÐ SEFUR

Súrkúla

TRUE FRIENDS ARE HARD TO COME BY. SES!

Sigurrós

Riel

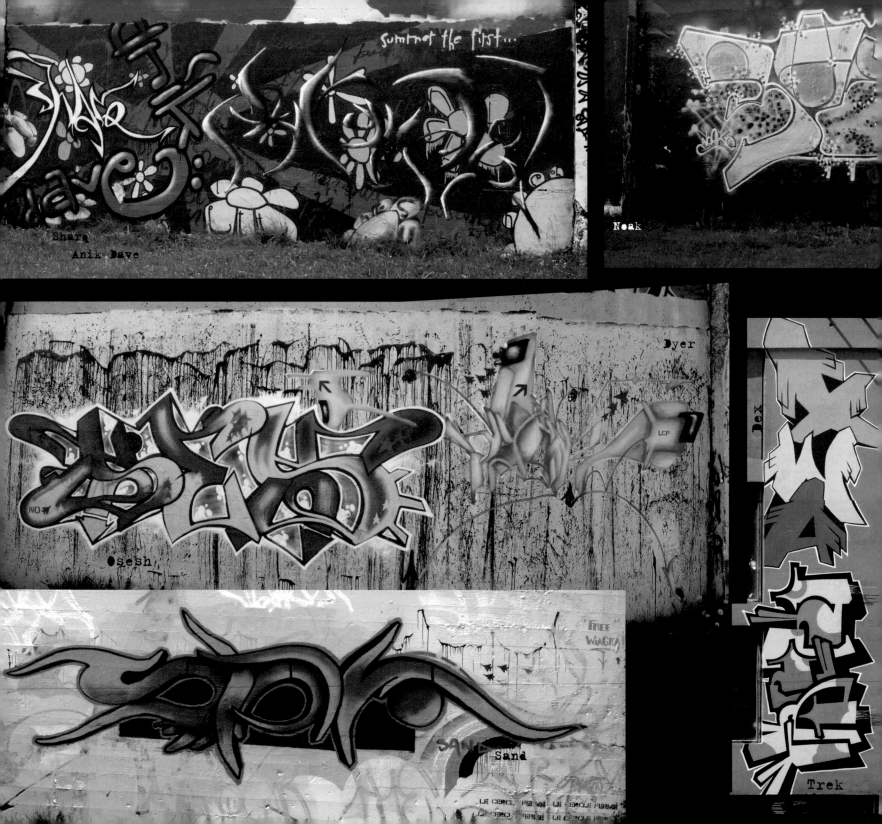

summer the first...

Sharq

Anik Dave

Kyle

Noak

Dyer

Osesh

Dex

FREE WIAGRA

SAND Sand

Trek

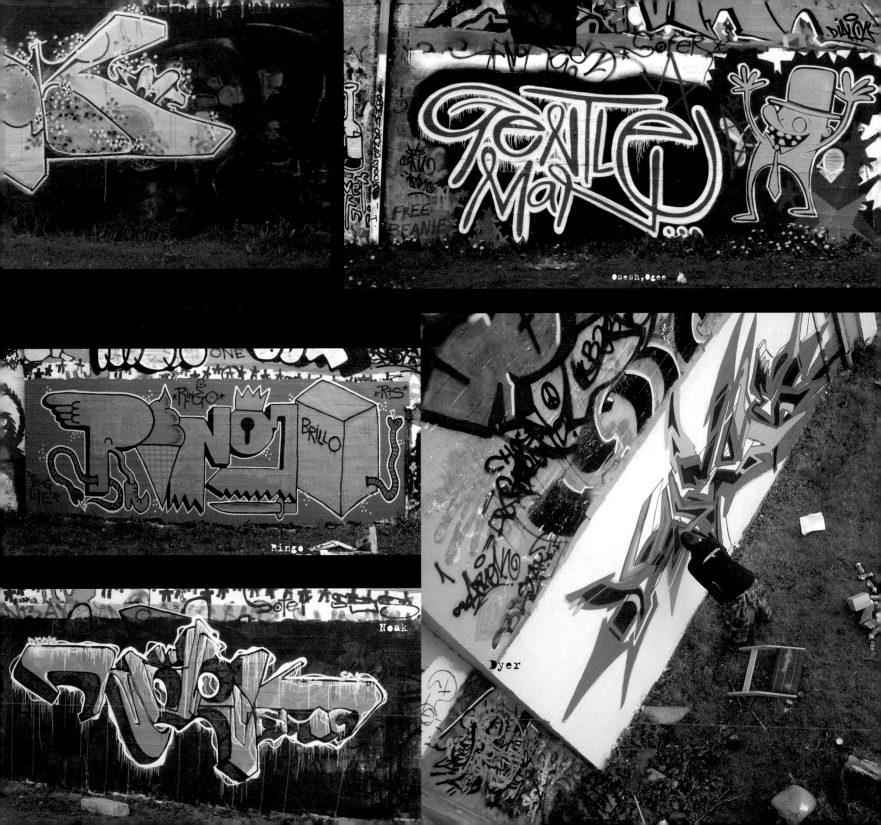

@sesh,@gee

Ringo

Noak

Dyer

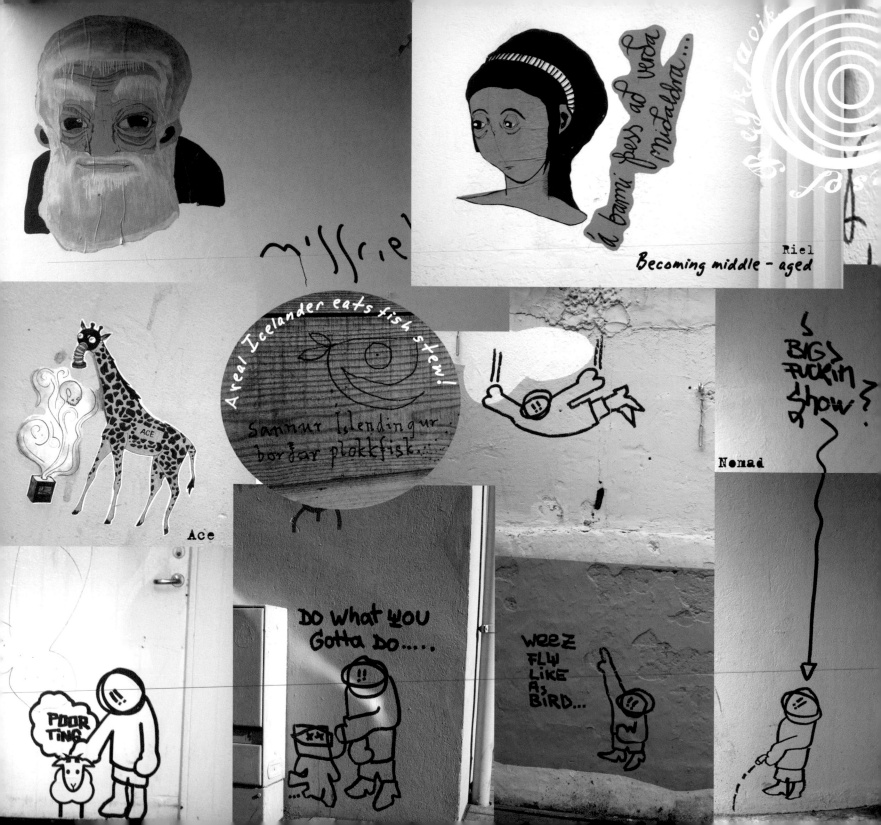

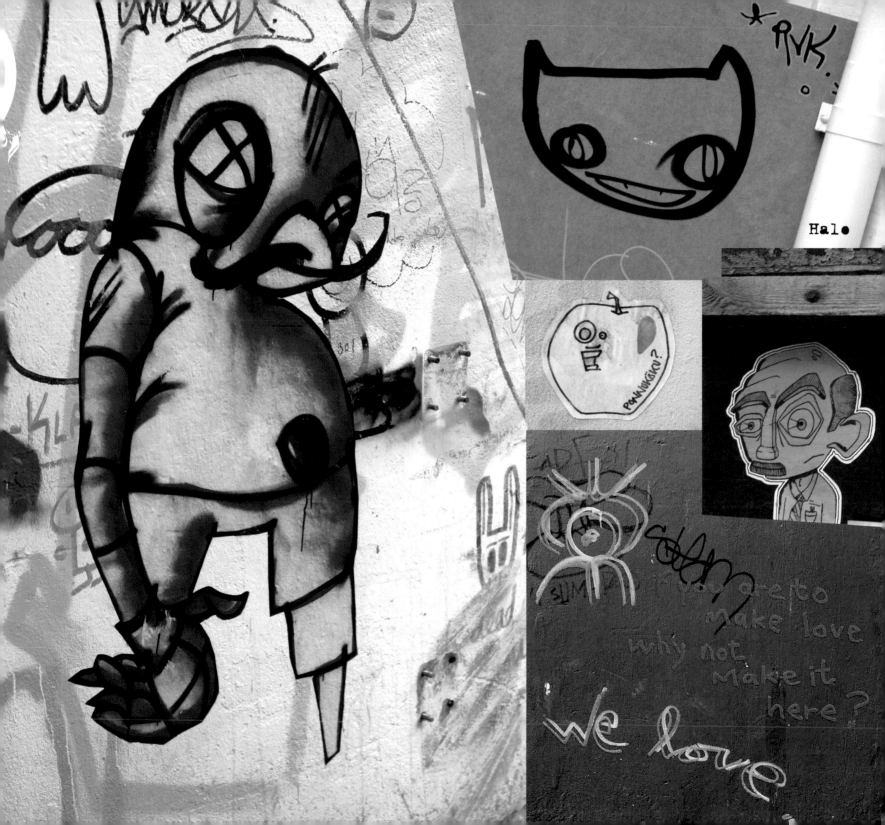

Halo

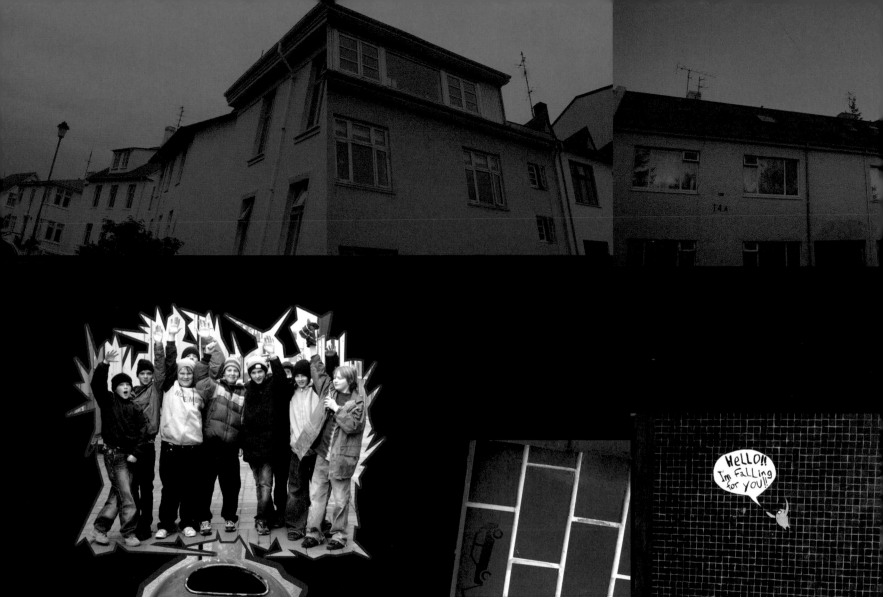

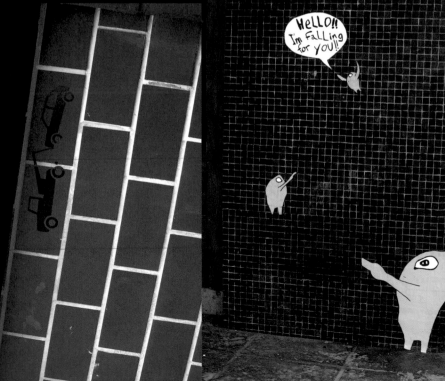

"Twisted Minds" by Megadeath

*megadeath

Ima

-DAT!

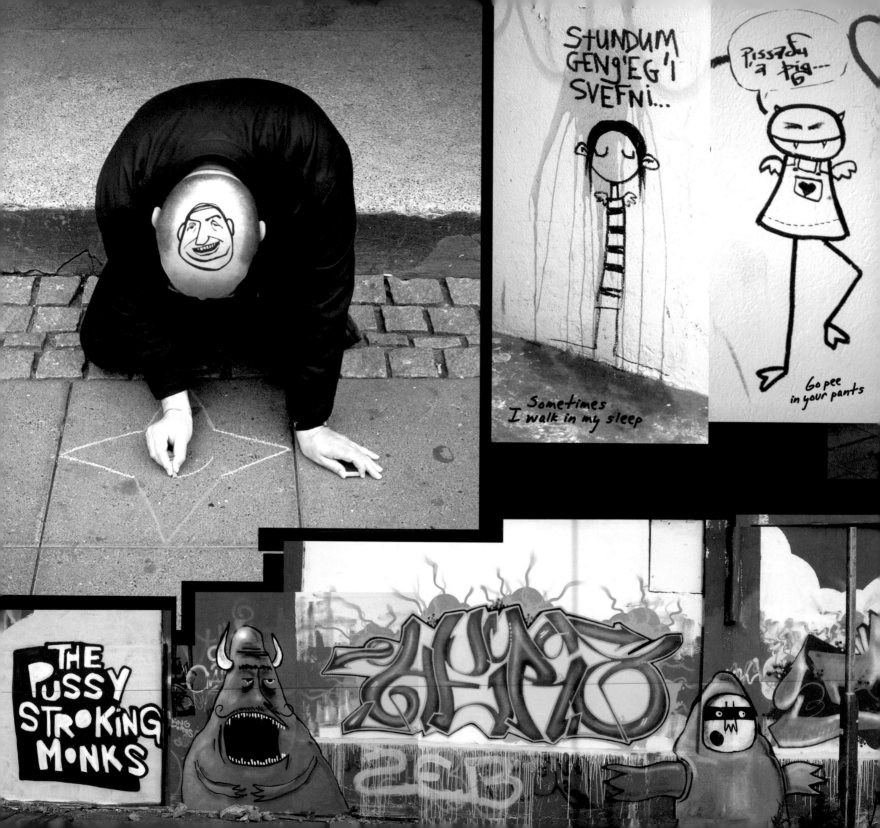

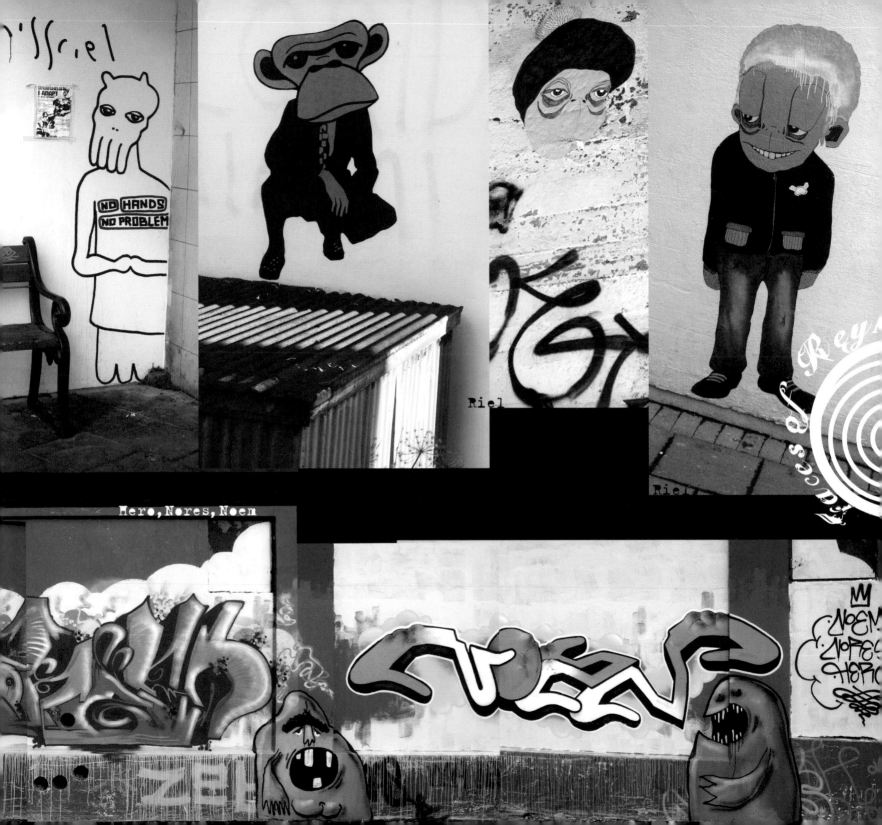

Riel

Riel

Hero, Nores, Noem

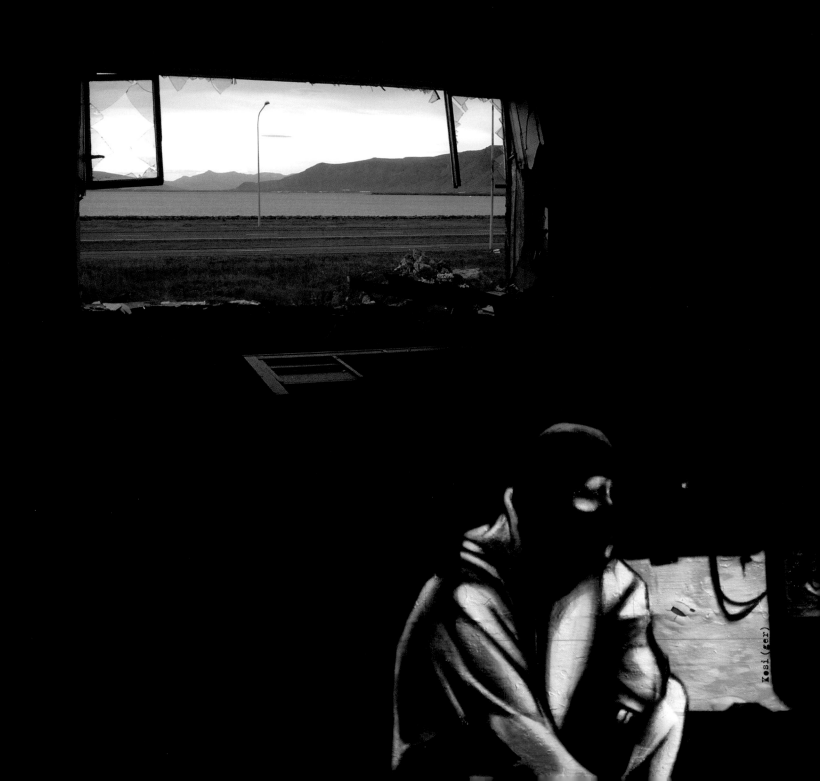

Kosi(ger)

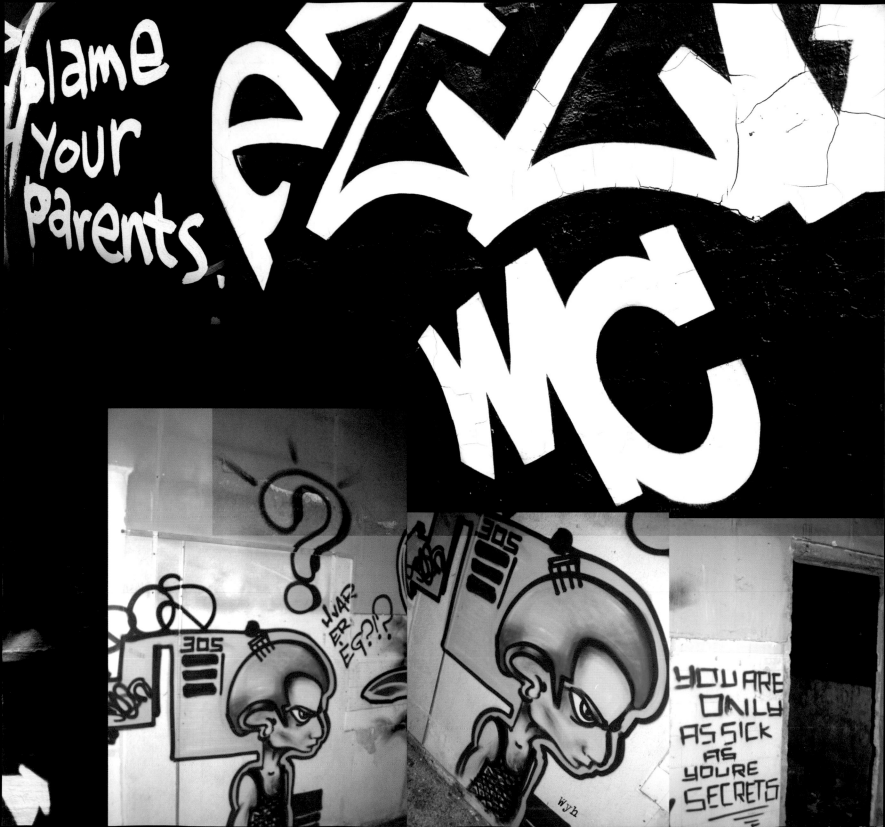

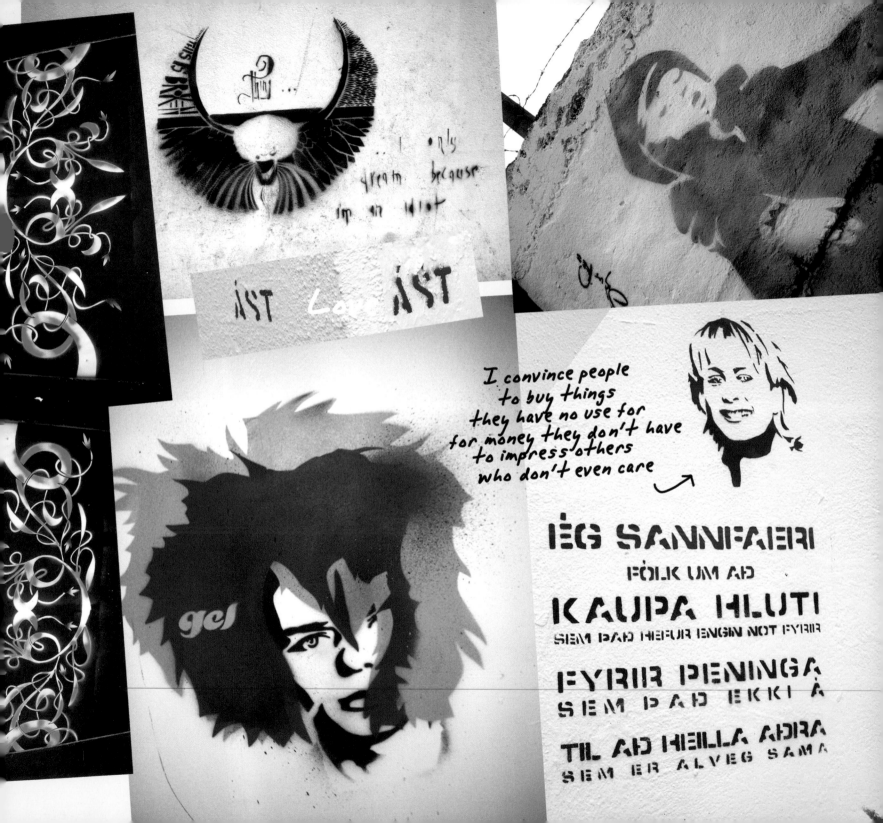

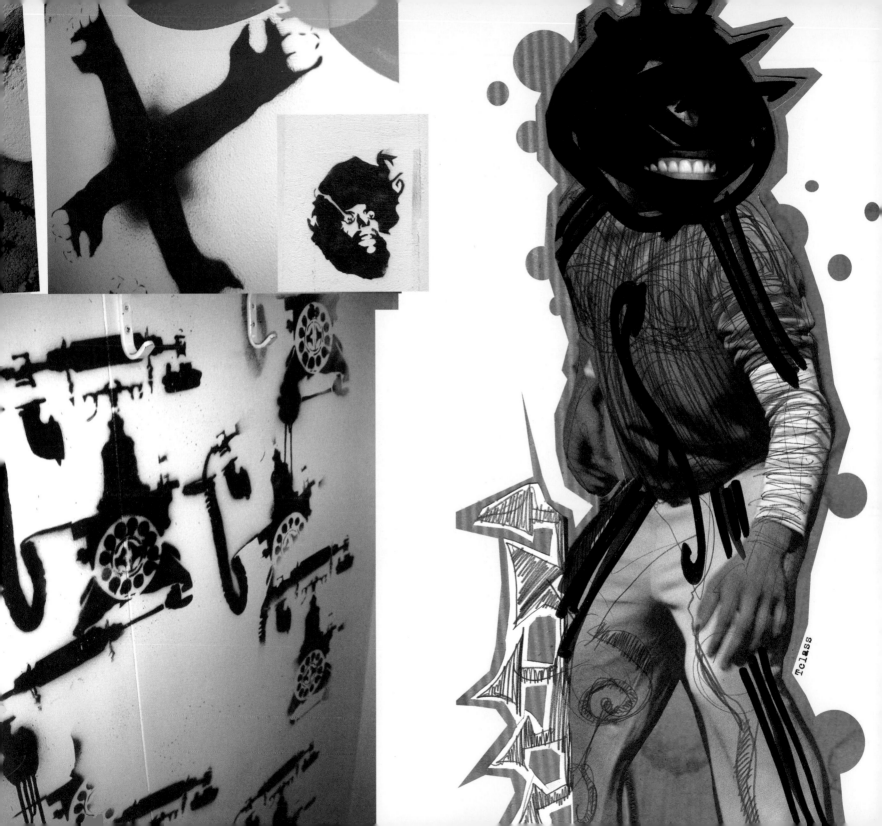

tclass

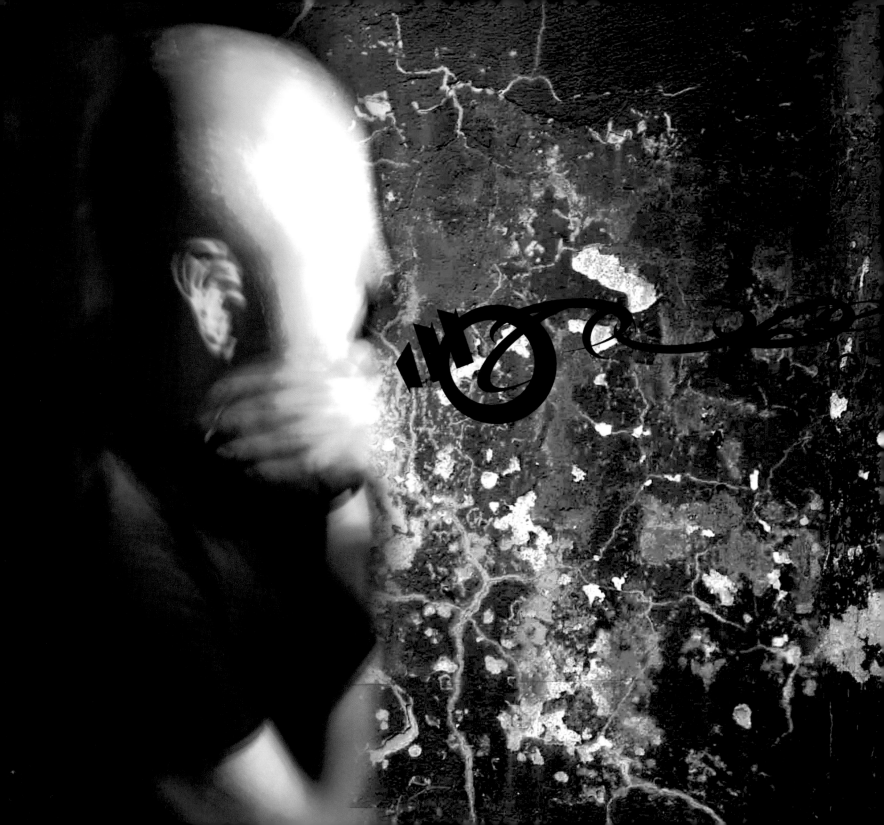

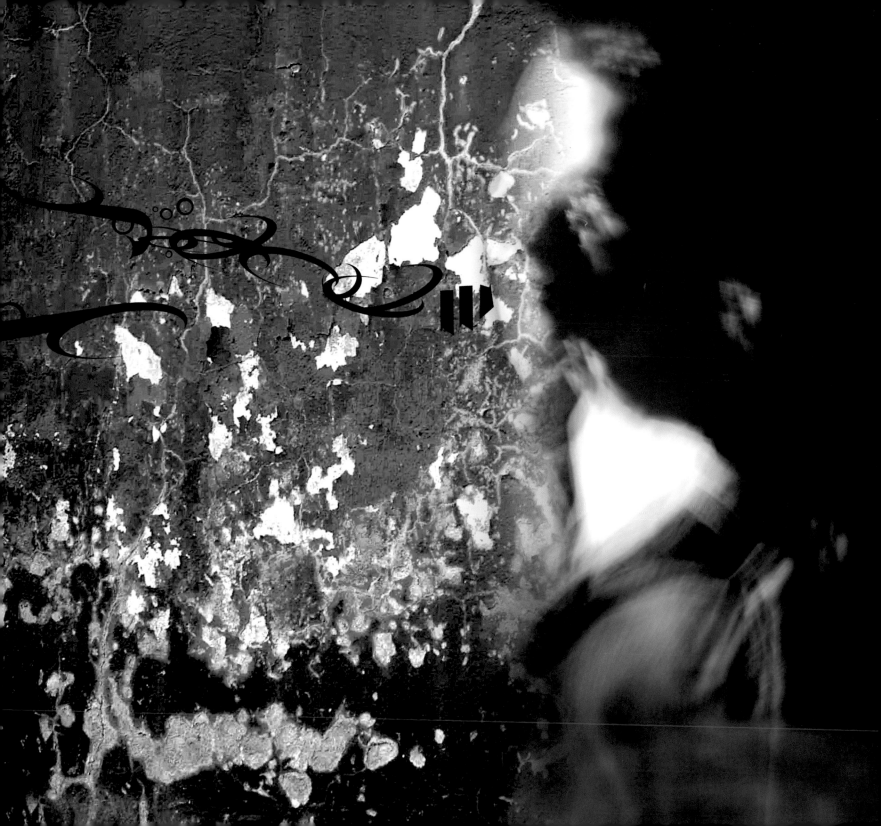

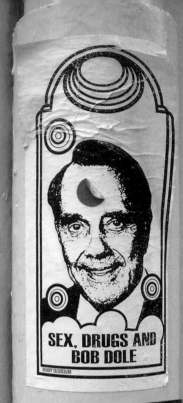

SEX, DRUGS AND
BOB DOLE

SICK O FUCK

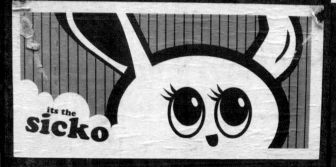

its the
sicko

WUSSUP
CHICKA!

NORES·TMC

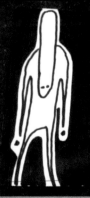

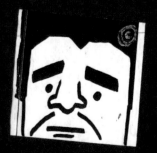

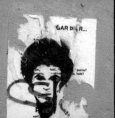

GAR Þ£ R...

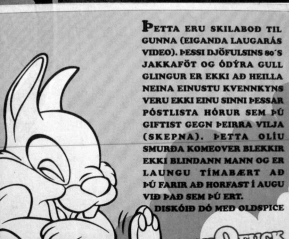

ÞETTA ERU SKILABOÐ TIL
GUNNA (EIGANDA LAUGARÁS
VIDEO). ÞESSI DJÖFULSINS 80´S
JAKKAFÖT OG ÓDÝRA GULL
GLINGUR ER EKKI AÐ HEILLA
NEINA EINUSTU KVENNKYNS
VERU EKKI EINU SINNI ÞESSAR
PÓSTLISTA HÓRUR SEM ÞÚ
GIFTIST GEGN ÞEIRRA VILJA
(SKEPNA). ÞETTA OLÍU
SMURÐA KOMEOVER BLEKKIR
EKKI BLINDANN MANN OG ER
LAUNGU TÍMABÆRT AÐ
ÞÚ FARIR AÐ HORFAST Í AUGU
VIÐ ÞAÐ SEM ÞÚ ERT.
DISKÓIÐ DÓ MEÐ OLDSPICE

SICK O FUCK

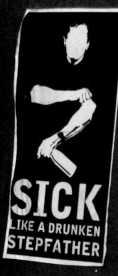

SICK
LIKE A DRUNKEN
STEPFATHER

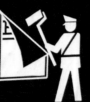

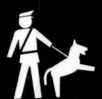

BNK

elskaðir af yfirvaldinu

Loved by the Government

BNK | BNK | BNK

Hey you! I reject your so called art completely.
A job in a hot dog stand would suit you better.
So take off your designer-glasses and start
doing something for real.

HEY ÞÚ...

ÉG SEGJI HIKLAUST NEI
VIÐ ÞESSARI SVOKALLAÐRI
LIST ÞINNI. STARF Í
PULSUVAGNI ÆTTI BETUR
VIÐ ÞIG. SVO RÍFÐU AF ÞÉR
TÝPUGLERAUGUN OG FARÐU AÐ
GERA EITTHVAÐ AÐ VITI.

STÓRI BRÓÐIR FYLGIST MEÐ

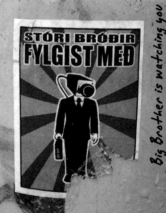

Big Brother is watching you

THE GOVERNMENT DOESN'T LOVE YOU!!!

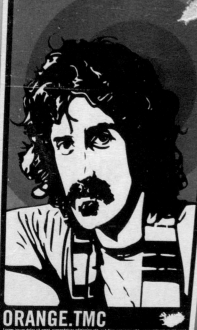

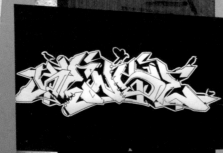

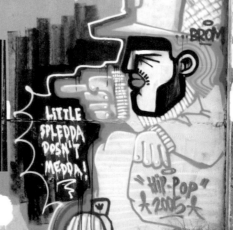

LITTLE
SPLEDDA
DOSN'T
MEDDA!

"HIP-POP"
2005

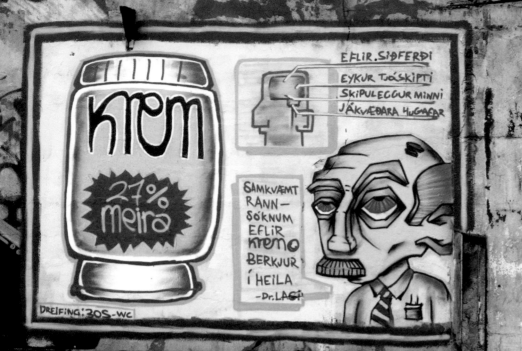

Krem, Lagi

sexy

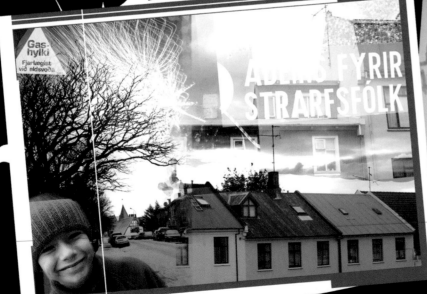

Gas-
hylki
Fjarlægist
við eldsvoða

AÐEINS FYRIR
STRARFSFÓLK

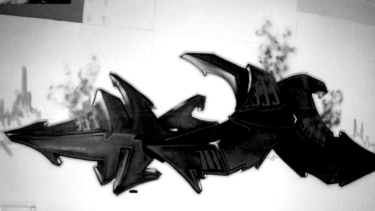

Wyh

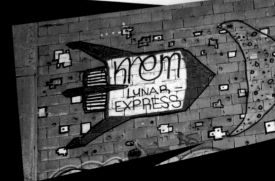

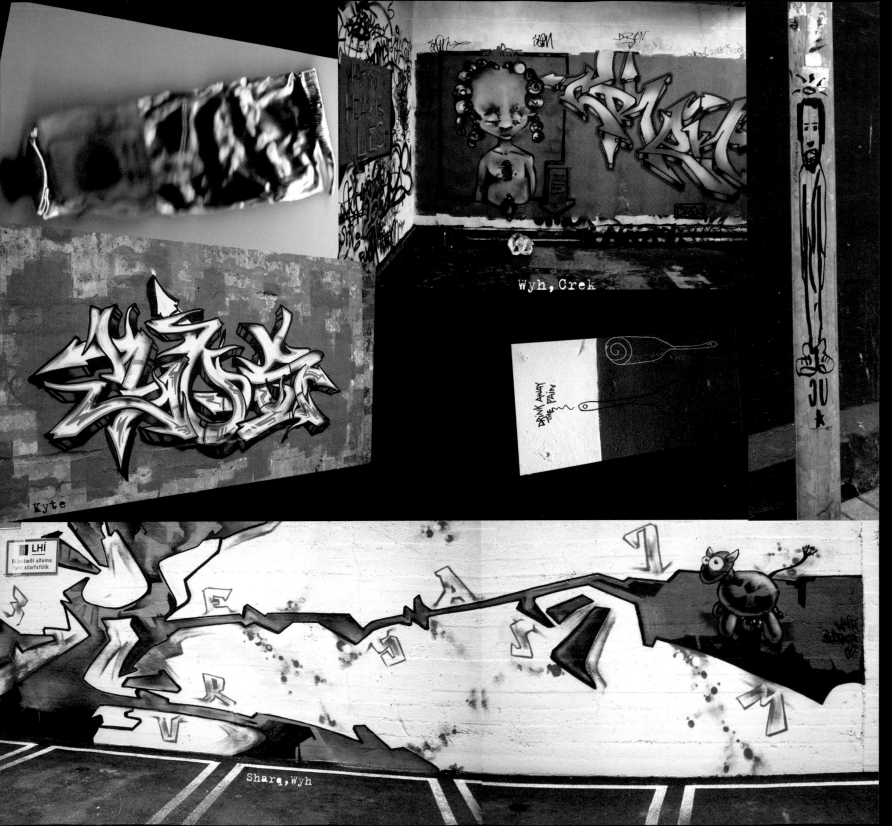

Wyh, Crek

Kyte

Shara, Wyh

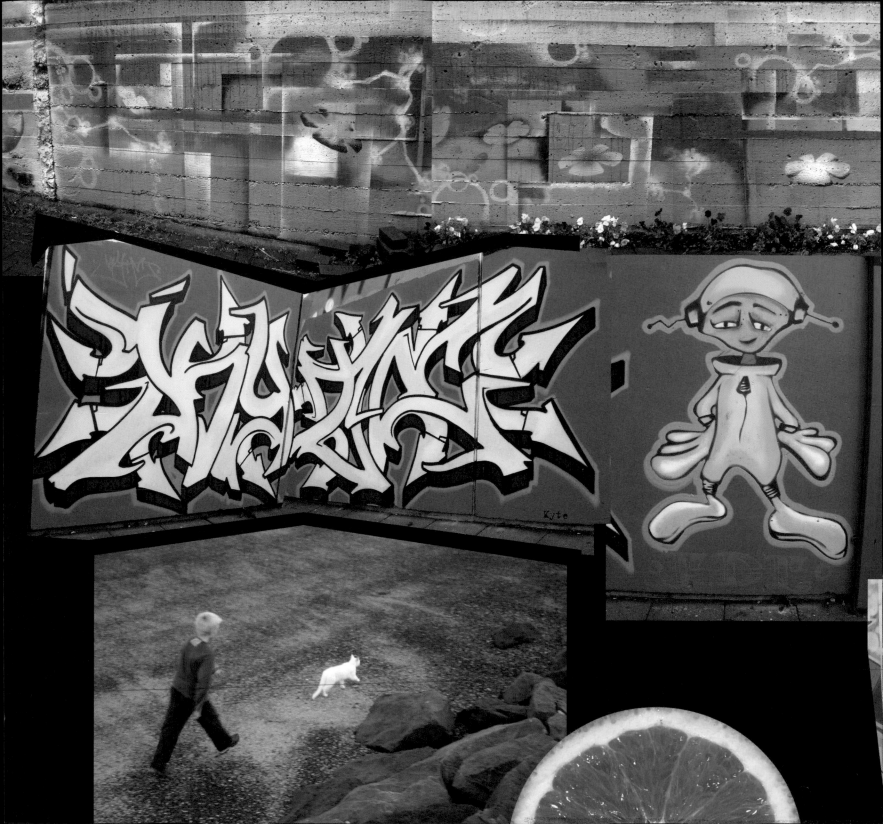

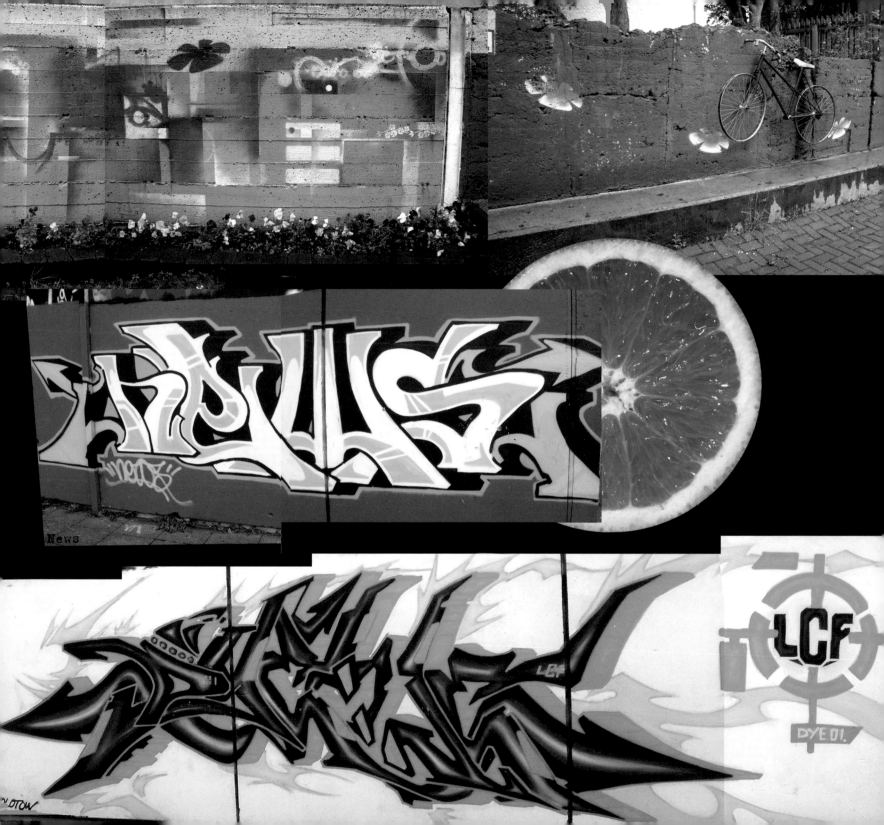

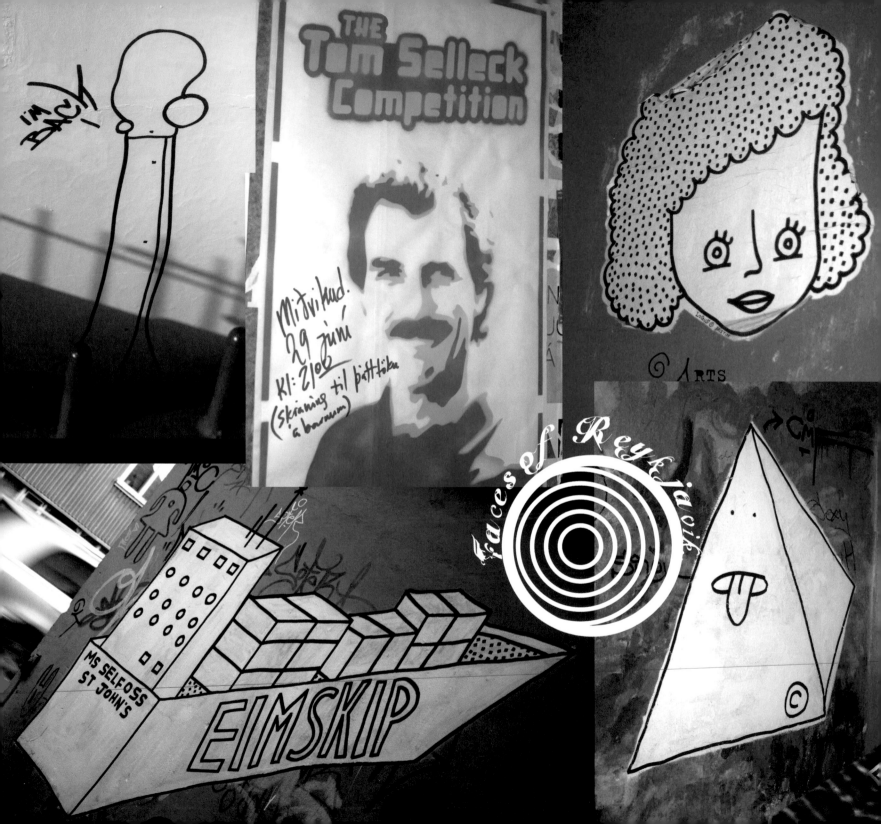

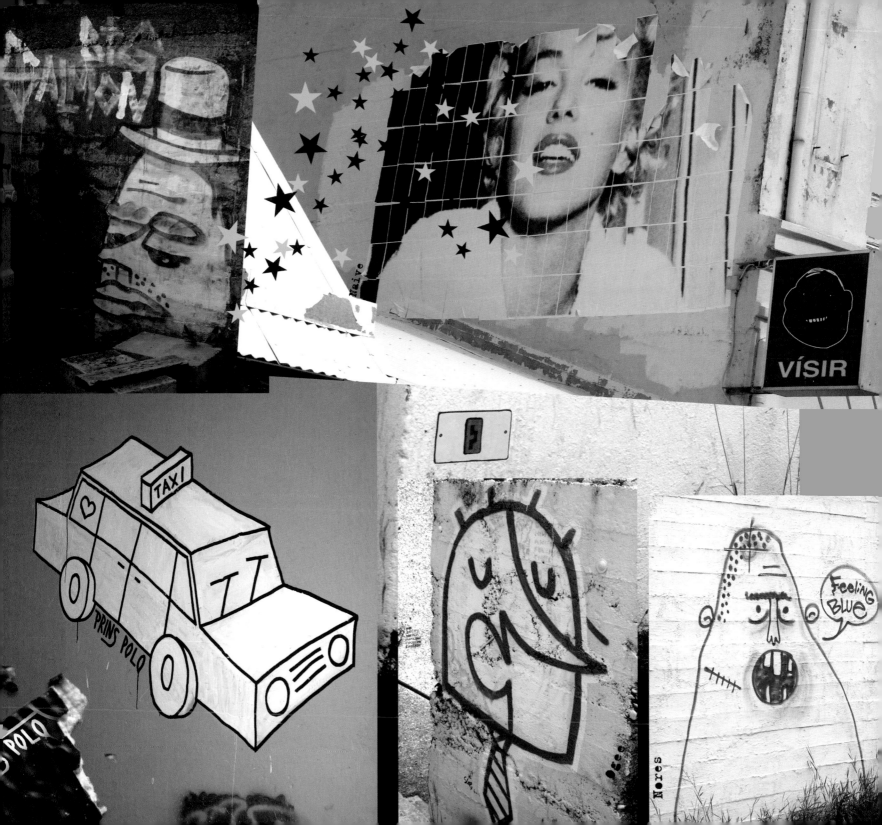

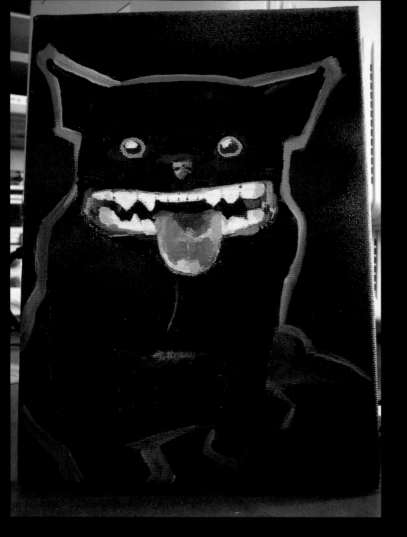

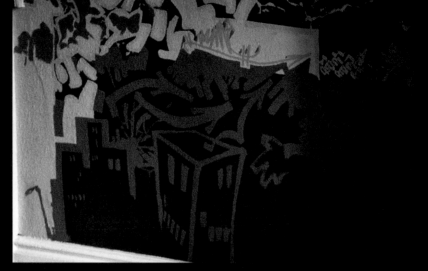

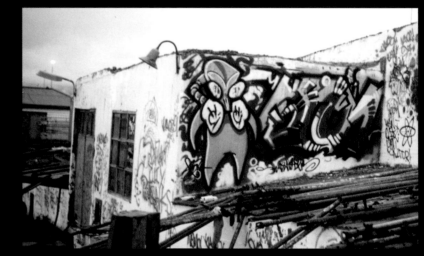

Aton, Kez

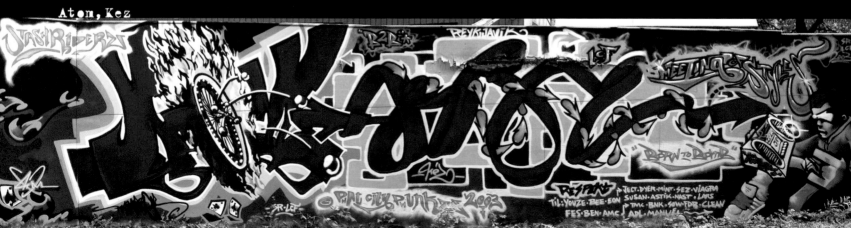

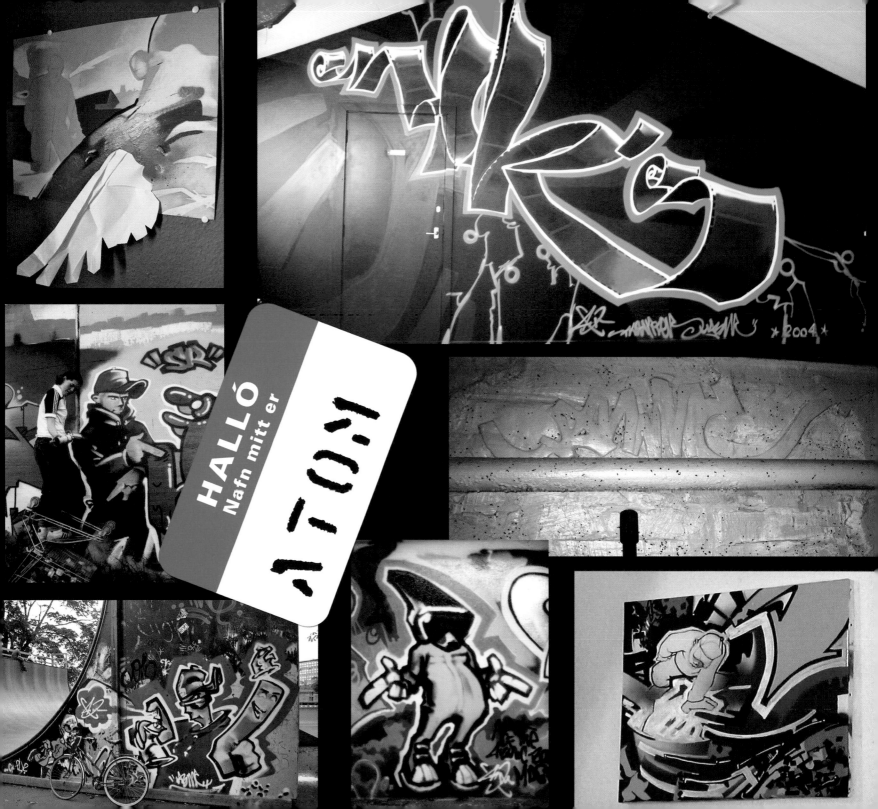

HALLÓ
Nafn mitt er
ATON

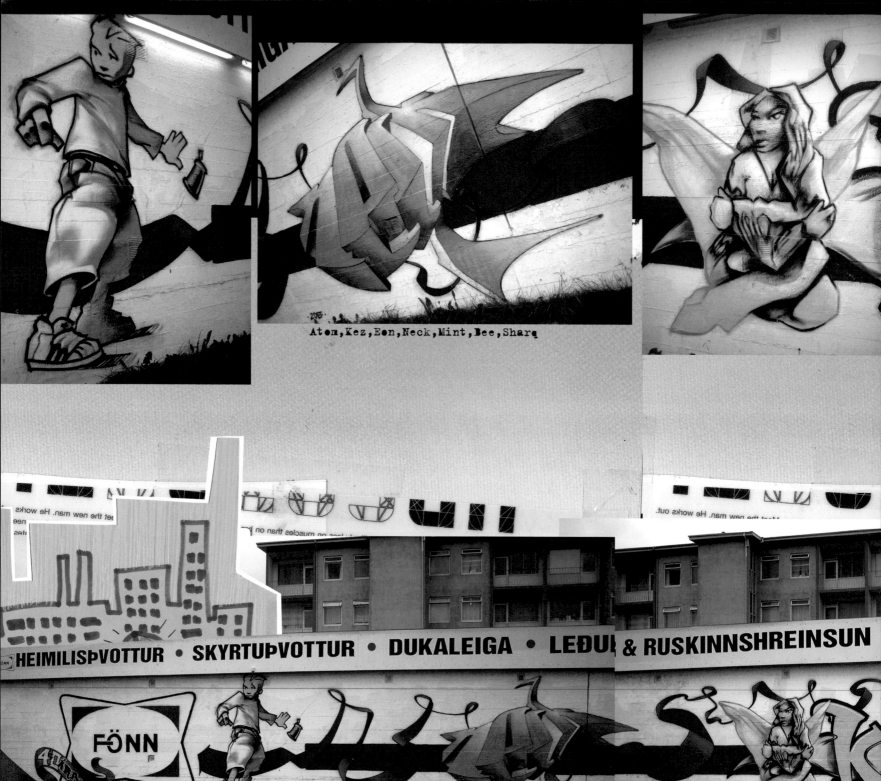

Atem,Kez,Eon,Neck,Mint,Bee,Sharq

HEIMILISÞVOTTUR • SKYRTUÞVOTTUR • DUKALEIGA • LEÐUI & RUSKINNSHREINSUN

FÖNN

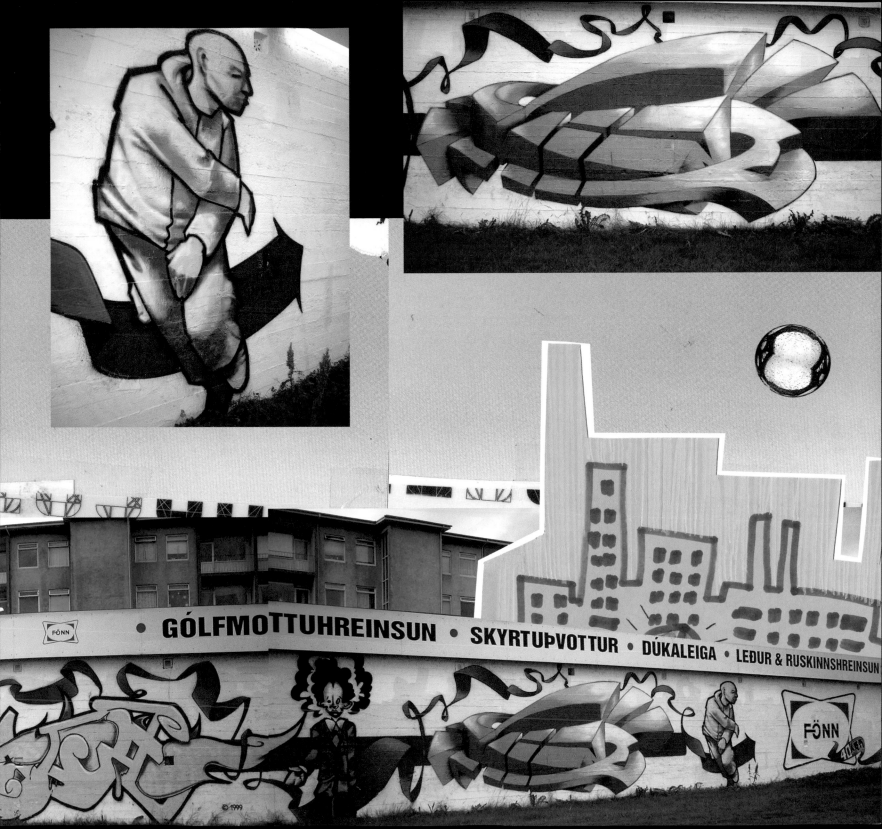

GÓLFMOTTUHREINSUN • SKYRTUÞVOTTUR • DÚKALEIGA • LEÐUR & RUSKINNSHREINSUN

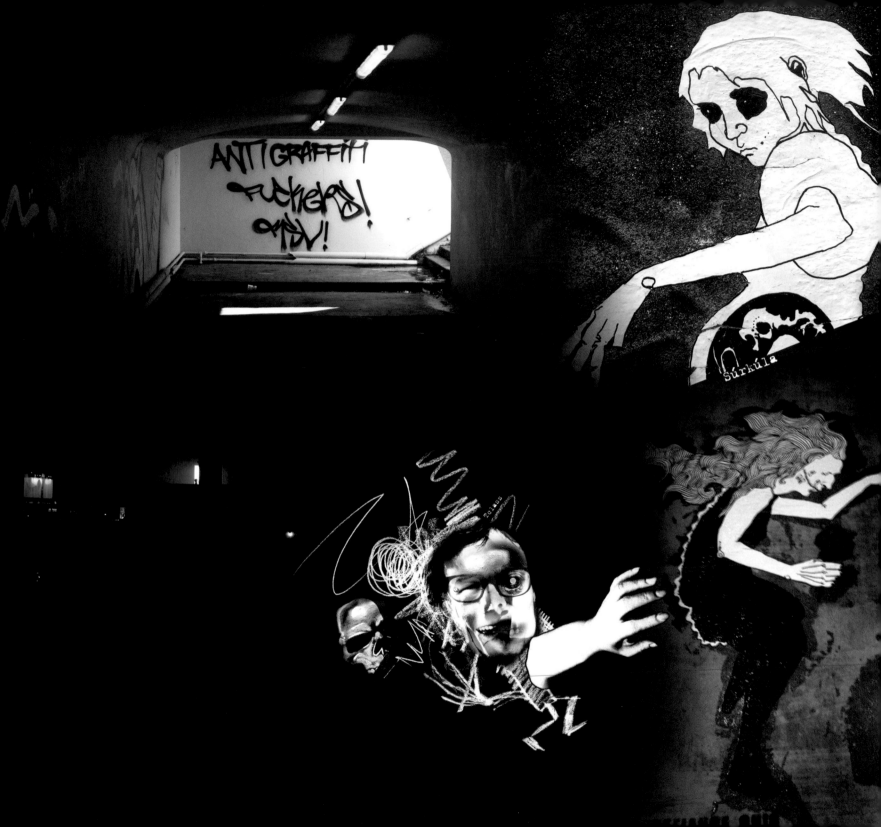

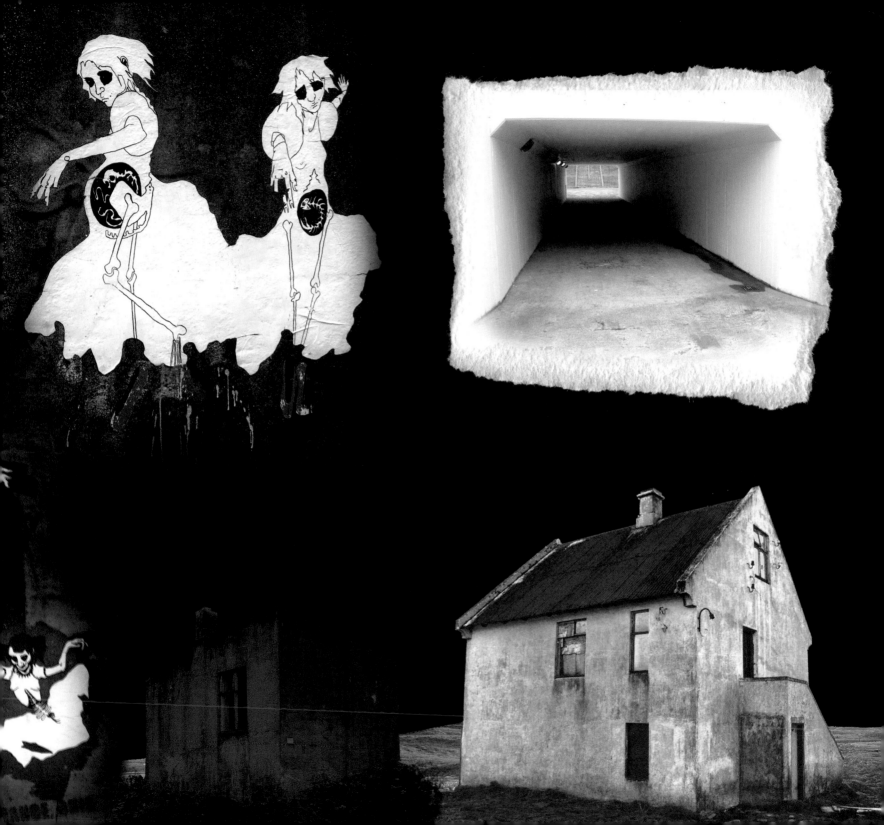

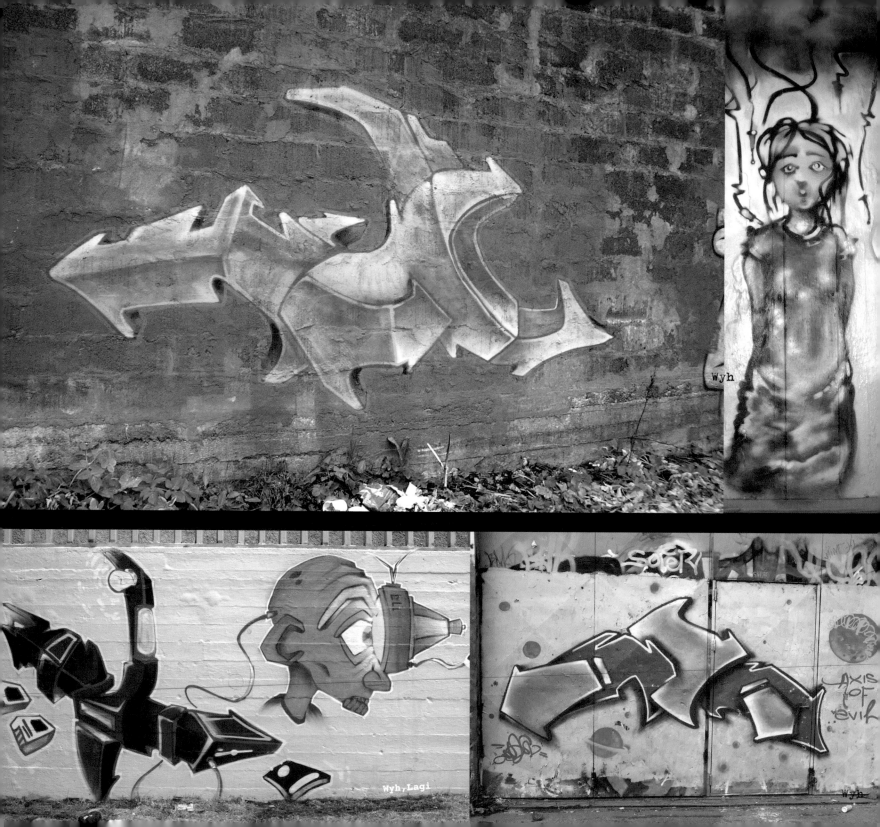

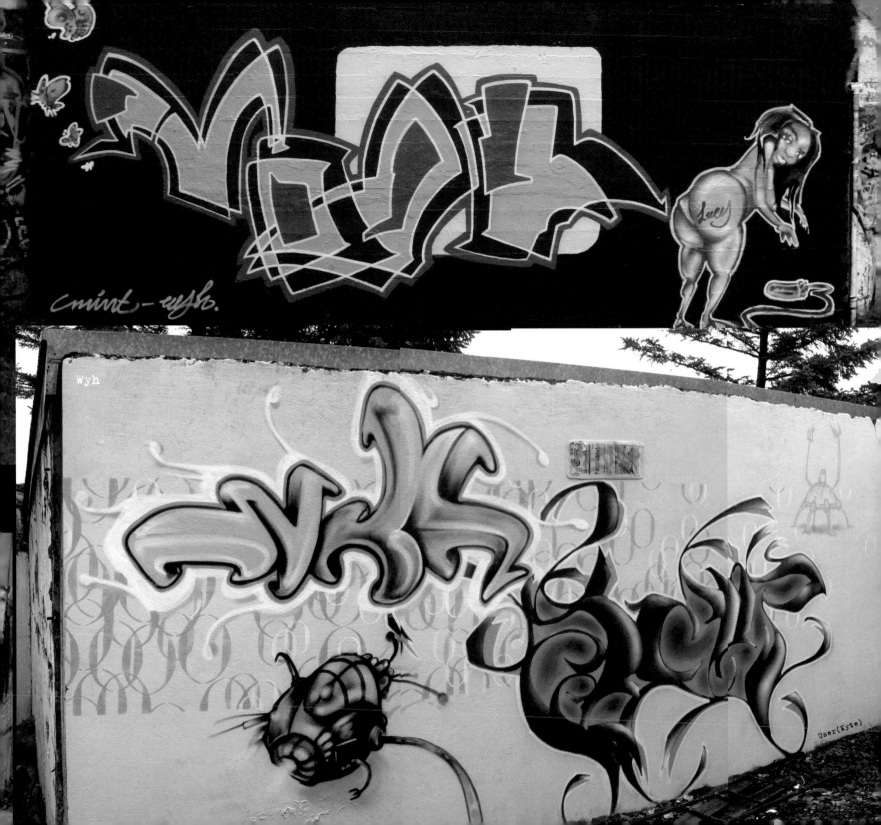

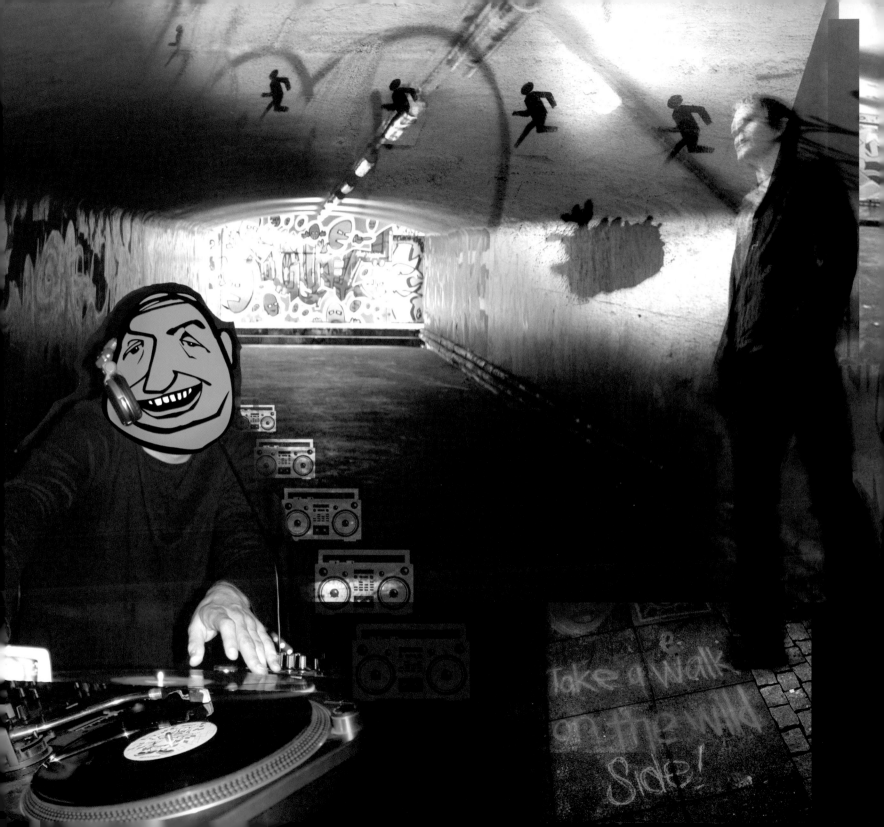

Take a walk
on the wild
Side!

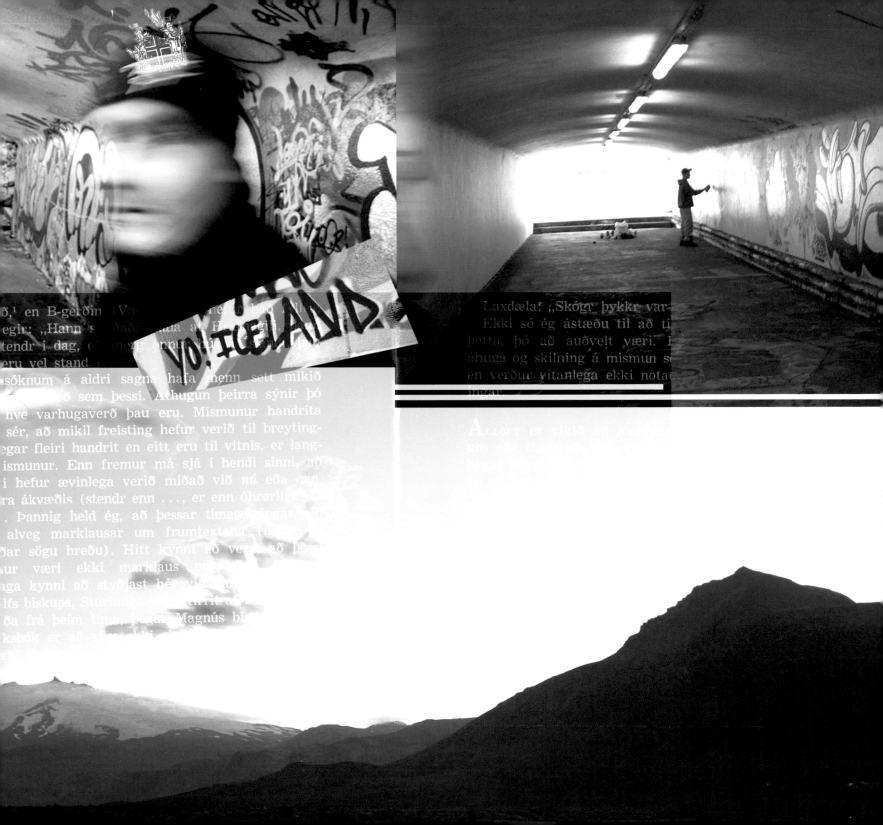

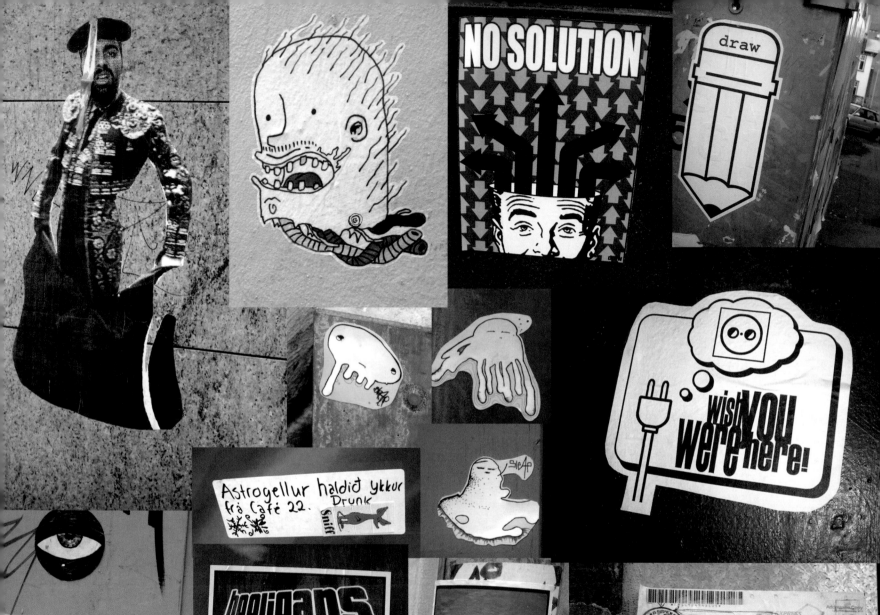

NO SOLUTION

draw

wish YOU were here!

Astrogellur haldid ykkur frá Café 22. Drunk Sniff

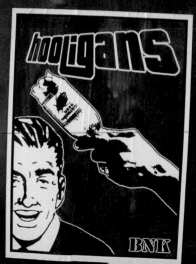

hooligans

BNK

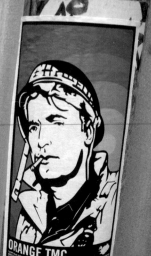

ORANGE TMC

Once there was a nores and he was a big nores, and came from nores. he nores and nores till he nores and nores. I nores nores nores res nores snores noorse snnreosne nores evonen os nores nore SNORES nores

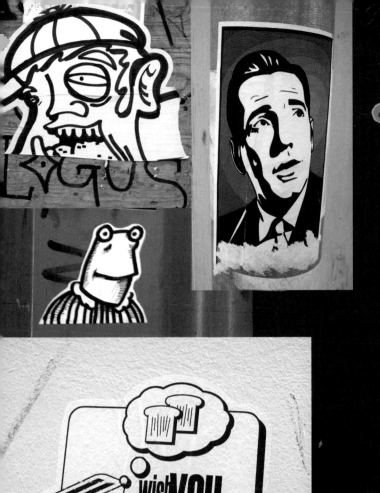

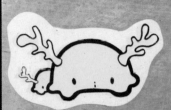

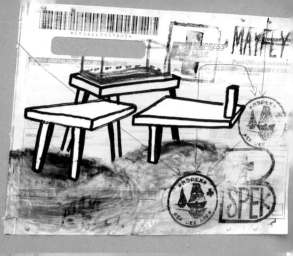

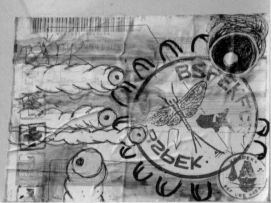

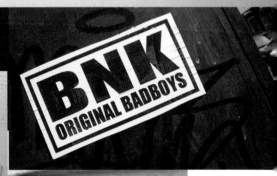

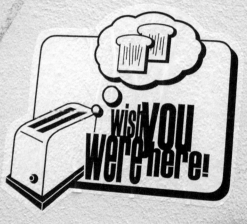

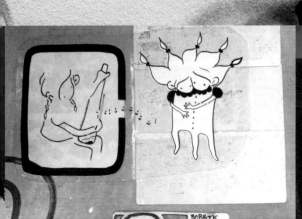

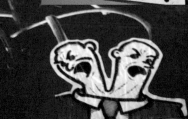

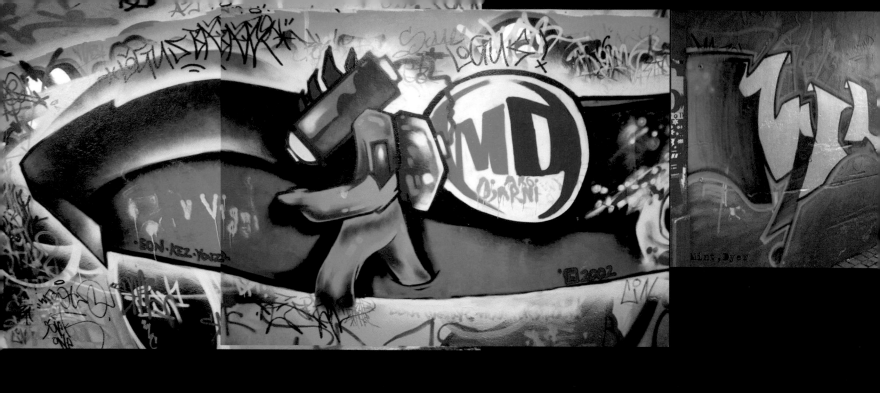
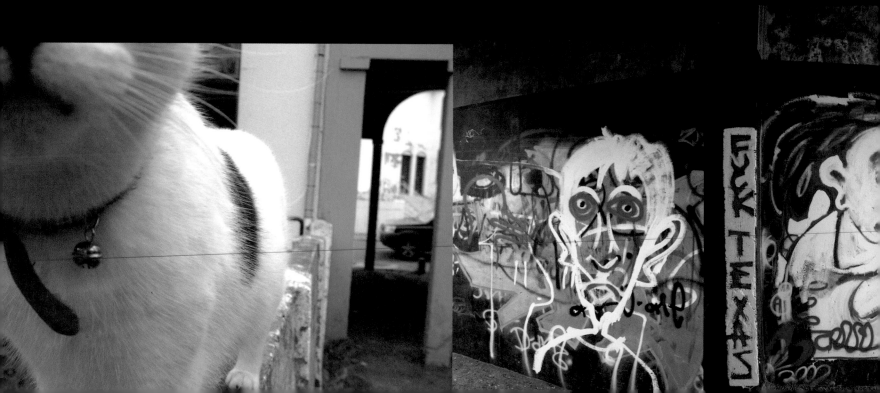

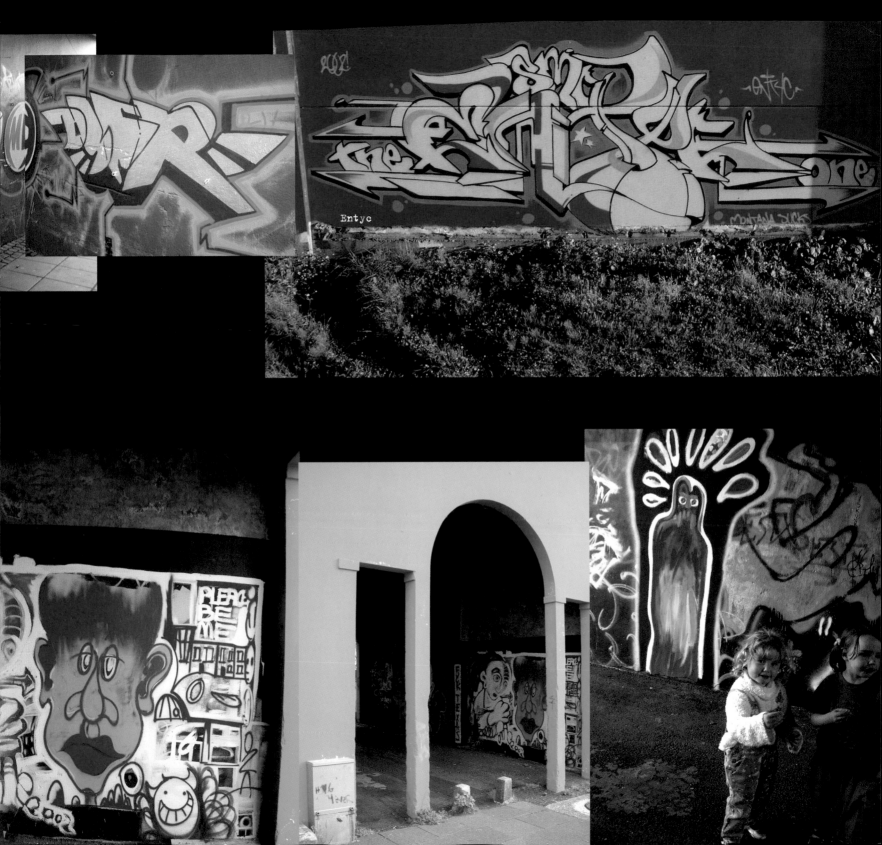

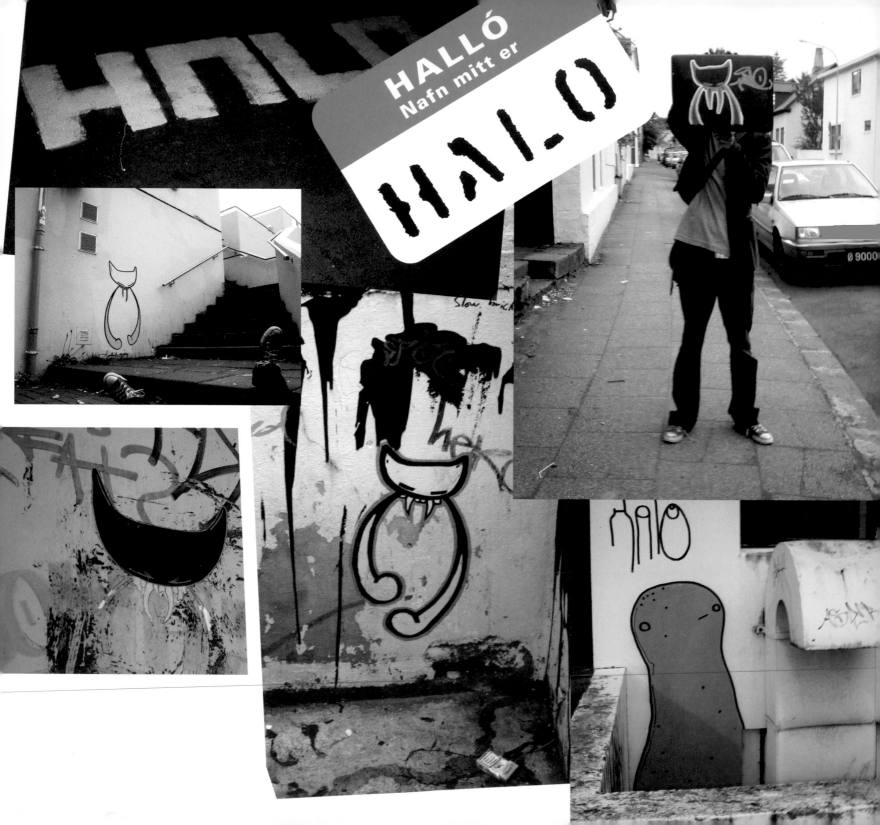

HALLÓ
Nafn mitt er

HALO

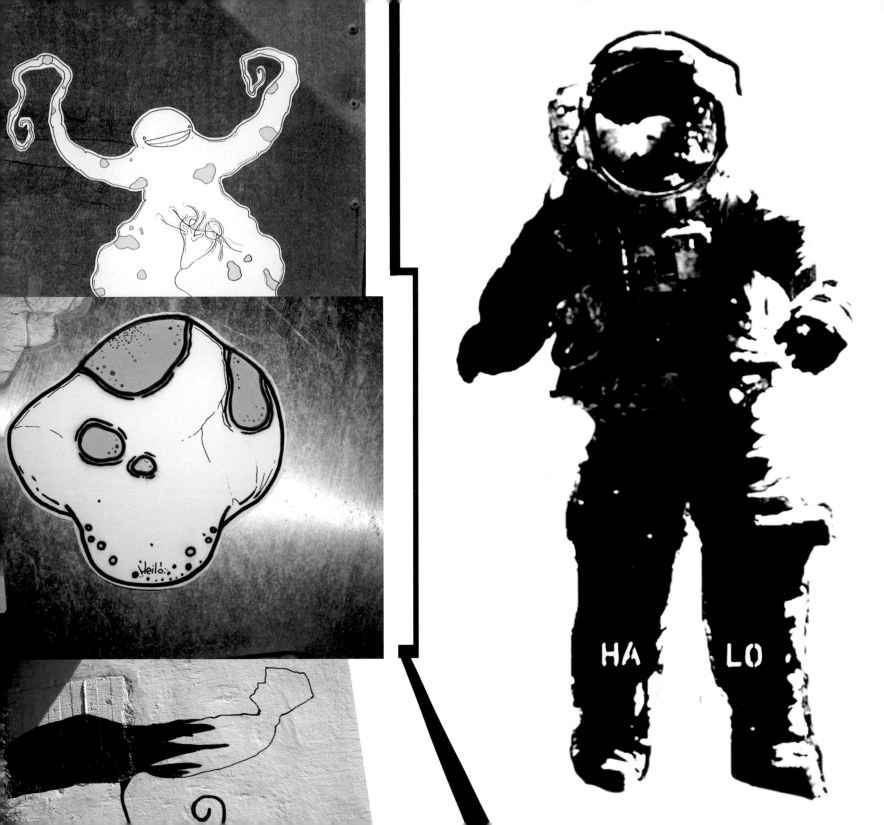

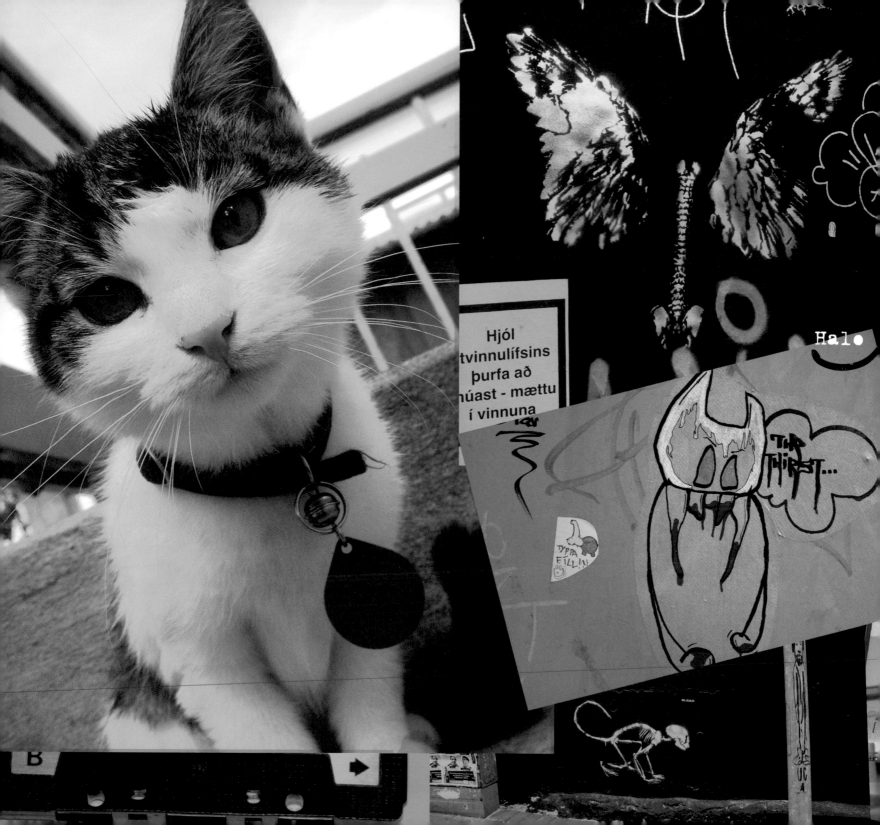

Hjól
atvinnulífsins
þurfa að
snúast - mættu
í vinnuna

Halo

THE
THIRST...

DYPRA
FÍLL!!!

B ➡

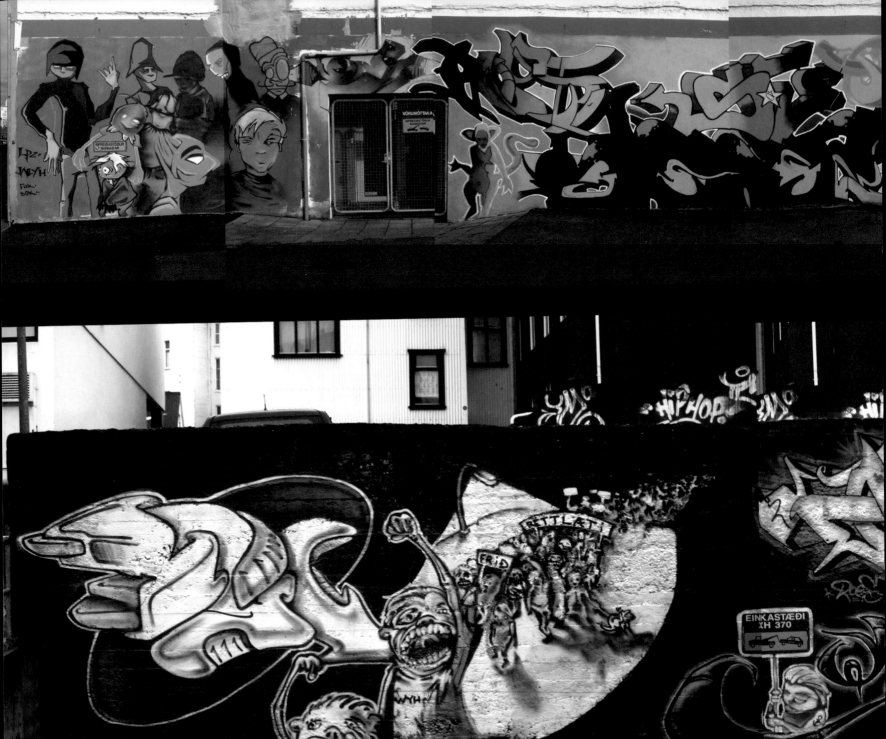

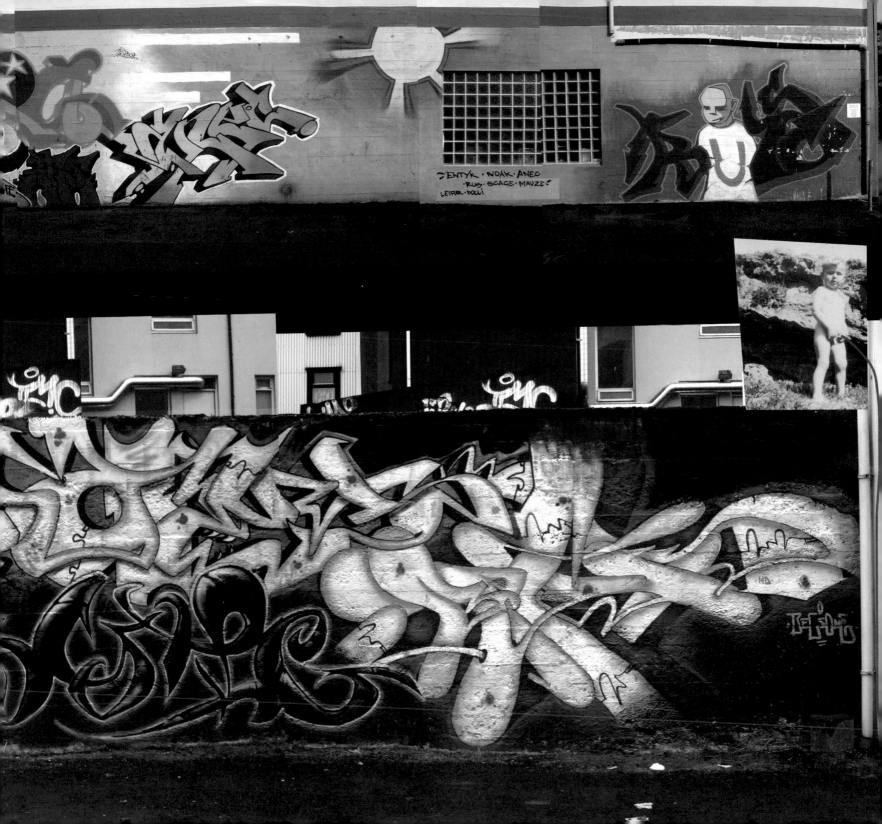

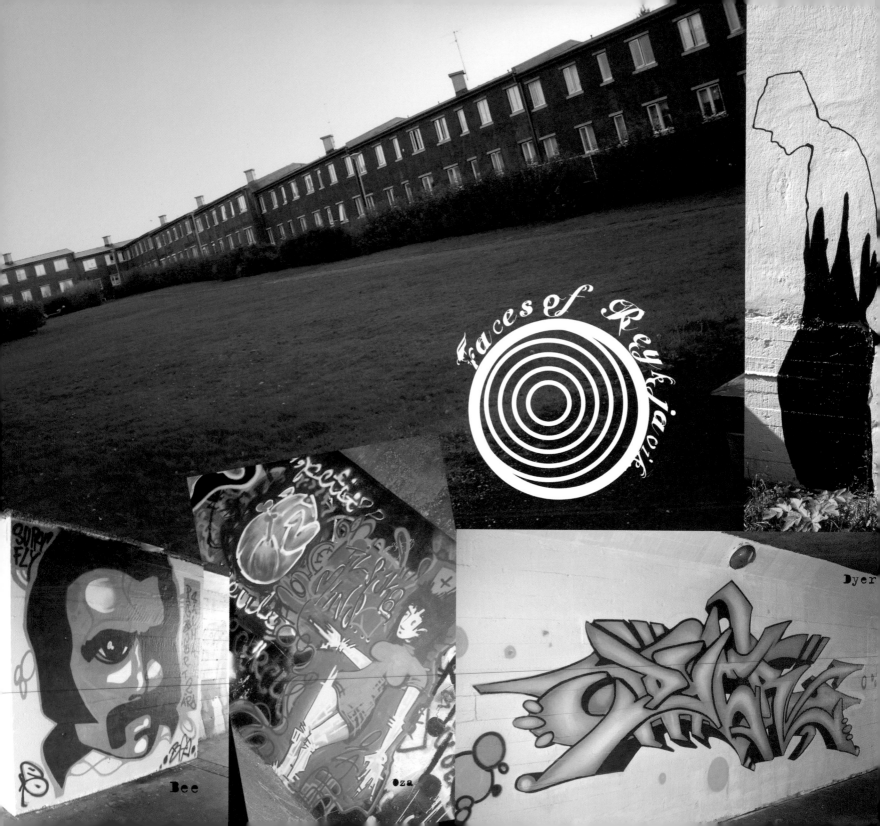

Faces of Reykjavik

Bee

Oza

Dyer

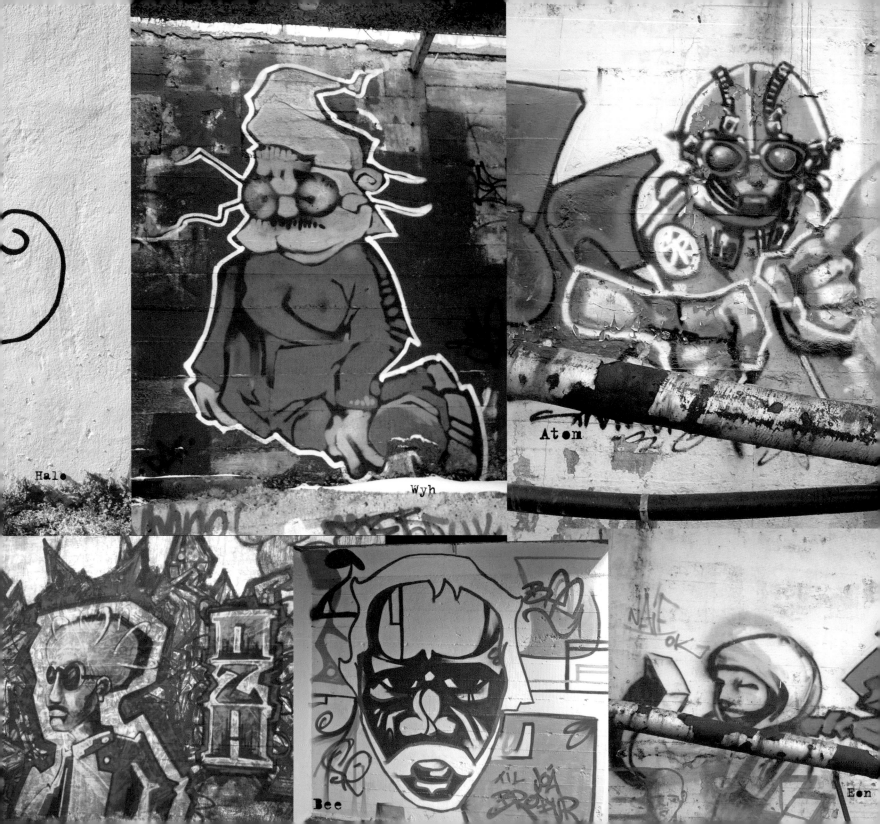

Halo

Wyh

Atom

Bee

Eon

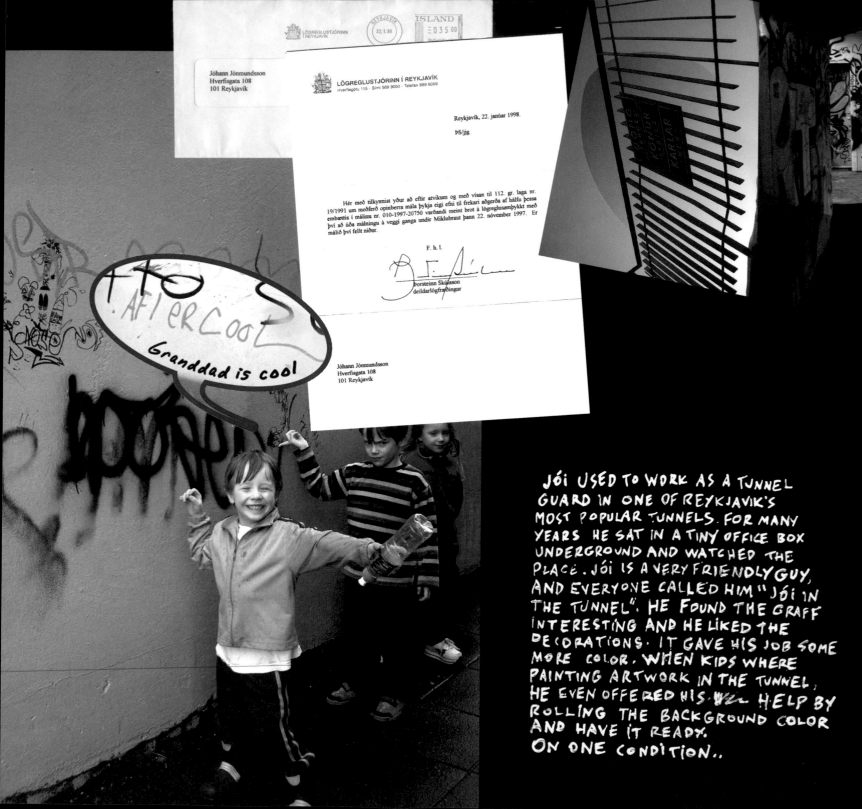

JÓI USED TO WORK AS A TUNNEL
GUARD IN ONE OF REYKJAVIK'S
MOST POPULAR TUNNELS. FOR MANY
YEARS HE SAT IN A TINY OFFICE BOX
UNDERGROUND AND WATCHED THE
PLACE. JÓI IS A VERY FRIENDLY GUY,
AND EVERYONE CALLED HIM "JÓI IN
THE TUNNEL". HE FOUND THE GRAFF
INTERESTING AND HE LIKED THE
DECORATIONS. IT GAVE HIS JOB SOME
MORE COLOR. WHEN KIDS WHERE
PAINTING ARTWORK IN THE TUNNEL,
HE EVEN OFFERED HIS HELP BY
ROLLING THE BACKGROUND COLOR
AND HAVE IT READY.
ON ONE CONDITION..

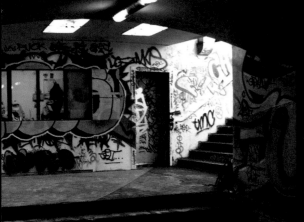
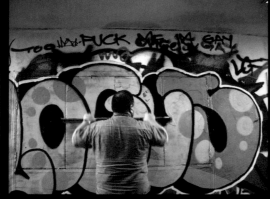
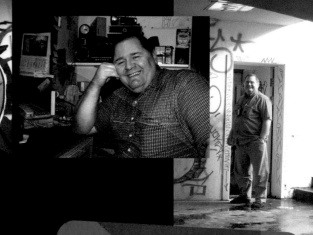

"I WILL ROLL THE BACKGROUND FOR YOU GUYS"..!

"DO NOT PAINT ANY MOTIVES CONTAINING VIOLENCE OR PORN. SIMPLE AS THAT. A MUTUAL TRUST AND TEAMWORK. WAS CREATED BETWEEN JÓI THE GUARD AND GRAFF-WRITERS. HE PHOTOGRAPHED THE WALLS CAREFULLY FOR MANY YEARS. AND HIS ALBUMS ARE A PRICELESS DOCUMENTATION OF THE EARLY STEPS IN REYKJAVÍK GRAFF-ITI SCENE. A FRAGMENT OF HIS COLLECTION IS ON THE NEXT SPREAD. ONE DAY HE GOT A LETTER FROM THE POLICE DEPARTMENT. — THEY ASKED ME TO BE AT THEIR OFFICE BECAUSE OF A REPORT THEY WERE MAKING ON GRAFFITI PAINTING. I BROUGHT MY PHOTO ALBUMS AND SHOWED THEM THE NICE DECORATIONS. I TOLD THEM: "LOOK..

THERE IS NOTHING BRUTAL IN THESE PAINTINGS, AND THIS CAN'T BE A CRIME. THE KIDS AND I HAVE AN AGREEMENT, AND THEY ALWAYS CLEAN UP THE TUNNEL WITH EMPTY CANS AND PIZZA BOXES. IT WORKS JUST FINE.." WHY NOT LET THE KIDS DEVELOP THEIR ARTISTIC SKILLS IN MY TUNNEL — INSTEAD OF HAVING THEM PAINTING THE WHOLE TOWN IN ANGER?..

THE POLICE DECIDED TO DROP THE CASE.. A FEW YEARS LATER HE LOST HIS JOB IN THE TUNNEL.

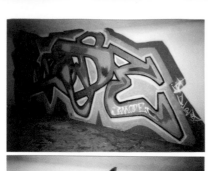
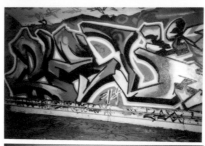
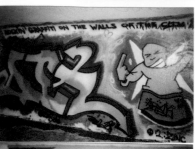
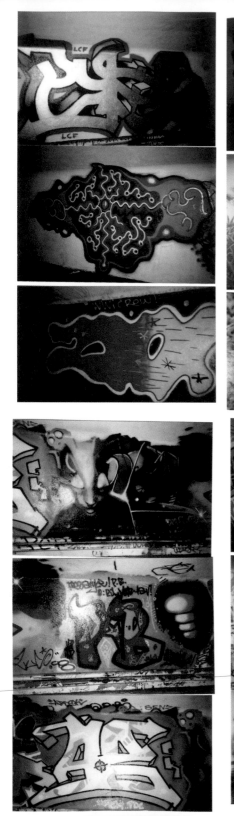
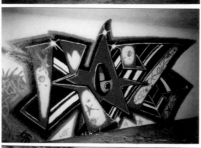
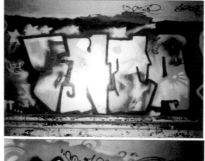
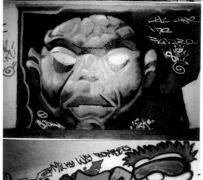
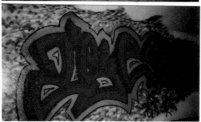
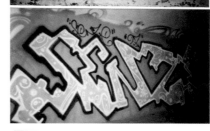
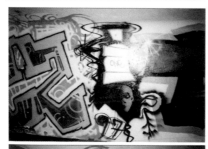
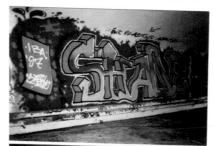
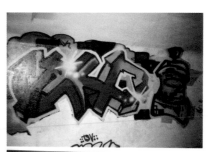
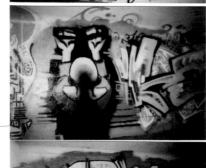
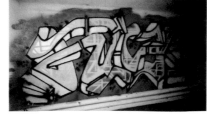
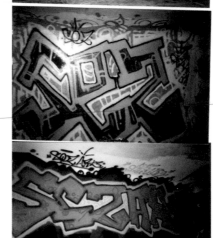
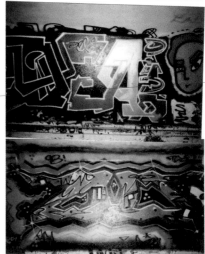

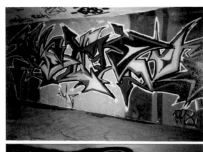
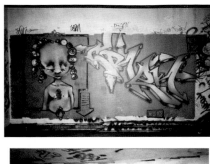
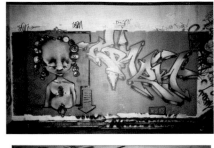

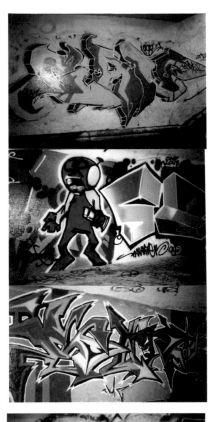
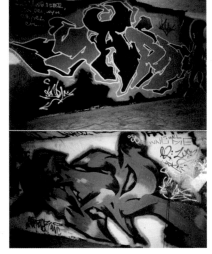
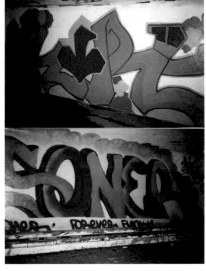
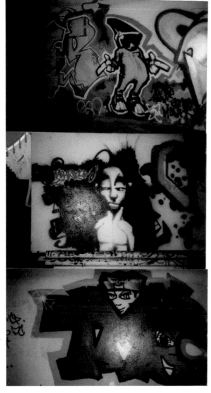

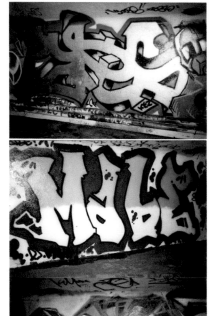
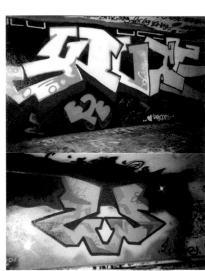

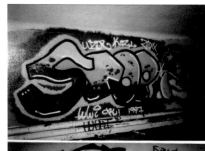
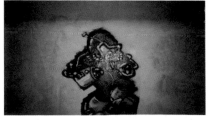

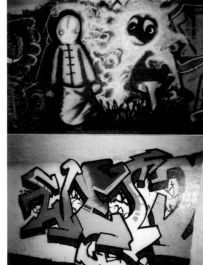
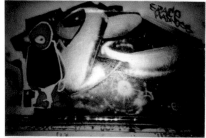

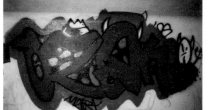

some of Jöi's old pictures
from the tunnel walls

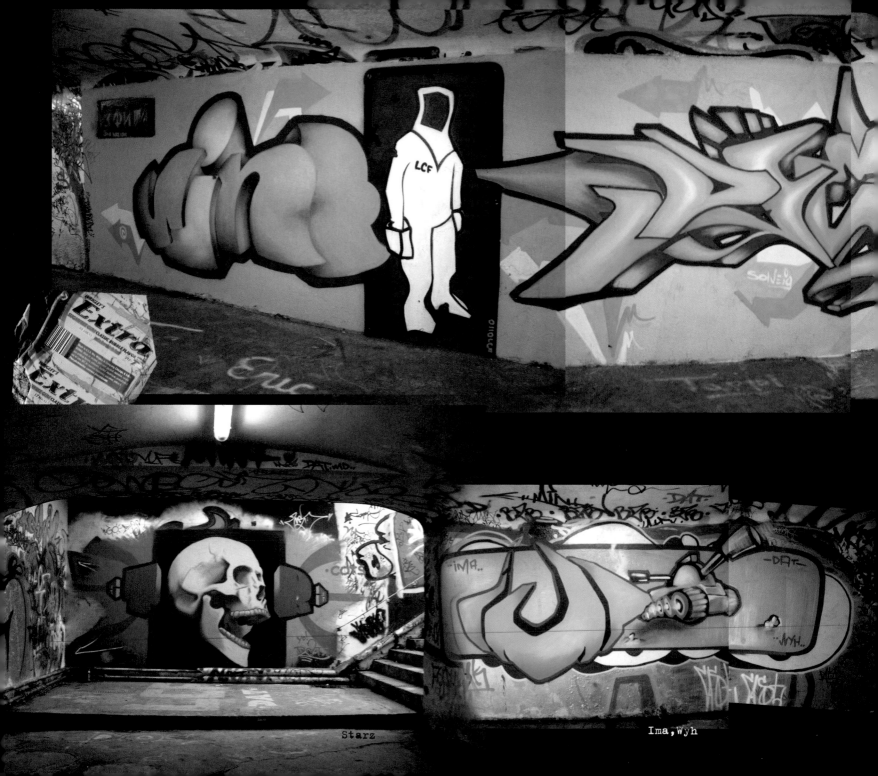

Starz

Ima,Wyh

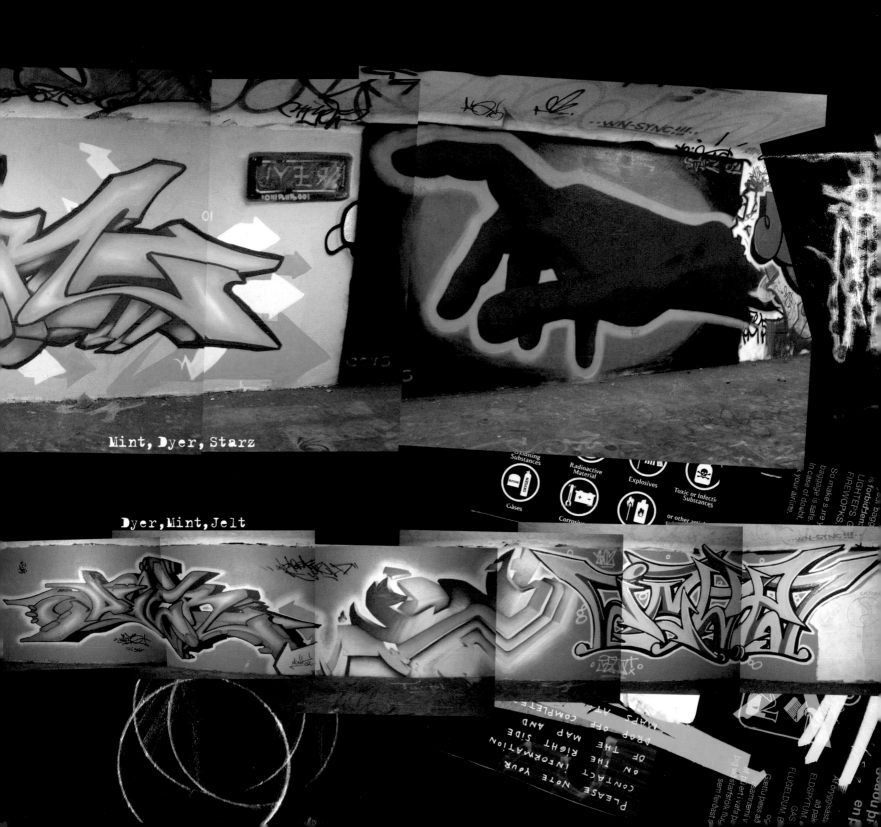

Mint, Dyer, Starz

Dyer, Mint, Jelt

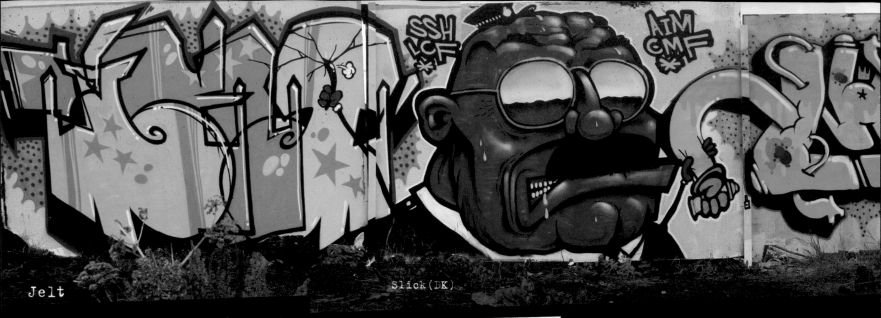

Jelt

Slick(DK)

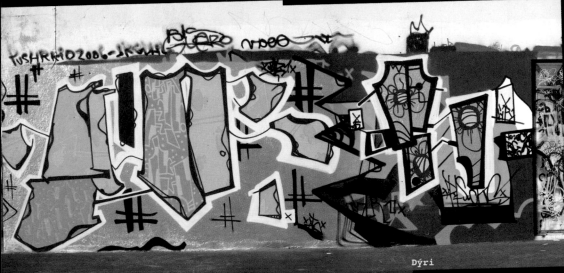

Dýri

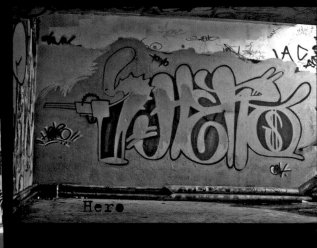

Hero

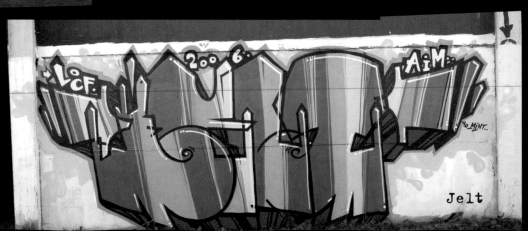

Jelt

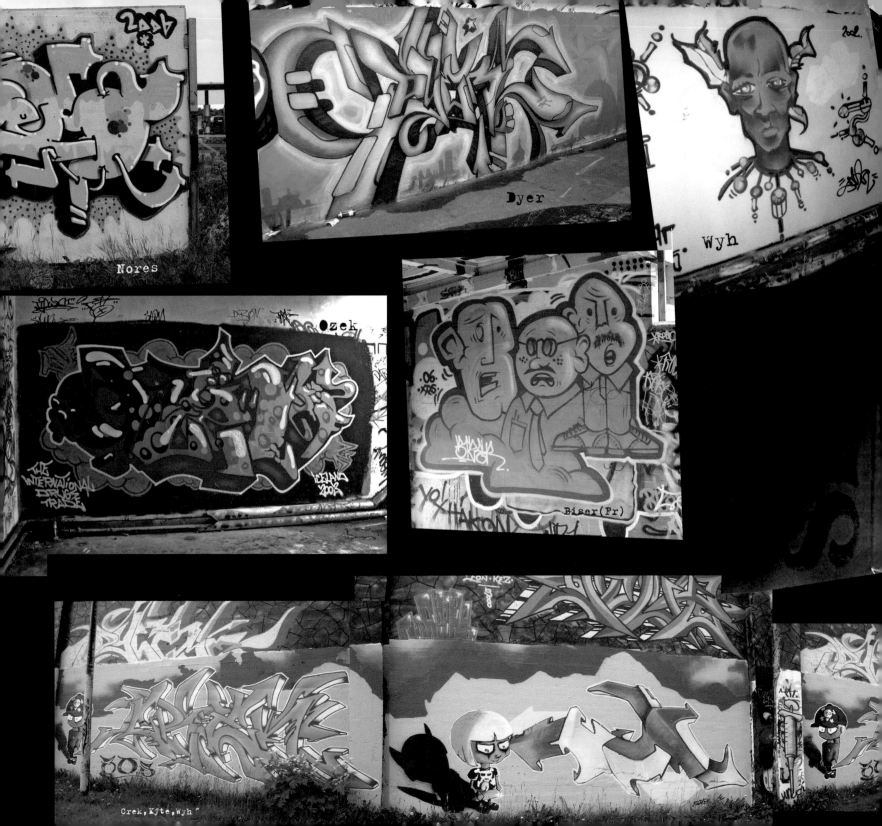

Nores

Dyer

Wyh

Ozek

Biser(Fr)

Crek, Kyte, Wyh

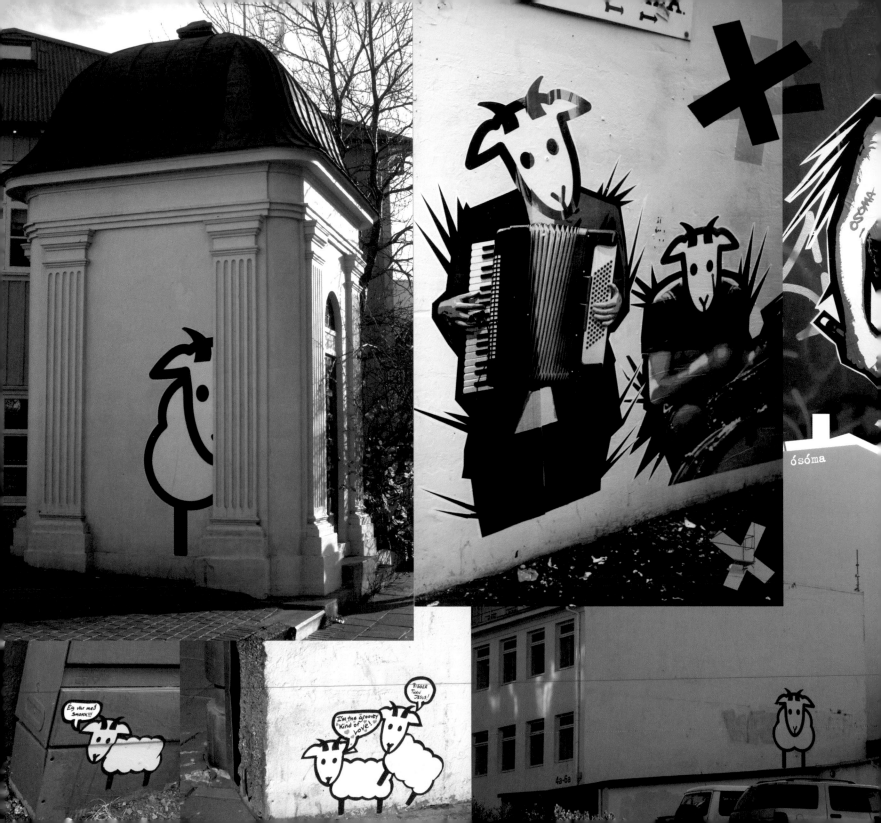

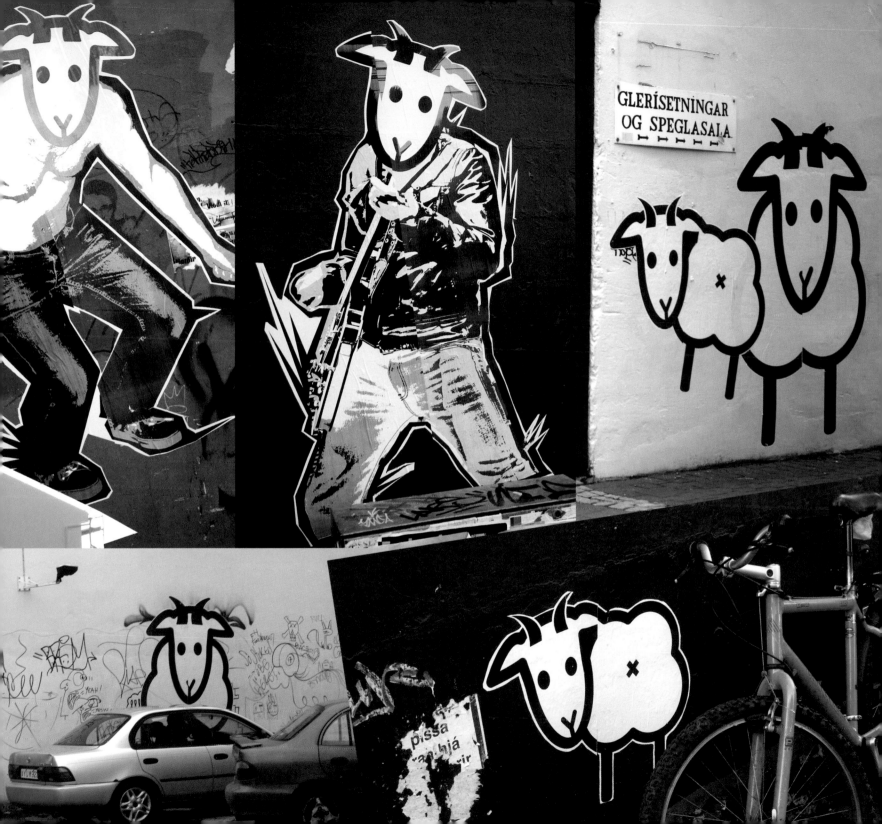

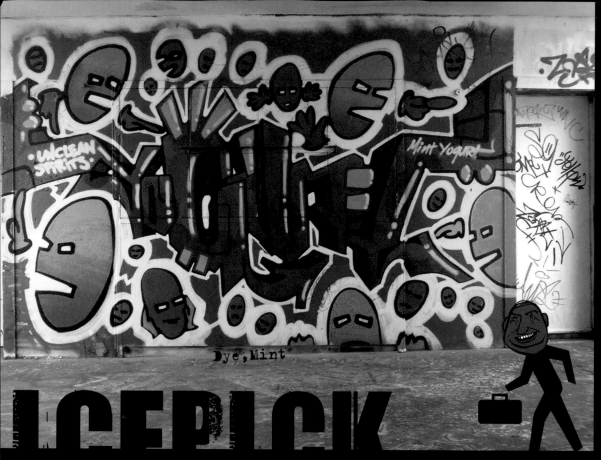

UNCLEAN SPIRITS

Mint Yogurt

Dye, Mint

ICEPICK

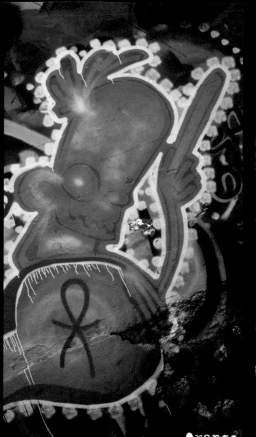

Orange

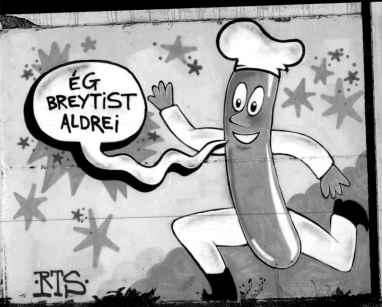

ÉG BREYTIST ALDREI

RTS

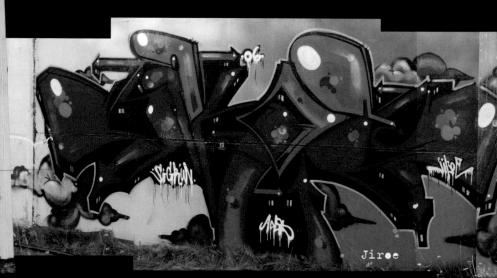

Jiroe

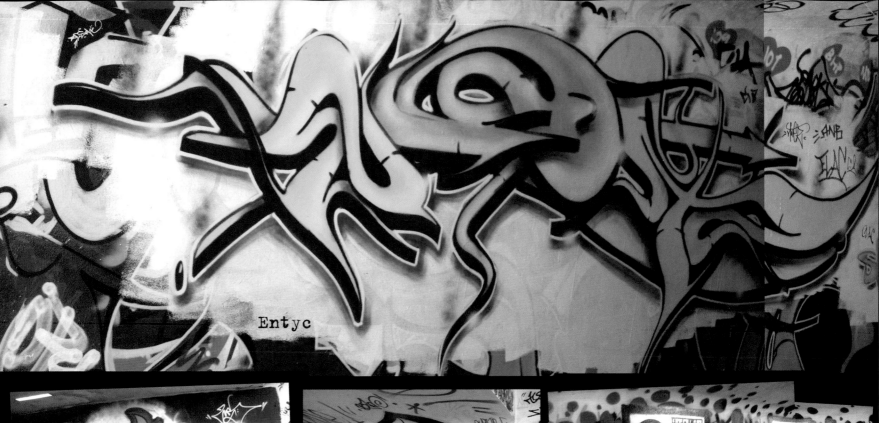

Entyc

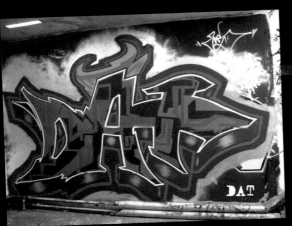

DAT

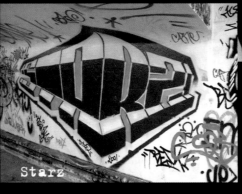

Starz

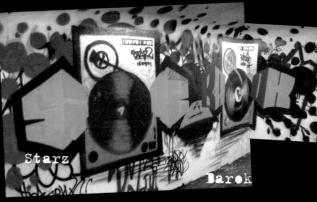

Starz

Barok

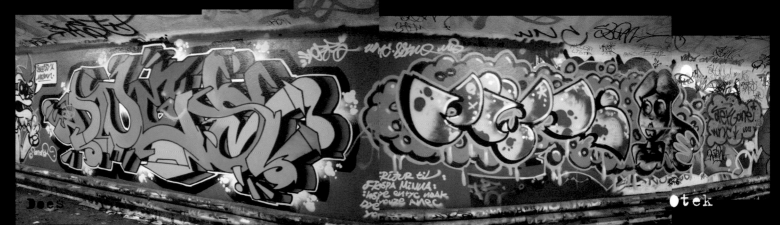

DooS

Otek

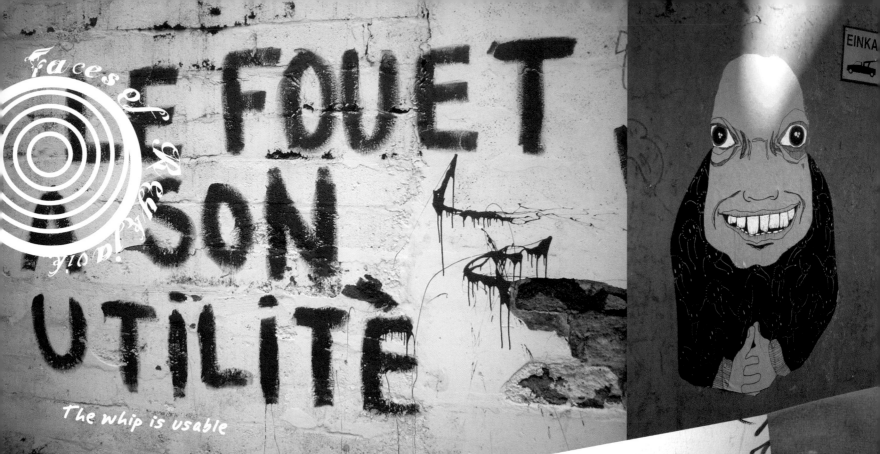

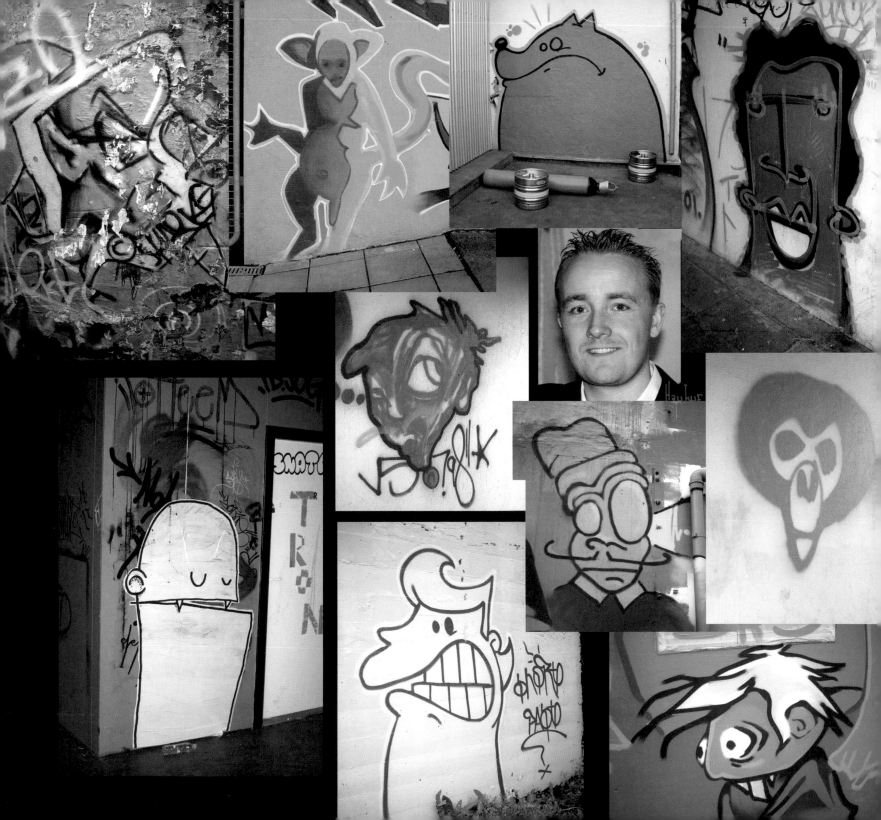

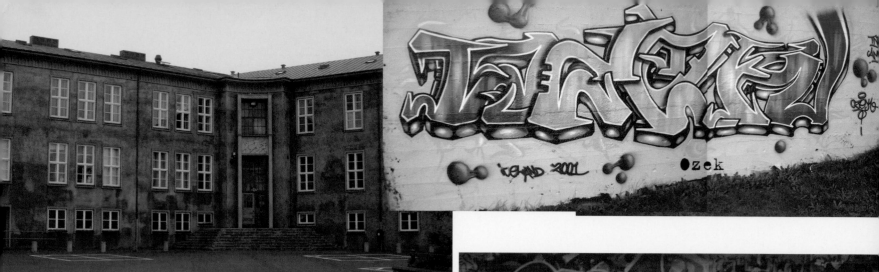

Ozek

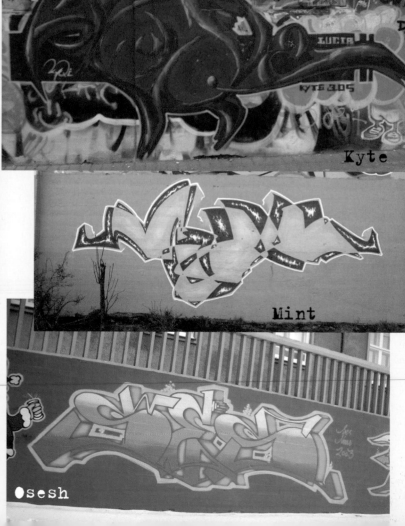

Kyte

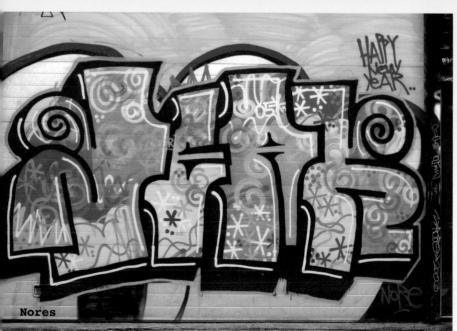

Nores

Mint

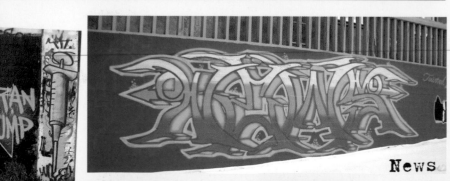

News

Osesh

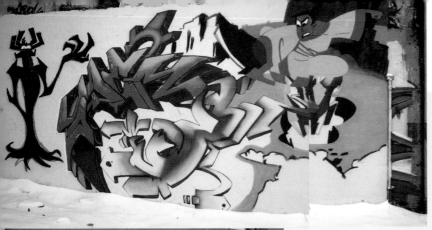

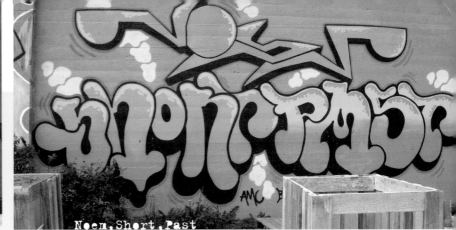

AMC

Noen.Short.Past

Noem

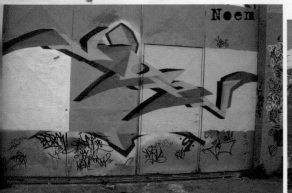

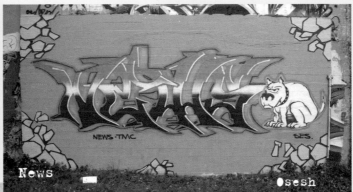

NEWS·TMC

News

Osesh

SES.

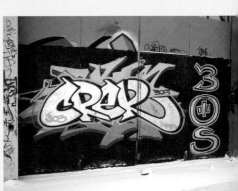

3
S

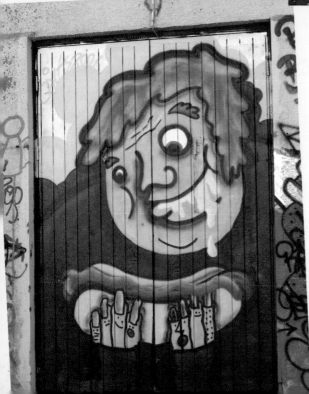

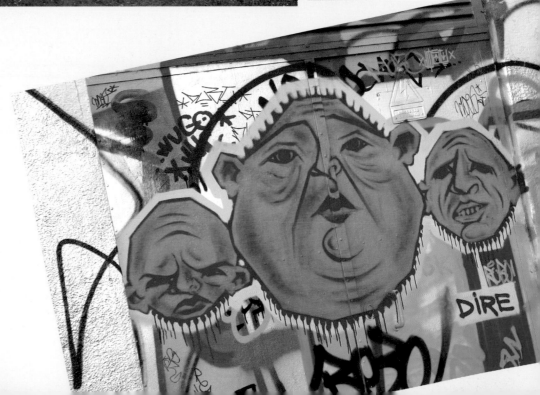

DIRE

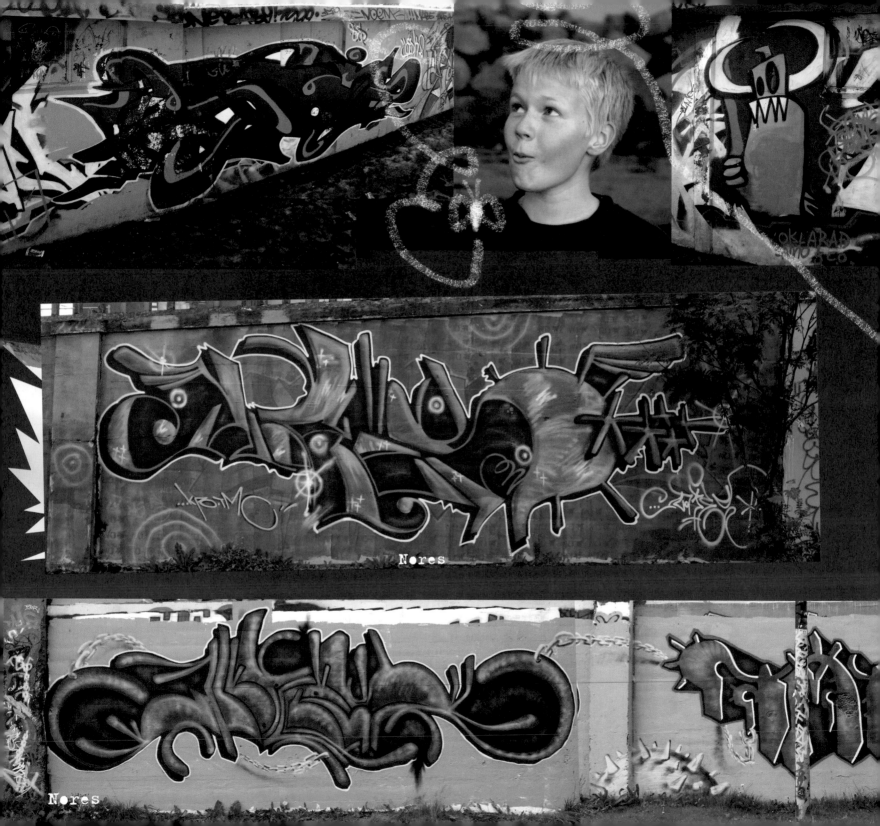

Nores

Nores

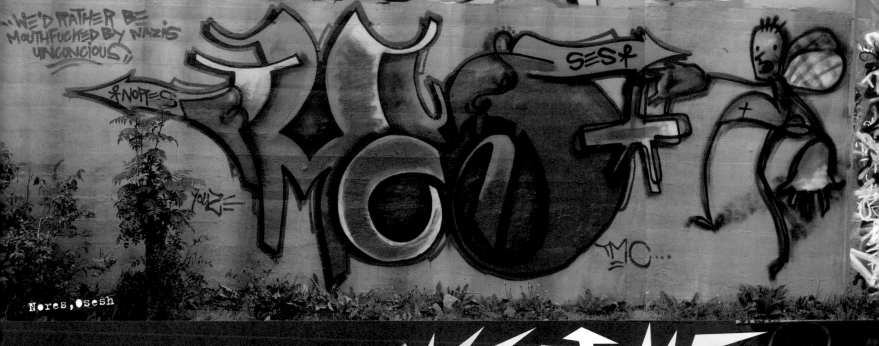

"WE'D RATHER BE
MOUTHFUCKED BY NAZIS
UNCONCIOUS"

SES

Nores,Osesh

ELEMENTARY school

Austur
bæjar
skóli

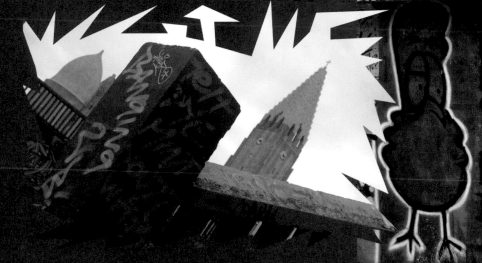

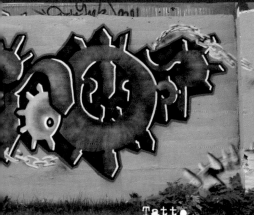

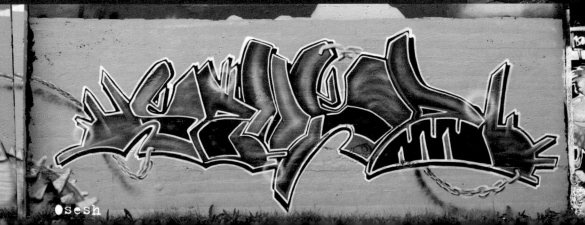

Tatt

Osesh

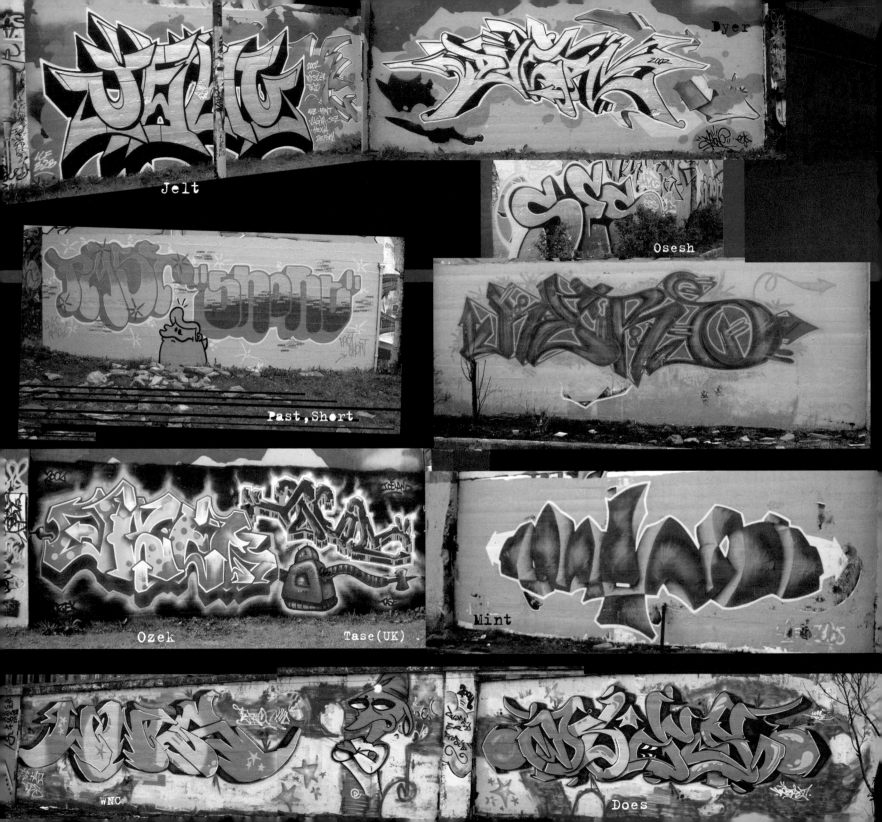

Dyer

Jelt

Osesh

Past, Short

Ozek Tase(UK)

Mint

WNC Does

WRITING WITH OUT A REASON

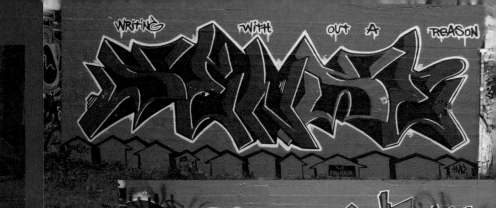

Sense

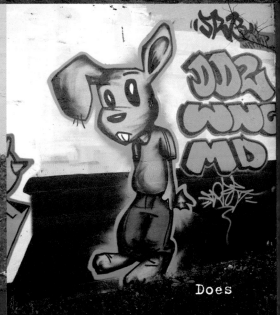

Becks

Does

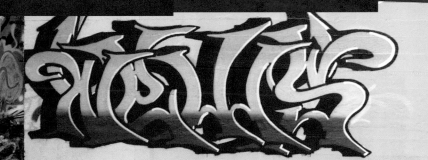

News

Trek

THE REGULA

TREK

TREK THIS

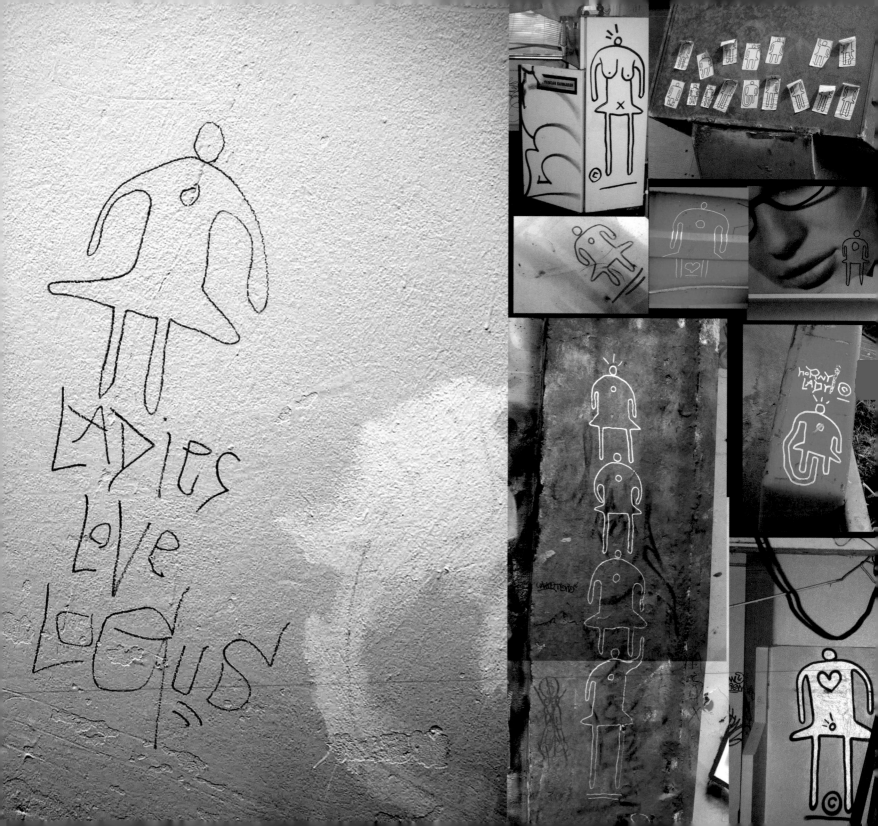

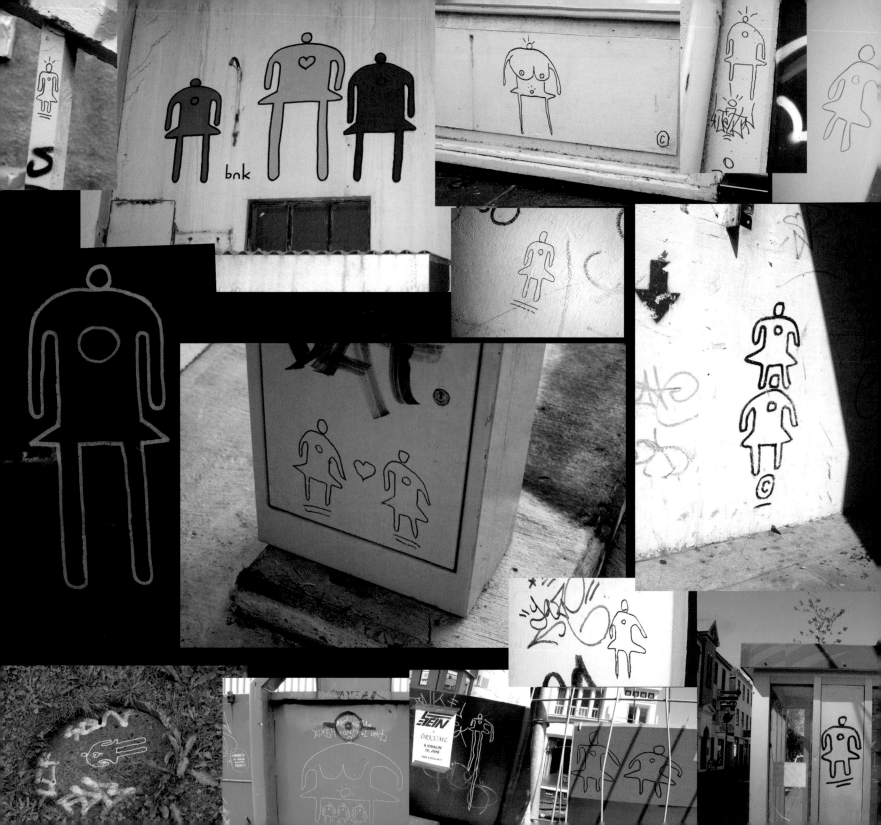

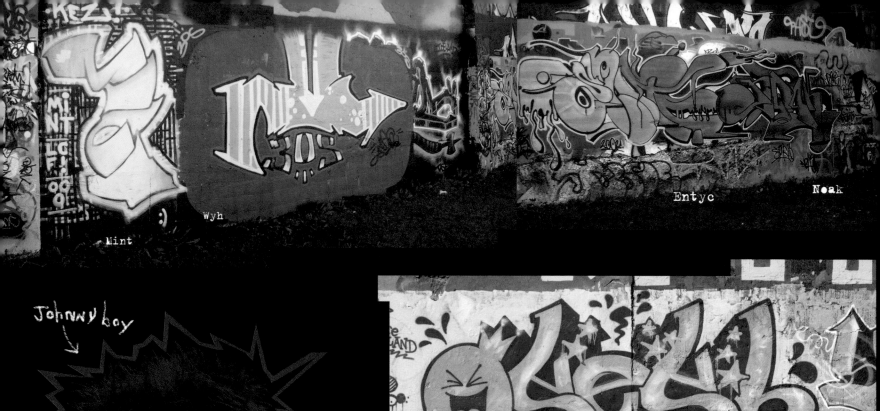

Mint

Wyh

Entyc

Noak

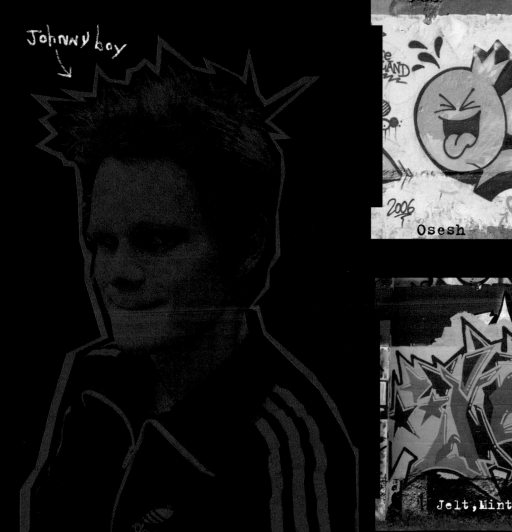

Johnny boy

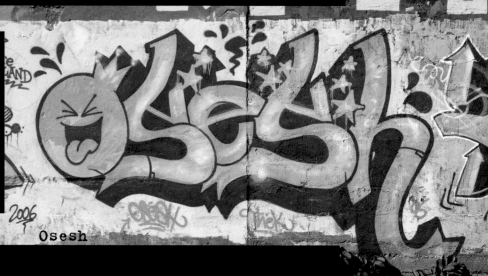

2006

Osesh

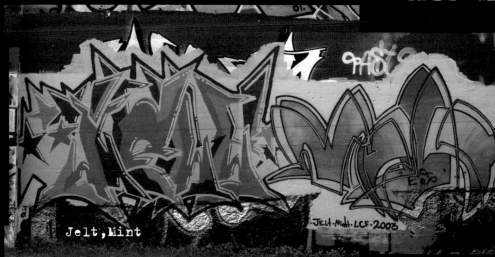

Jelt,Mint

Jelt·Mint·LCF·2003

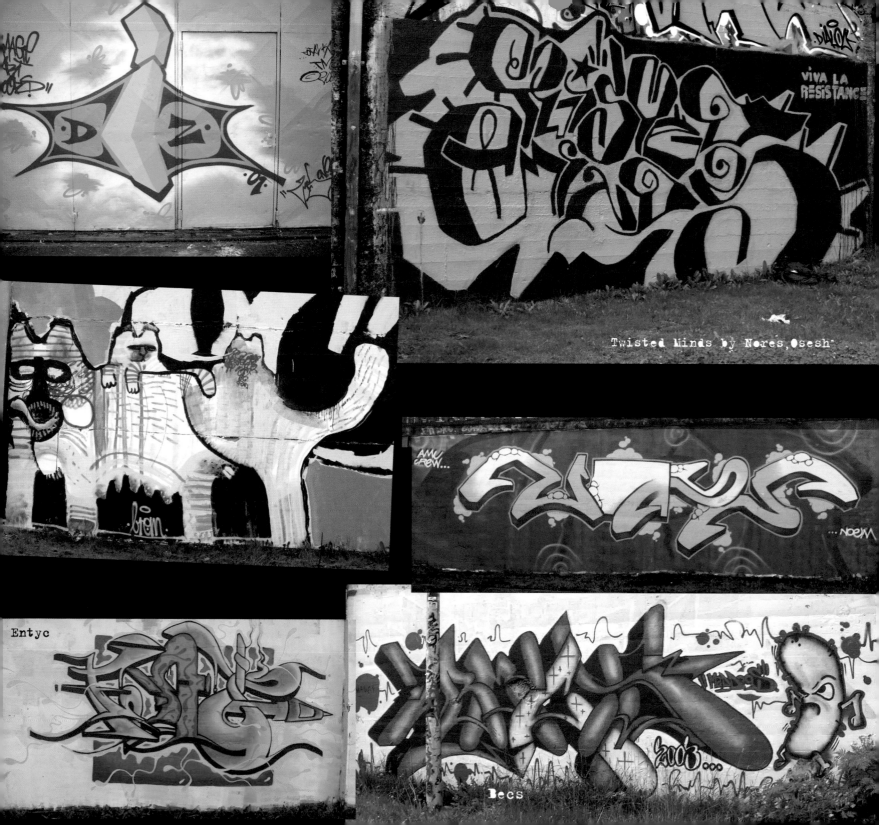

VIVA LA RESISTANCE!

Twisted Minds by Nores, Osesh

Entyc

Becs

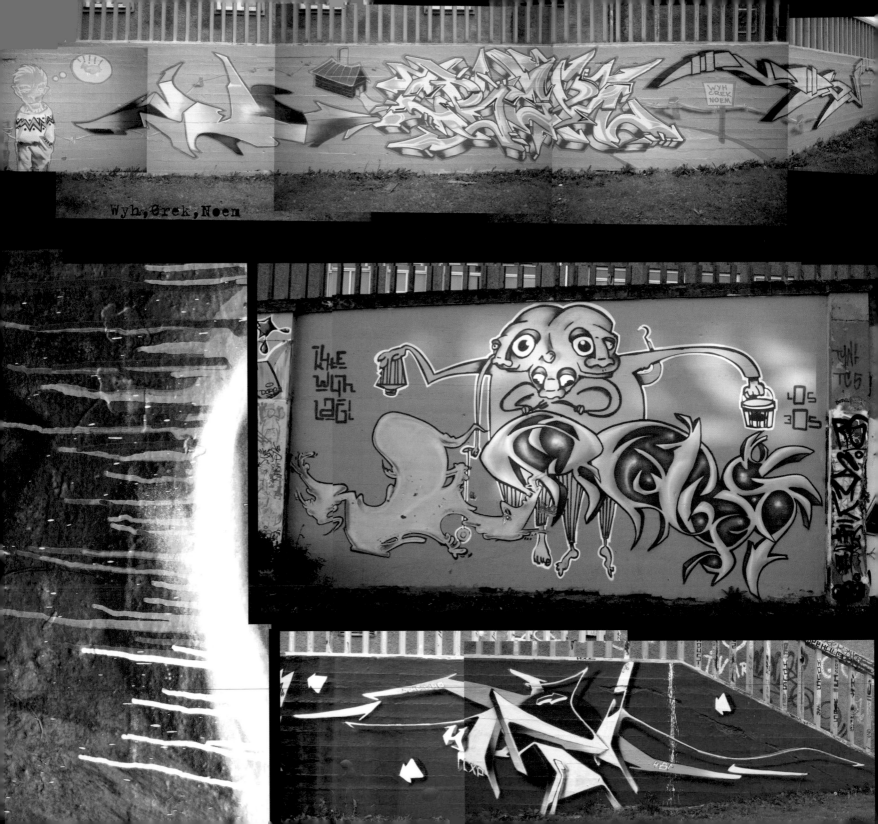

Wyh, Crek, Noen

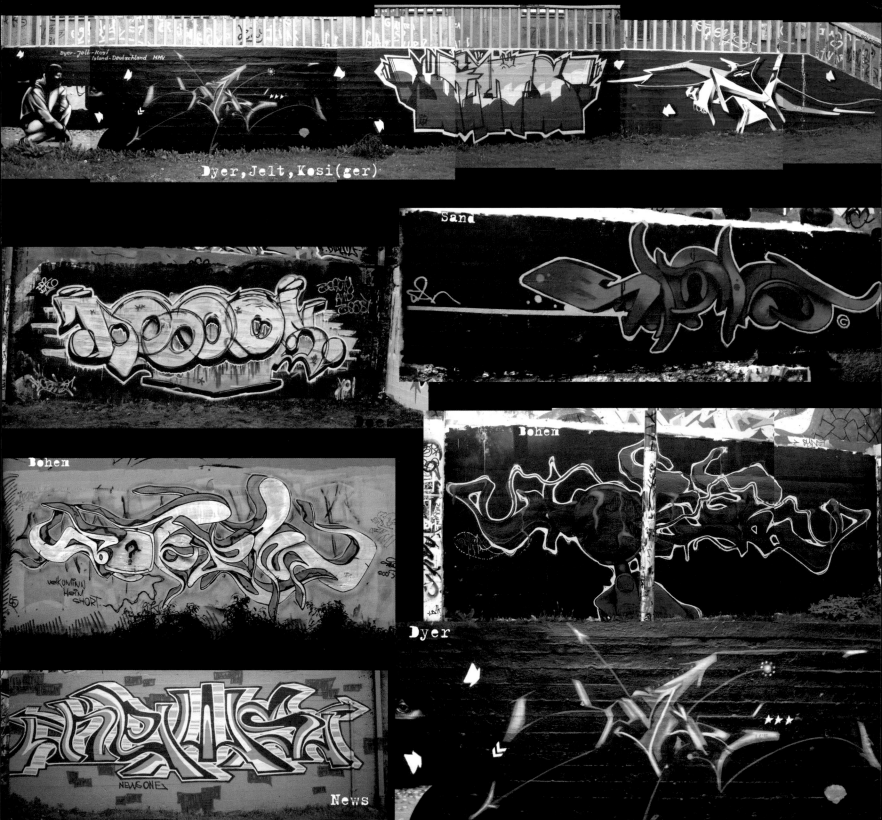

Dyer,Jelt,Kosi(ger)

Bohen

News

Sand

Bohen

Dyer

HALLÓ
Nafn mitt er

KEZ

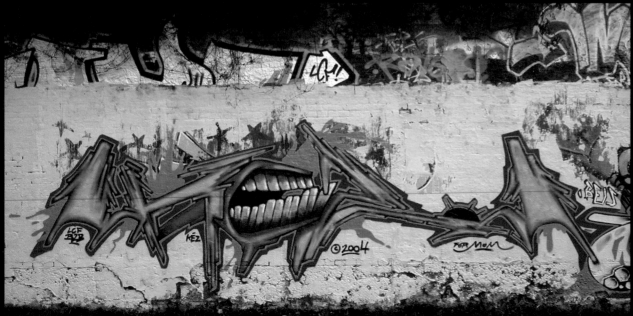

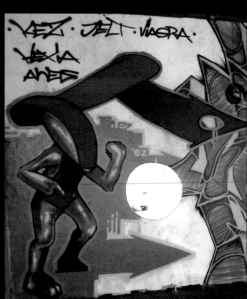

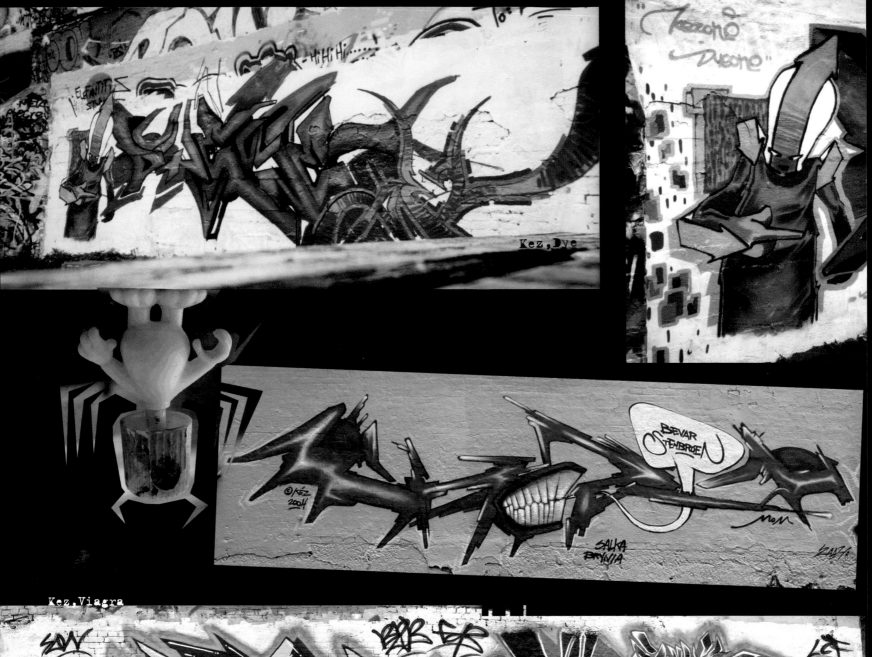

Kez,Dve

Kez,Viagra

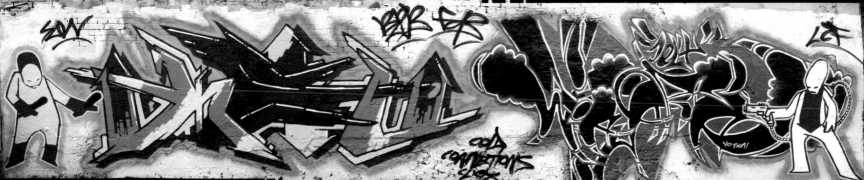

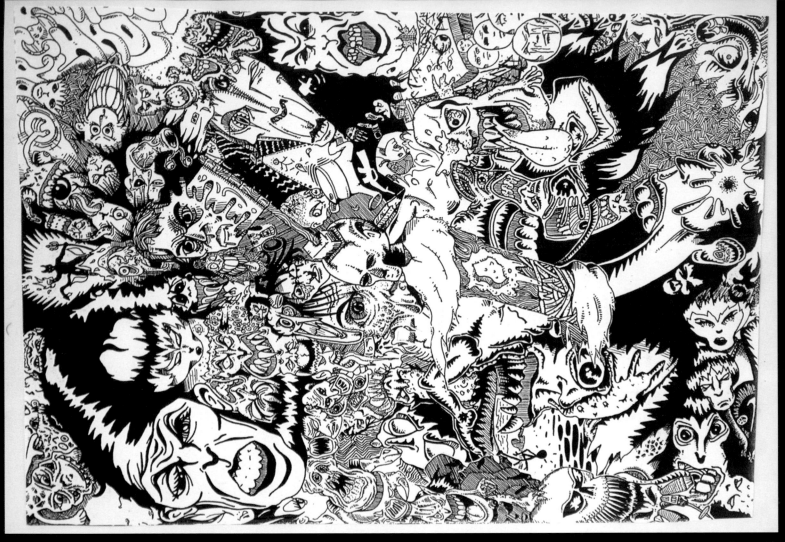

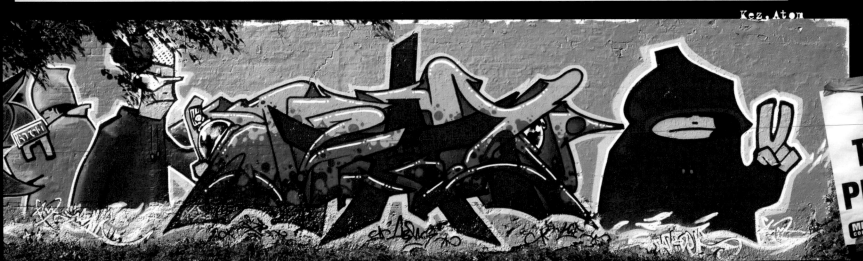

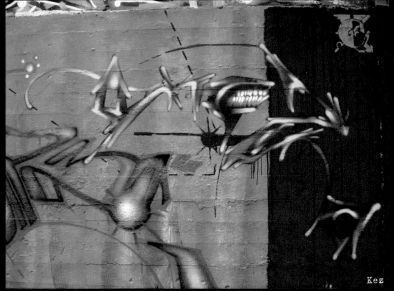

Kez

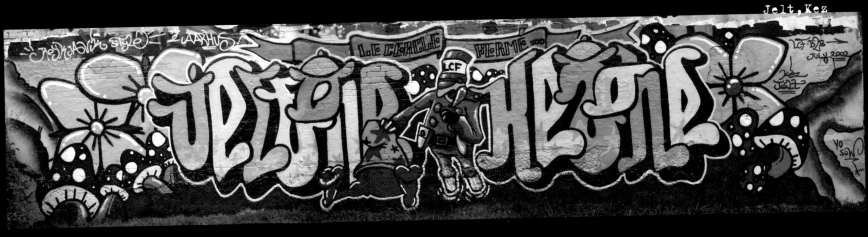

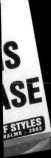

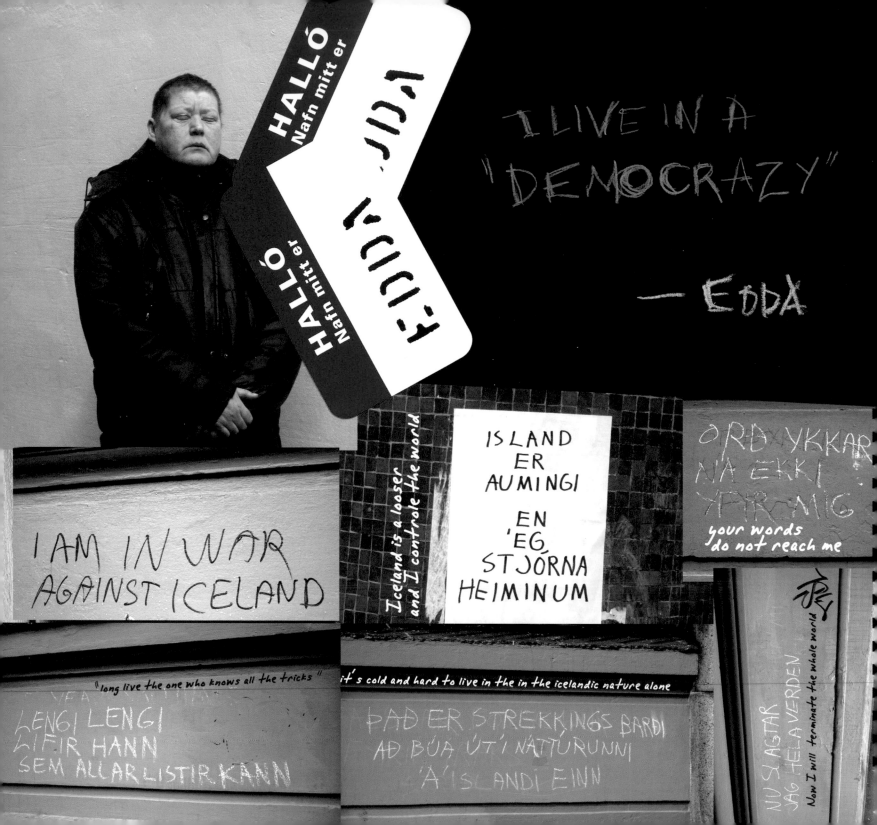

HALLÓ
Nafn mitt er

HALLÓ
Nafn mitt er

EDDA

I LIVE IN A
"DEMOCRAZY"

— EDDA

ISLAND
ER
AUMINGI

EN
ÉG
STJÓRNA
HEIMINUM

Iceland is a looser and I controle the world

ORÐ YKKAR
NÁ EKKI
YFIR MIG

your words
do not reach me

I AM IN WAR
AGAINST ICELAND

"long live the one who knows all the tricks"

it's cold and hard to live in the in the icelandic nature alone

LENGI LENGI
LIFIR HANN
SEM ALLAR LISTIR KANN

ÞAÐ ER STREKKINGS BARÐI
AÐ BÚA ÚT Í NÁTTÚRUNNI
Á ÍSLANDI EINN

NÚ SLAGTAR
JAG HELA VERDEN

Now I will terminate the whole world

DEMOCRACY BJROCRAZYORD YKKAR
HEAVEN KNOWS, DUST
MARTIN BORM HOW IT FEELS

TAKIÐ ÞIÐ
NÚ AFLEIÐINGUM
GERÐA YKKAR

WORM

take the consequences
of your own actions

FALSKAR FORSENDUR
FYRIR ÍRAKS
STRÍÐI ORÐRÓMUR

False reasons for the war on Iraq

ÖLL STRÍÐIN
ERU ÚTRYMT
MANNKYN

LÁTIÐ
MAYA
YKKUR

Don't let them
control you

All wars = lost lives forever

No man has any rights
while I don't have mine

Mistreating people -
caused by their origin is wrong

FRISTADEN ISLAND
BANNAÐ AÐ MISMUNA FÓLKI
EFTIR UPPRUNA LUFSUR

ÞAÐ HEFUR EKKI
NOKKUR MAÐUR
RÉTTINDI Á MEÐAN

ÉG HEF EKKI NOKKUR
RÉTTINDI

NO CLEAR
DORDEN

Nuclear on the
whole planet

53 YEARS YOU HAVE
TORTURED ME
NOW YOU GET IT ALL BACK

Irish artists don't pay taxes

IRSKIR LISTAMENN BORGA ENGAN SKATT

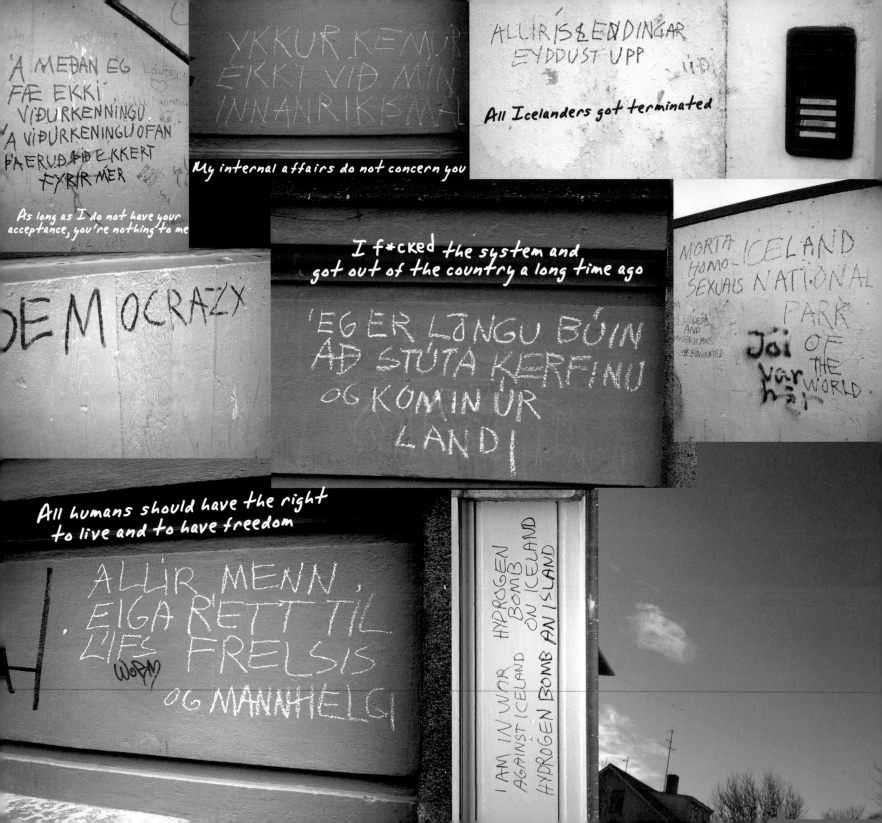

'Á MEÐAN EG FÆ EKKI VIÐURKENNINGU Á VIÐURKENINGU OFAN ÞÁ ERUÐ ÞIÐ EKKERT FYRIR MÉR

As long as I do not have your acceptance, you're nothing to me

YKKUR KEMUR EKKI VIÐ MÍN INNANRÍKISMÁL

My internal affairs do not concern you

ALLIR ÍS&ENDINGAR EYDDUST UPP

All Icelanders got terminated

DEMOCRAZY

I f*cked the system and got out of the country a long time ago

'EG ER LÖNGU BÚIN AÐ STÚTA KERFINU OG KOMIN ÚR LANDI

MORTA HOMO-ICELAND SEXUALS NATIONAL PARK OF THE WORLD

ISLANDERS AND AMERICANS TERMINATED

Jói var hér

All humans should have the right to live and to have freedom

ALLIR MENN EIGA RÉTT TIL LÍFS FRELSIS WORM OG MANNHELGI

I AM IN WAR AGAINST ICELAND HYDROGEN BOMB AN ISLAND HYDROGEN BOMB ON ICELAND

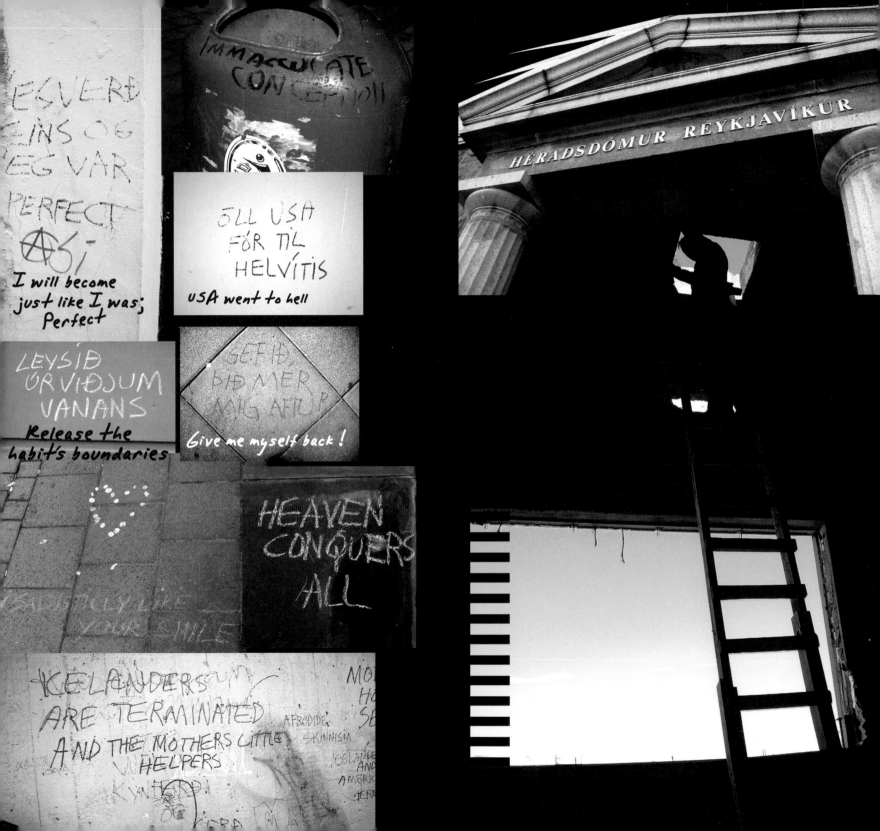

ÉGVERÐ EINS OG ÉG VAR PERFECT

I will become just like I was; Perfect

IMMACULATE CONCEPTION

ÖLL USA FÓR TIL HELVÍTIS

USA went to hell

HÉRADSDÓMUR REYKJAVÍKUR

LEYSIÐ ÚRVIÐJUM VANANS

Release the habit's boundaries

GEFIÐ, ÞIÐ MÉR MIG AFTUR

Give me myself back!

HEAVEN CONQUERS ALL

SADISTICLY LIKE YOUR SMILE

ICELANDERS ARE TERMINATED AND THE MOTHERS LITTLE HELPERS

AFRODIDE SKINNISM MO HO SE ICELANDER AND AMERIC

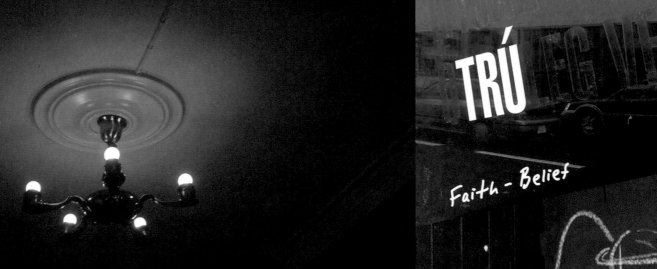

TRÚ

Faith - Belief

FLAPPING YOUR ARMS
CAN BE FLYING

AFRAID
OR
NOT ?

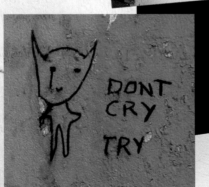
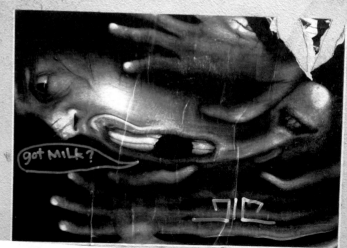

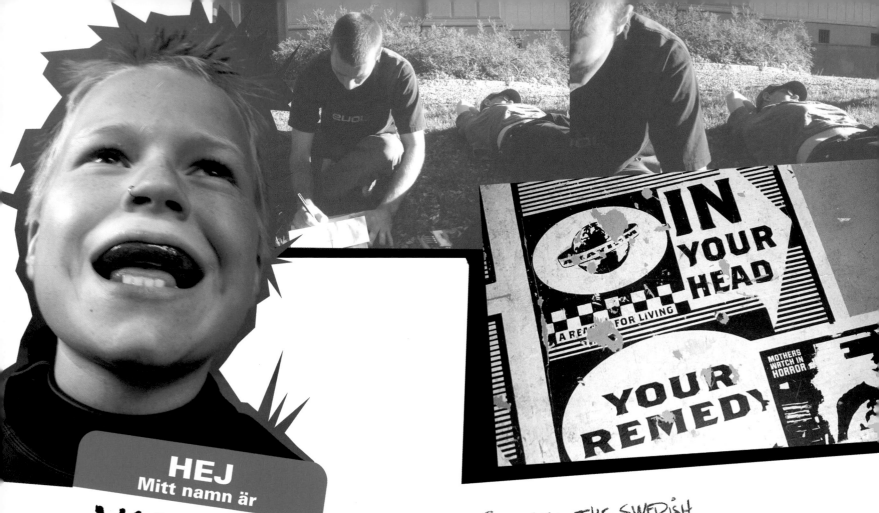

HEJ
Mitt namn är

AKAYISM
AND **ADAMS**

SOME TIME AGO, THE SWEDISH ARTISTS "AKAYISM, ADAMS & HOTEL" CAME TO ICELAND. THEY PUT UP AN EXHIBITION AT THE REYKJAVIK LIVING ART MUSEUM. THEIR WORK FILLED THE SPACE WITH CREATIVE POWER, AS WELL AS THE STREETS OF REYKJAVIK..

Denna
aksvara kan
din hälsa och
roendeframm-
allande
0 2005
5 542

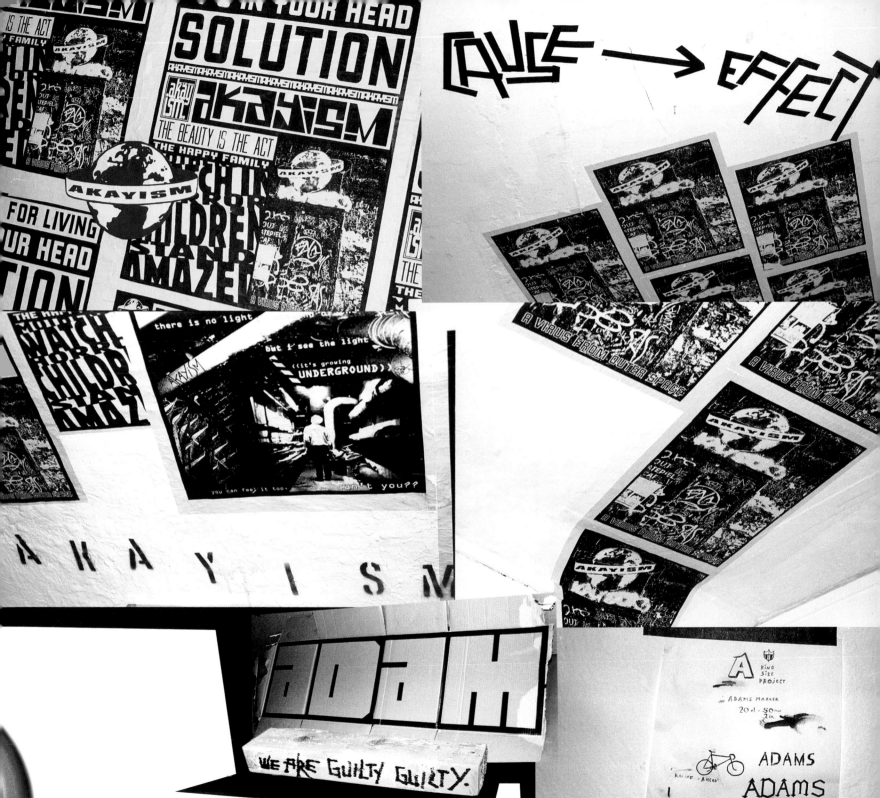

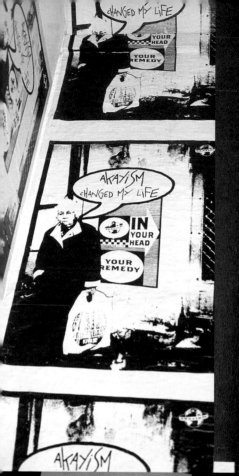

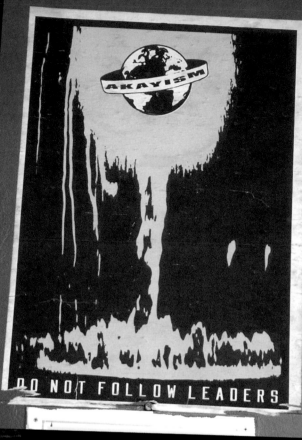

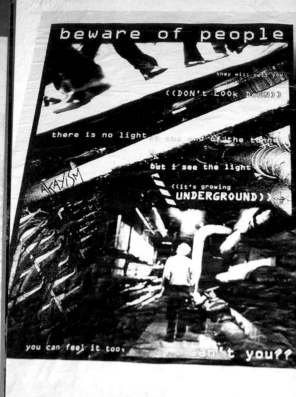

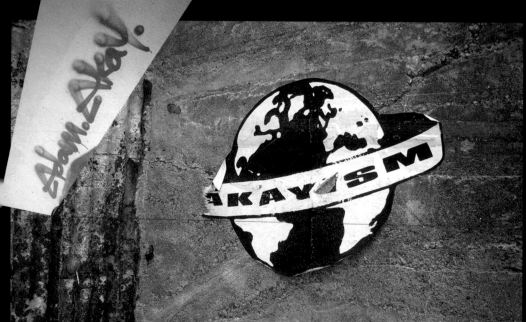

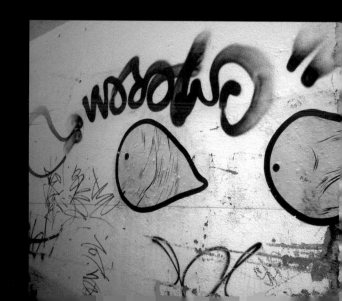

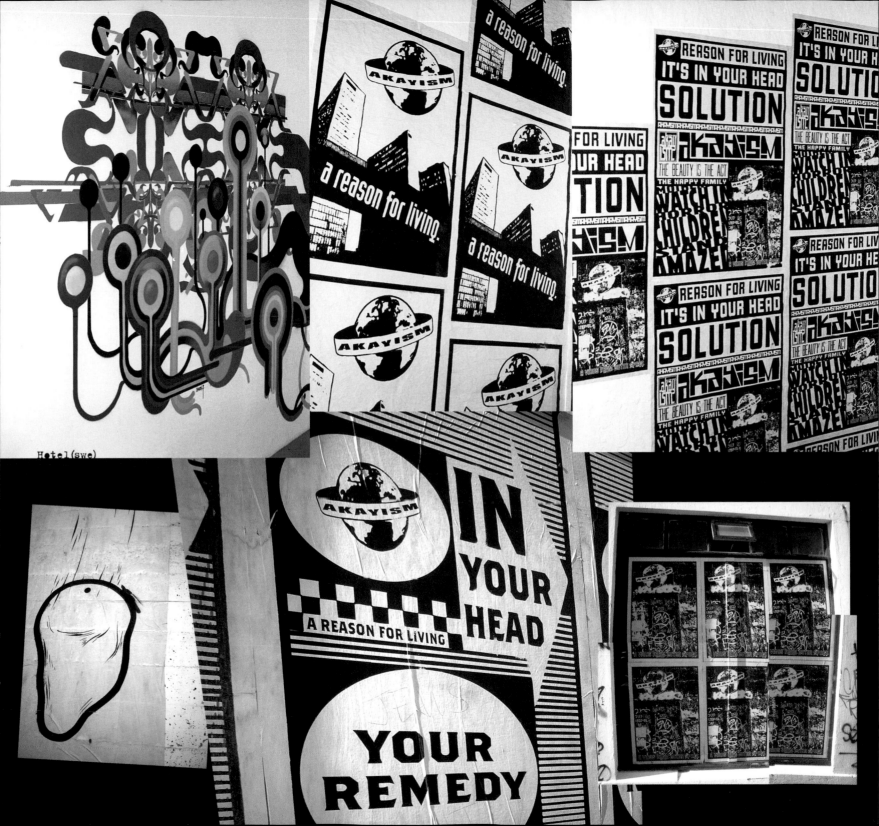

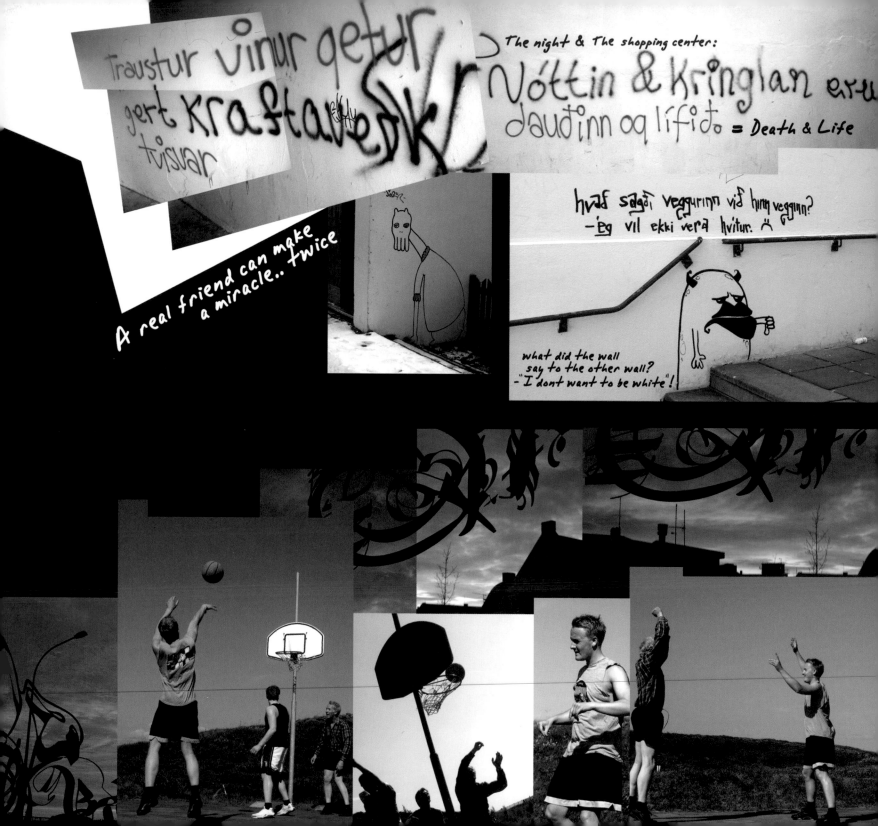

Traustur vinur getur gert kraftaverk tvisvar

A real friend can make a miracle.. twice

The night & The shopping center:
Nóttin & Kringlan eru dauðinn og lífið. = Death & Life

hvað sagði veggurinn við hinn vegginn?
—Ég vil ekki vera hvítur. Ä

what did the wall say to the other wall?
— "I dont want to be white"!

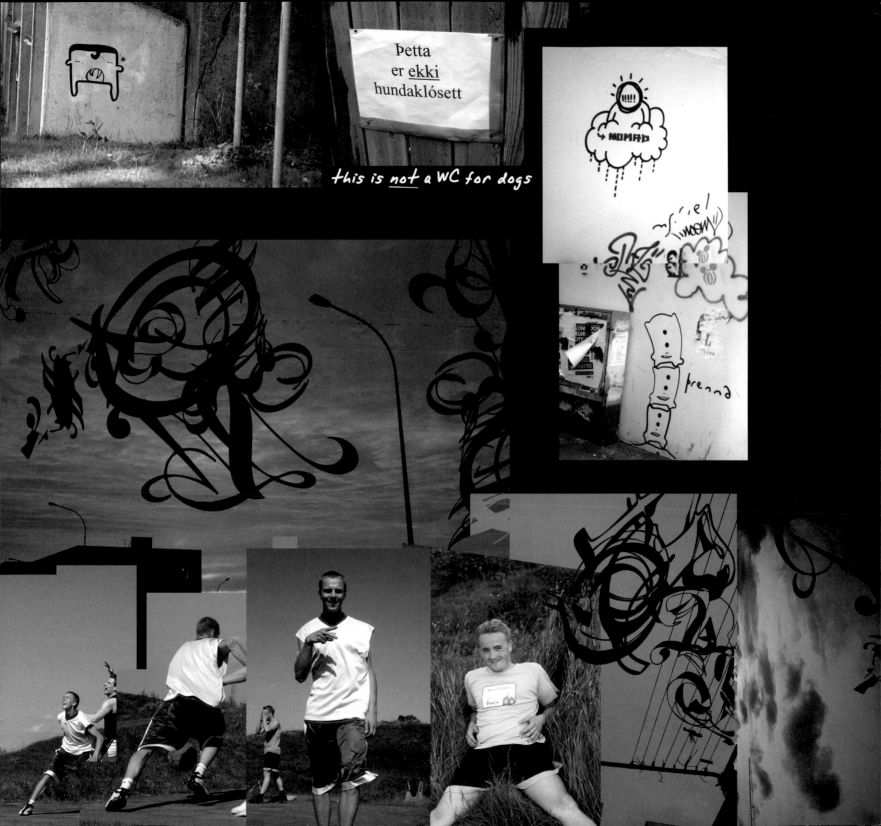

Þetta
er ekki
hundaklósett

this is not a WC for dogs

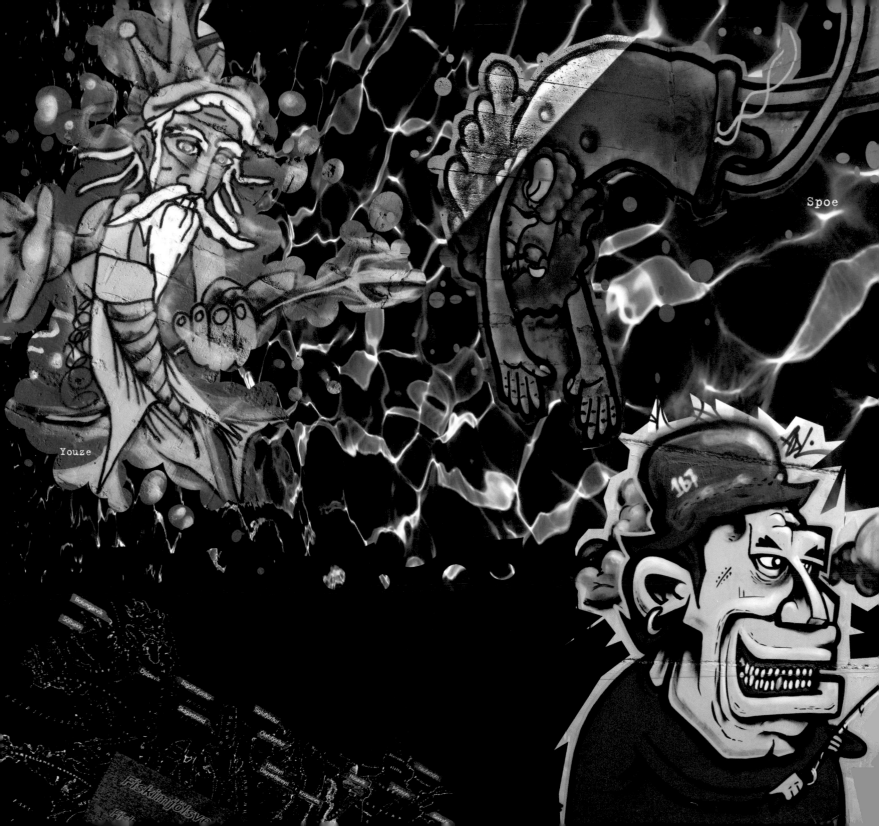

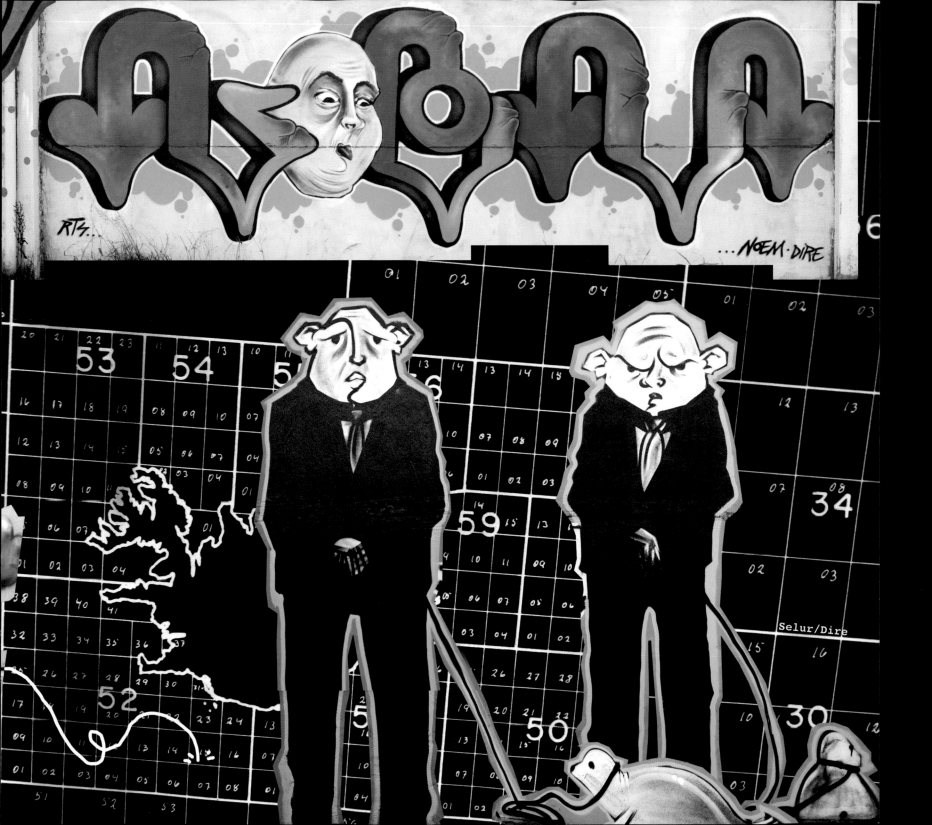

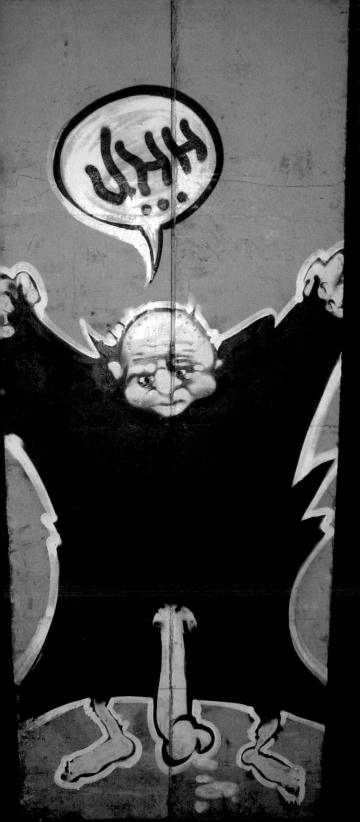
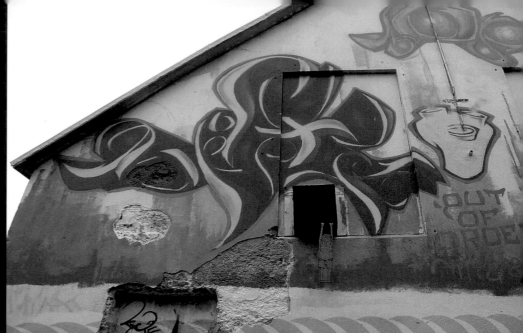
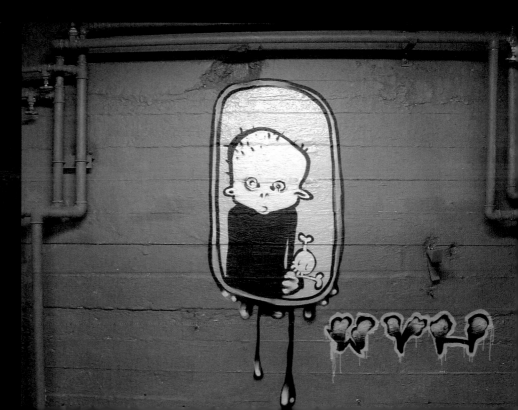

Kyte,Wyh

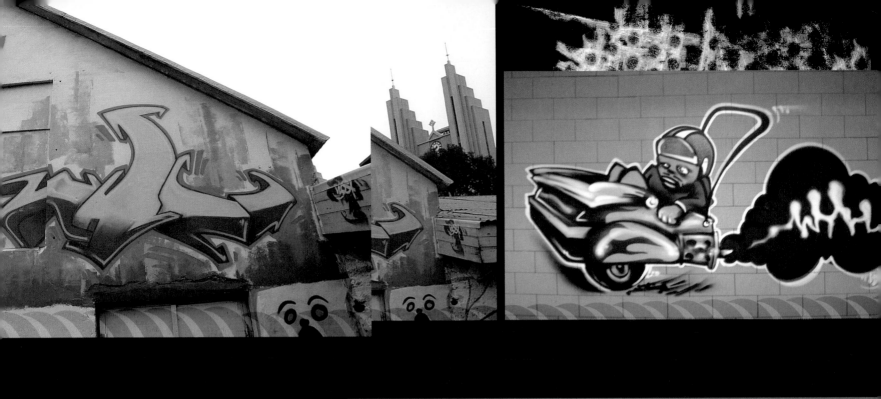
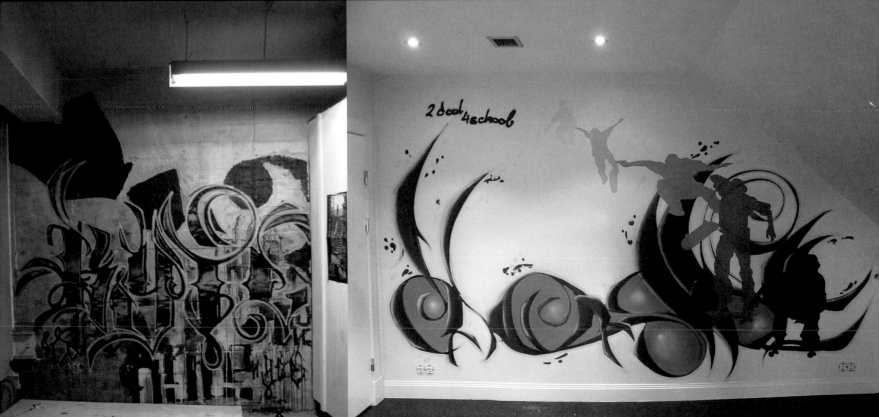

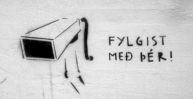

FYLGIST
MEÐ ÞÉR!

You're being watched!

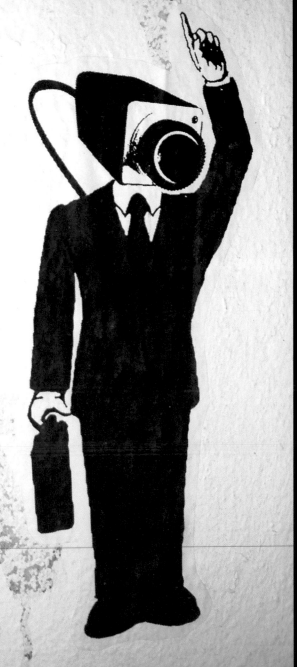

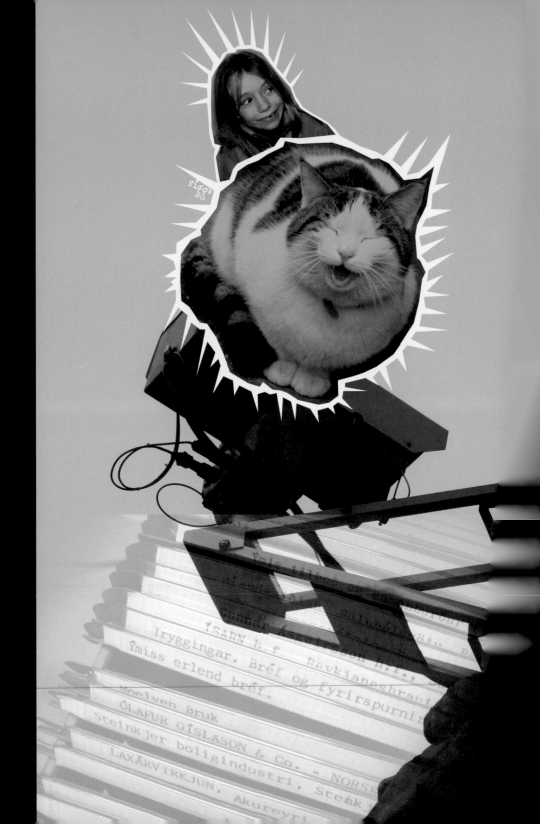

judge people by their looks

DÆMDU FÓLK EFTIR ÚTLITINU

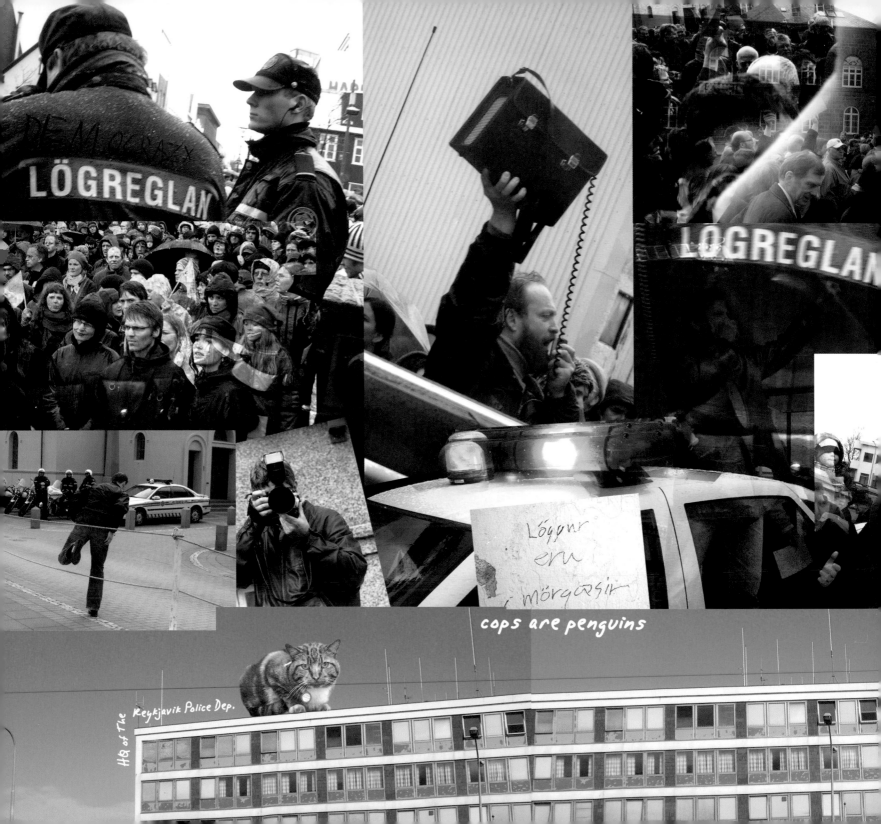

LÖGREGLAN

LÖGREGLAN

Löggur eru á mörgæsir

cops are penguins

HQ of The Reykjavik Police Dep.

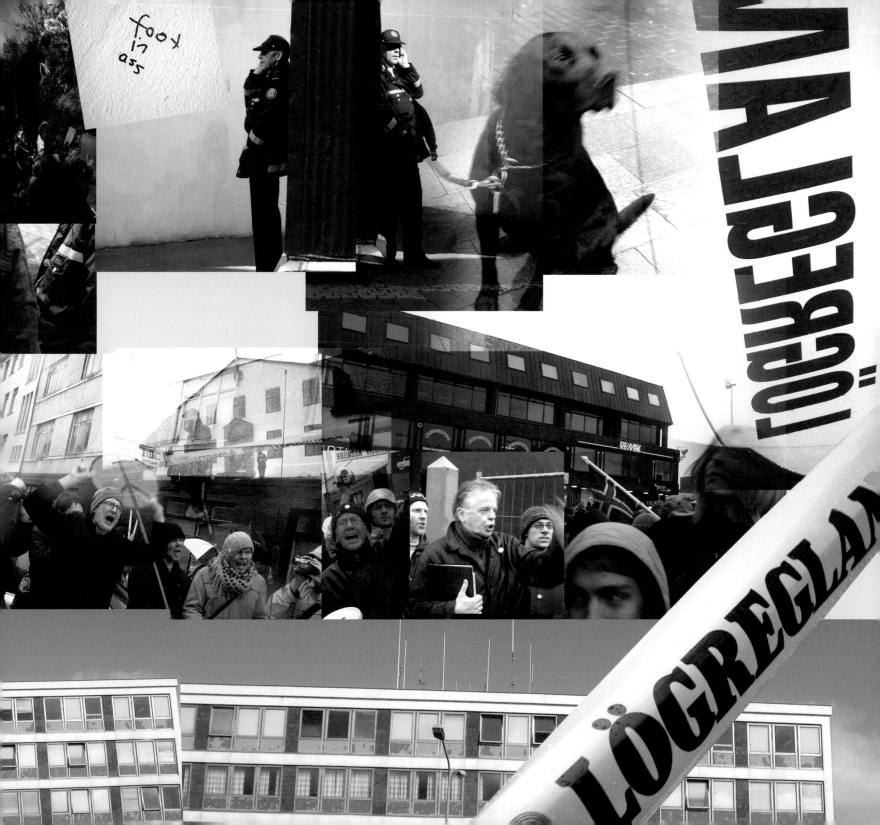

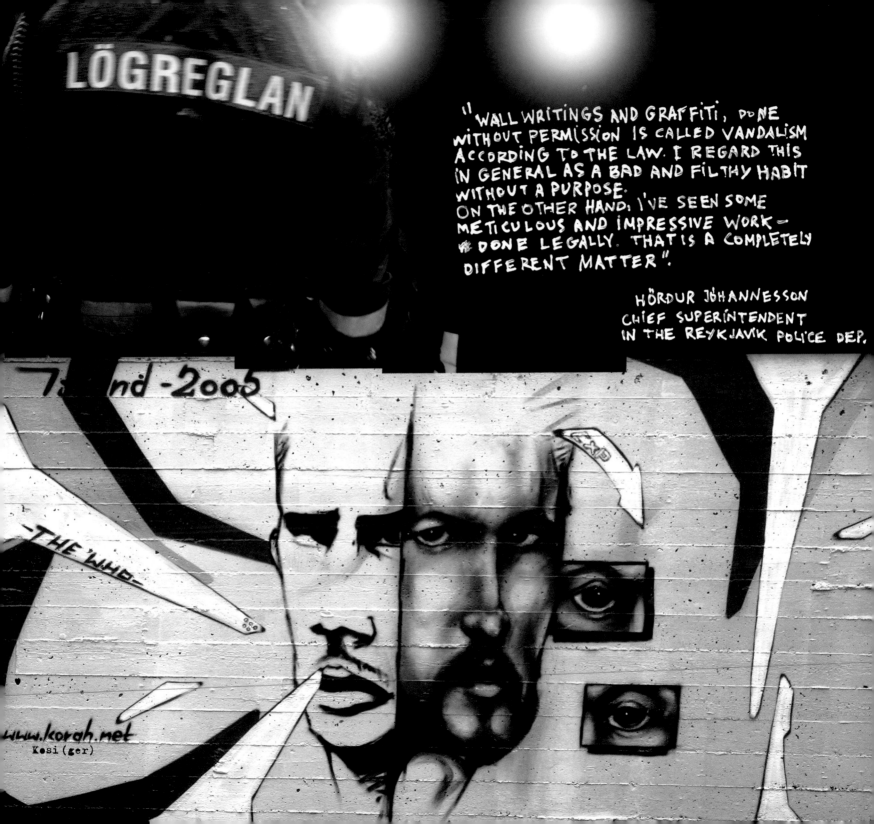

"WALL WRITINGS AND GRAFFITI, DONE WITHOUT PERMISSION IS CALLED VANDALISM ACCORDING TO THE LAW. I REGARD THIS IN GENERAL AS A BAD AND FILTHY HABIT WITHOUT A PURPOSE.
ON THE OTHER HAND, I'VE SEEN SOME METICULOUS AND IMPRESSIVE WORK — DONE LEGALLY. THAT IS A COMPLETELY DIFFERENT MATTER".

HÖRÐUR JÓHANNESSON
CHIEF SUPERINTENDENT
IN THE REYKJAVIK POLICE DEP.

LÖGREGLAN

7 ???nd -2005

-THE WHO-

www.korah.net
Kosi (ger)

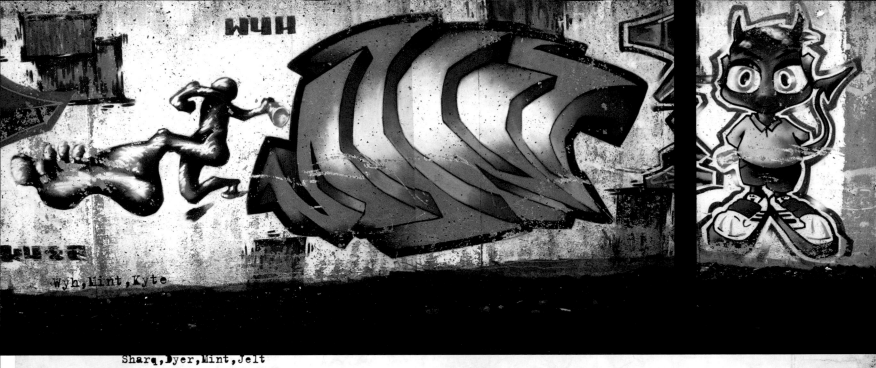
Wyh,Mint,Kyte

Sharq,Dyer,Mint,Jelt
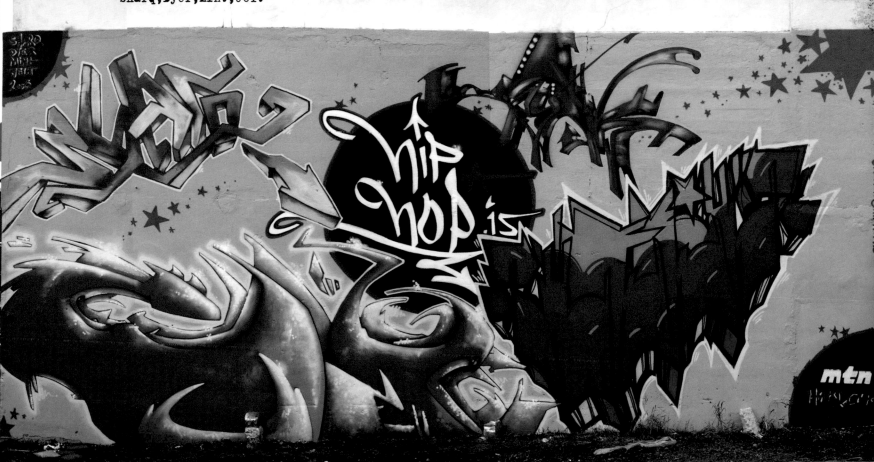

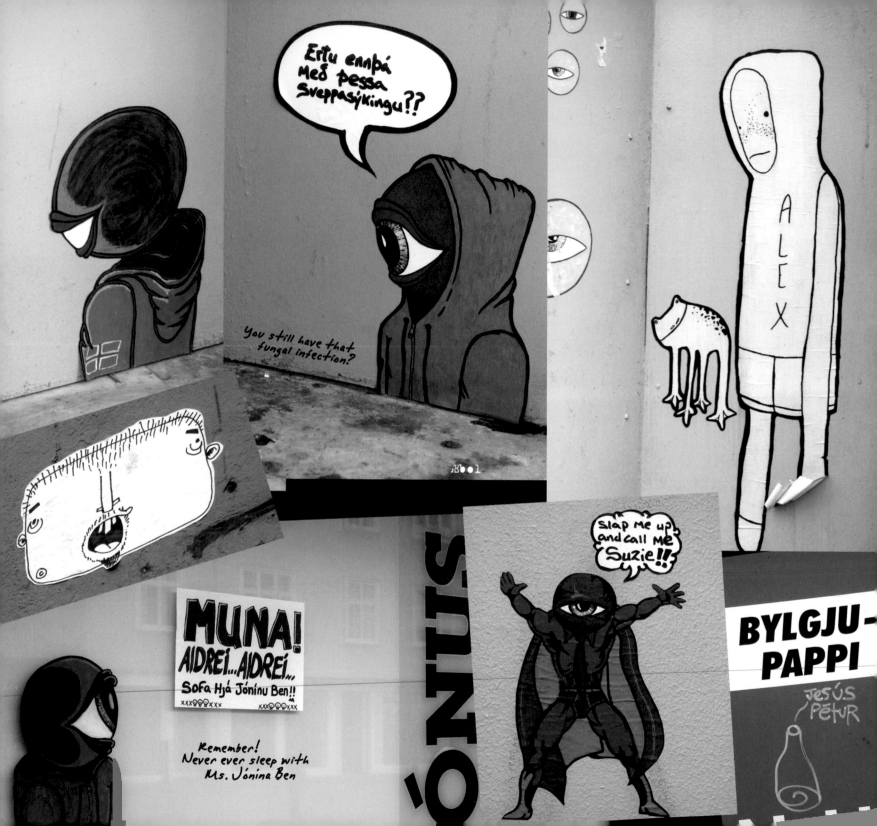

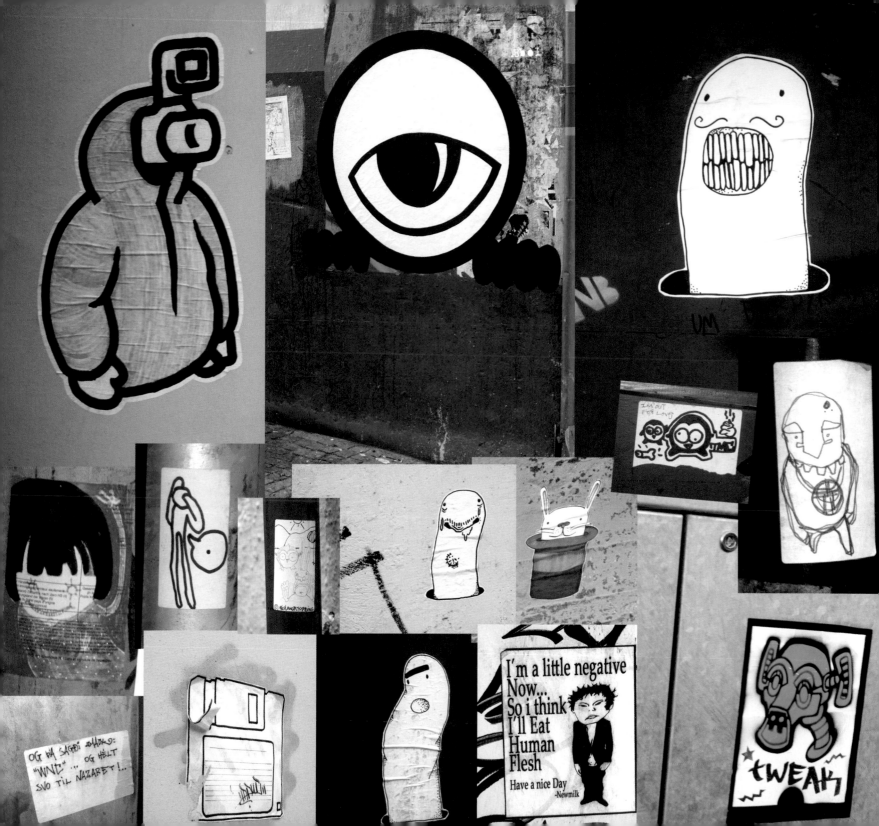

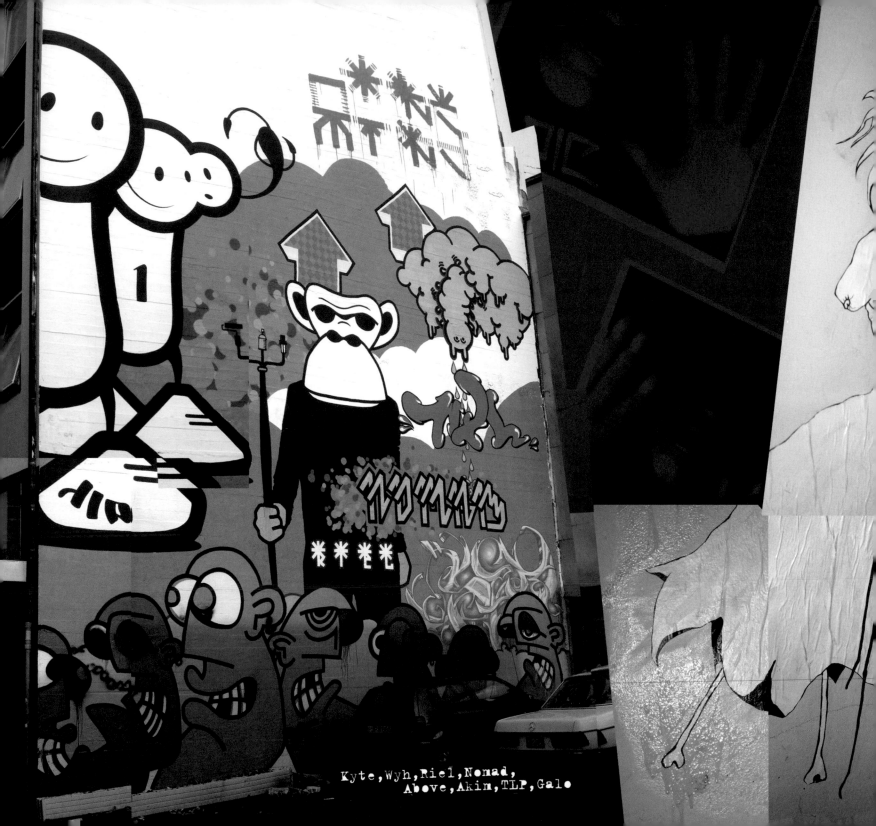

Kyte,Wyh,Riel,Nomad,
Above,Akin,TLP,Galo

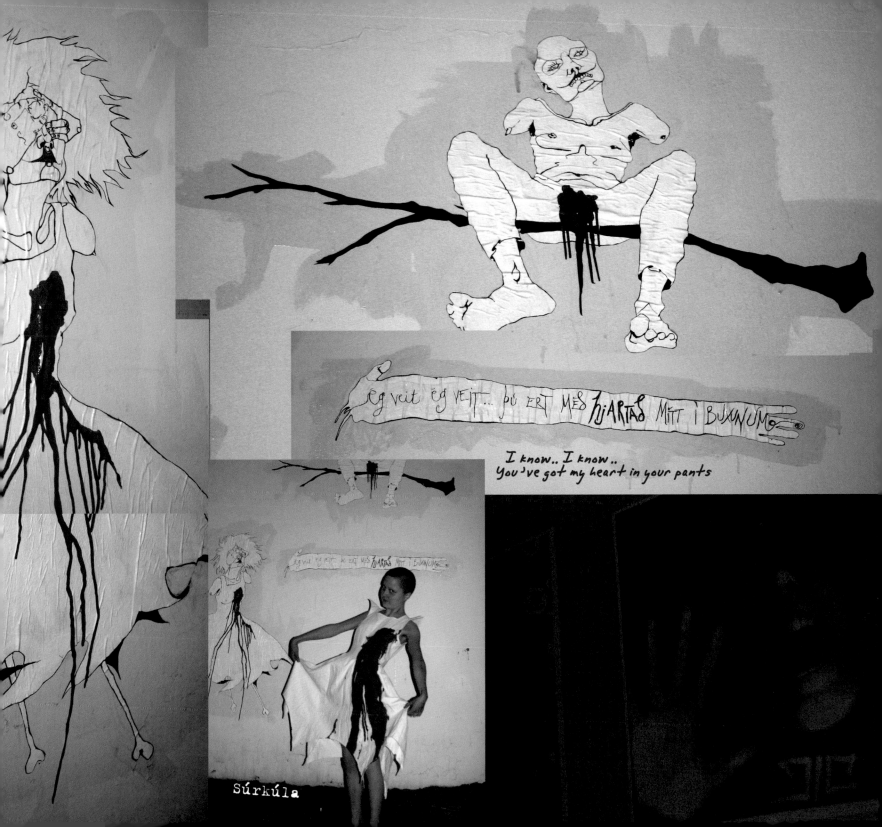

I know.. I know..
You've got my heart in your pants

Súrkúla

RUSSIA'S BLOODIEST SECRET:

chernobyl
CHILDREN

bobby knuckles

North
American
Terrorist
Organization

bobby knuckles

REMEMBER
THE HEROES
OF EIGHTIES TEEN COMEDIES

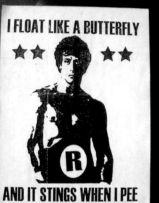

REMEMBER
JUDD NELSON

REMEMBER
LUKE PERRY

REMEMBER
MOLLY RINGWALD

REMEMBER
COREY FELDMAN

SELBSTKLEBEND

ZELFKLEVEND

REMEMBER
COREY
FELDMAN

I FLOAT LIKE A BUTTERFLY

★★ ★★

R

AND IT STINGS WHEN I PEE

bobby knuckles

REMEMBER
THEIR NÖÖ ÖLLU

FEITT RAS&S GAT

bobby knuckles

BOBBY K

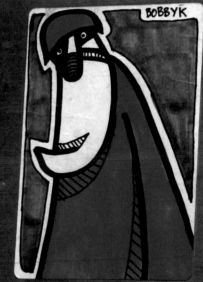

BOBBYK

HLUSTAU
A'
HALL &
OATES

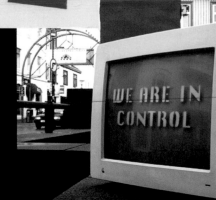

WE ARE IN
CONTROL

Bobby K

YOU'RE TOAST

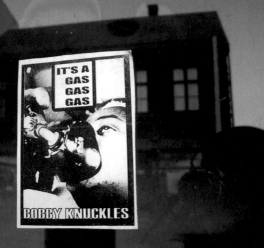

IT'S A
GAS
GAS
GAS

BOBBY KNUCKLES

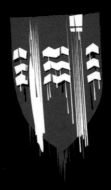

FUCK
FREEDOM
FRIES

bobby knuckles

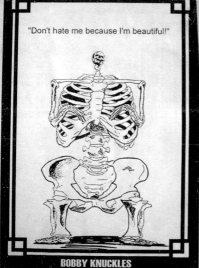

"Don't hate me because I'm beautiful!"

BOBBY KNUCKLES

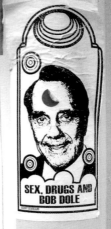

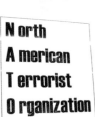

SEX, DRUGS AND
BOB DOLE

N orth
A merican
T errorist
O rganization

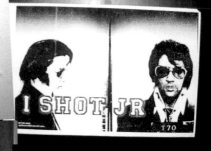

I SHOT JR

T70

THE BOOGIE VAN bobby knuckles

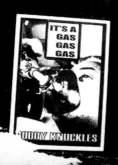

IT'S A
GAS
GAS
GAS

BOBBY KNUCKLES

REMEMBER
L.A. LAW

REMEMBER
HALL & OATES

HALLO
Nahn mitt er BOBBY K

HKE KEVIN
BACON
was here

the stars
are wathcing us

STJÖRNUR
FYLGJAST
MEÐ

VINSAMLEGAST
FARIÐ UR SKÓM

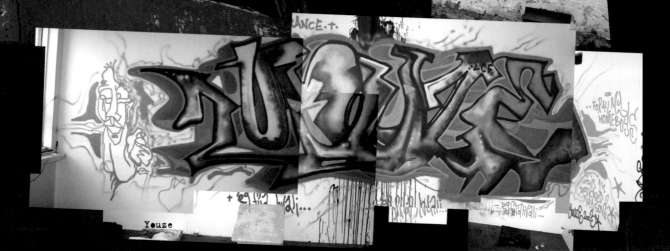

ANCE·T·

Youze

Please take off
your shoes.

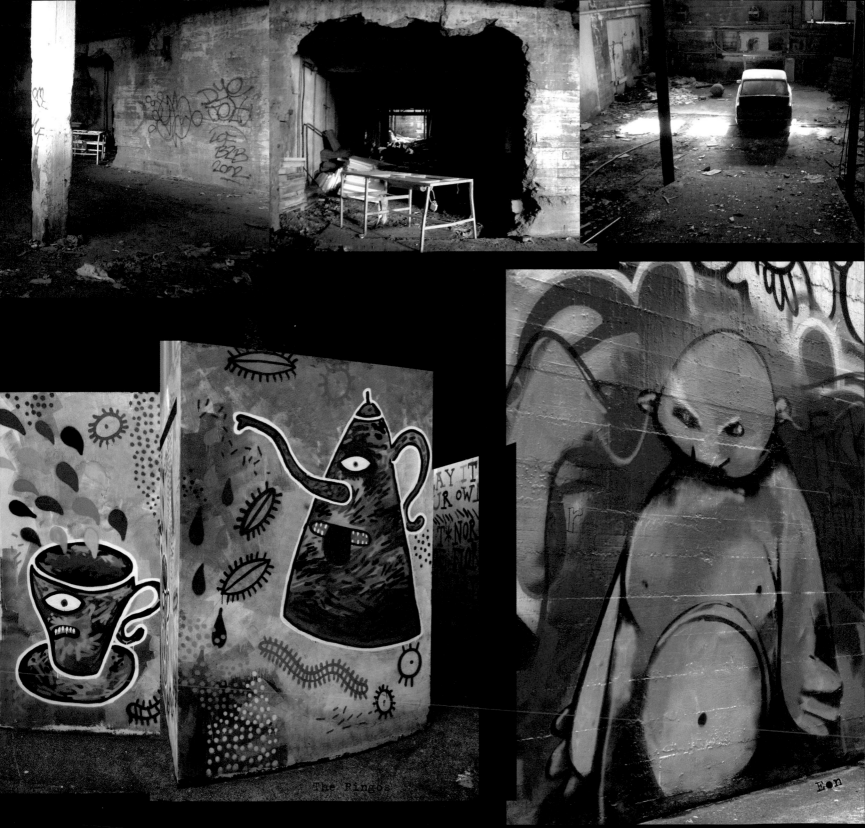

The Ringos

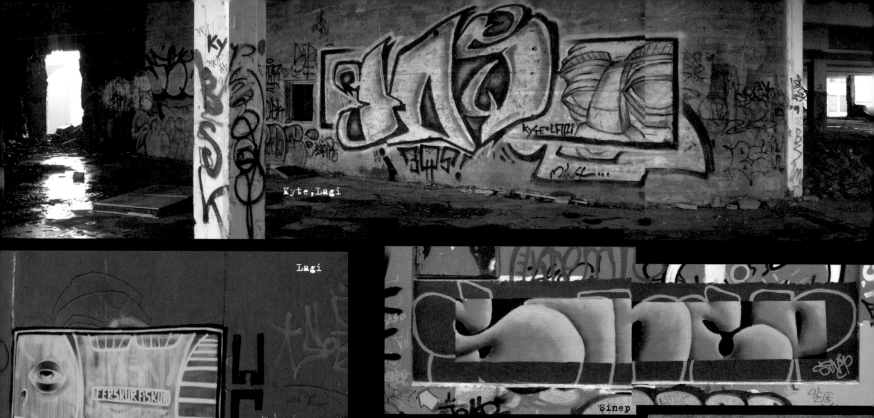

Kyte,Lagi

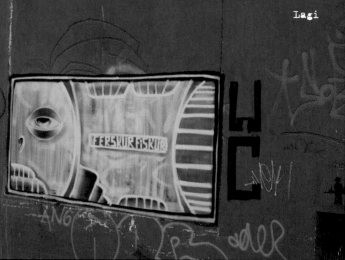

Lagi

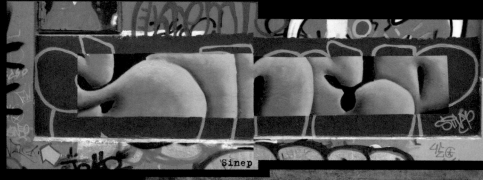

Sinep

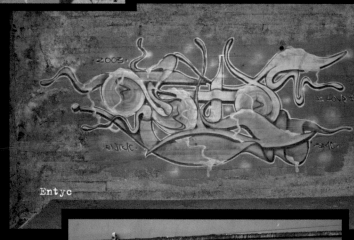

Entyc

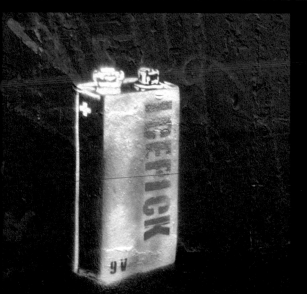

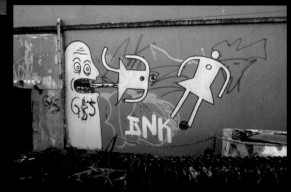

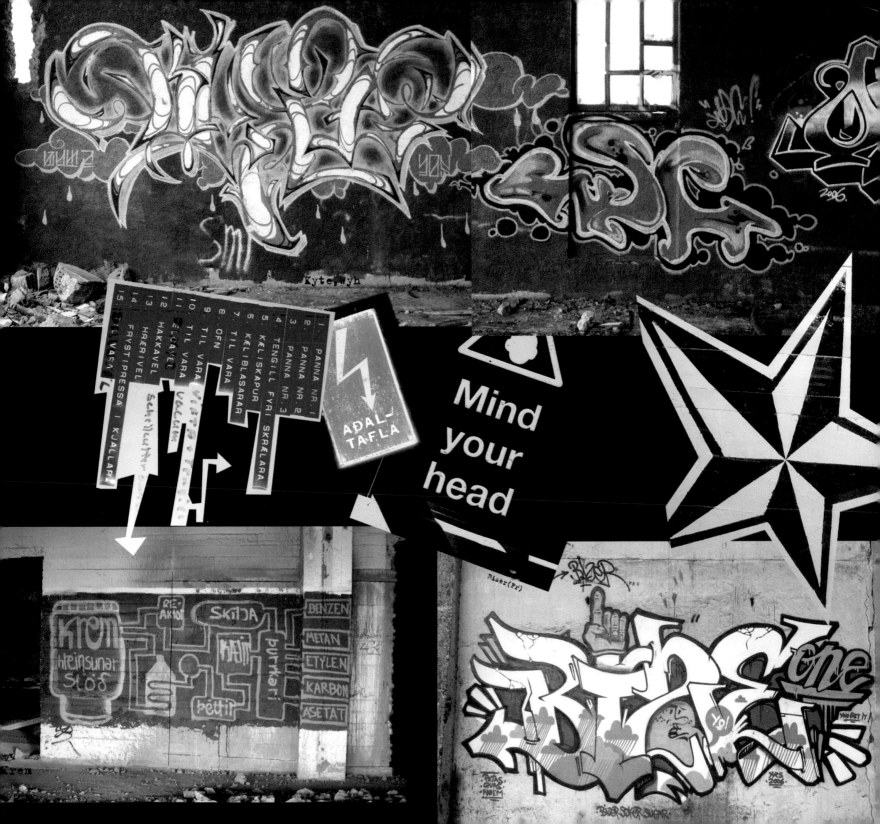

Kyte,Wyh

PANNA NR. 1
PANNA NR. 2
PANNA NR. 3
TENGILL FYRI SKRÆLARA
KÆLISKÁPUR
KÆLIBLÁSARAR
TIL VARA
OFN
TIL VARA
TIL VARA
TIL VARA
BLOÐVEL
HAKKAVEL
HRÆRIVEL
FRYSTIPRESSA Í KJALLARA

AÐAL-
TAFLA

Mind
your
head

Kyte,Wyh

Krem
hreinsunar
stöð

Rís-
Aktor

SKILDA

HEIN

þurrkari

pettir

BENZEN

METAN

ETYLEN

KARBON

ASETAT

Krem

Nioer(Fr)

BLÆZR

YO!

one

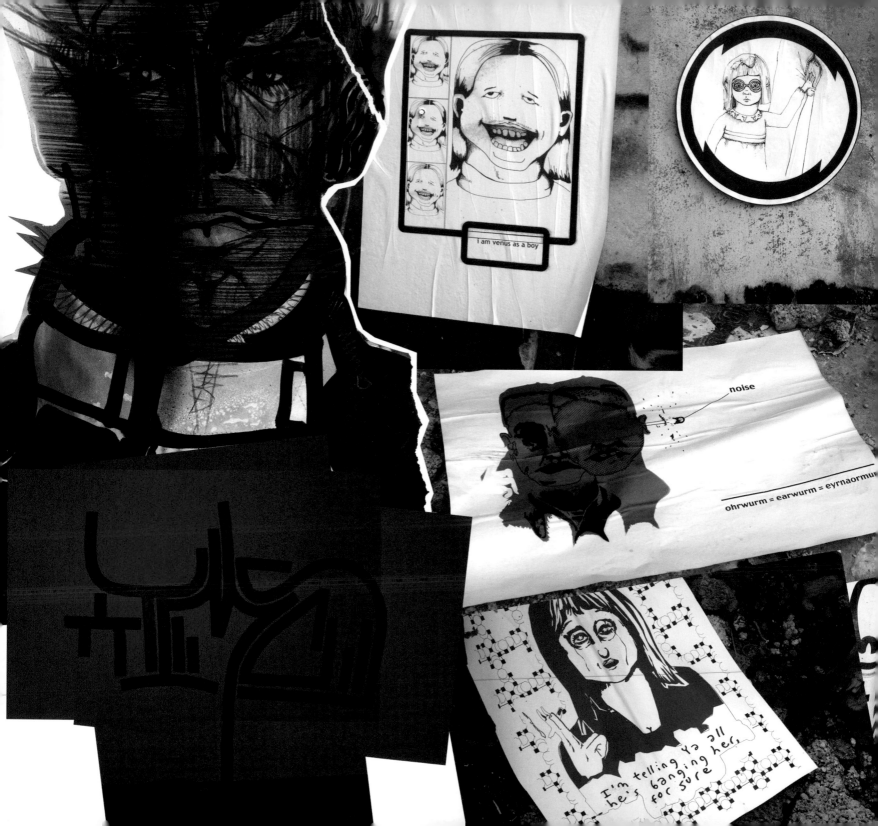

Dyer

poster
poster
poster

Legus

Alerte

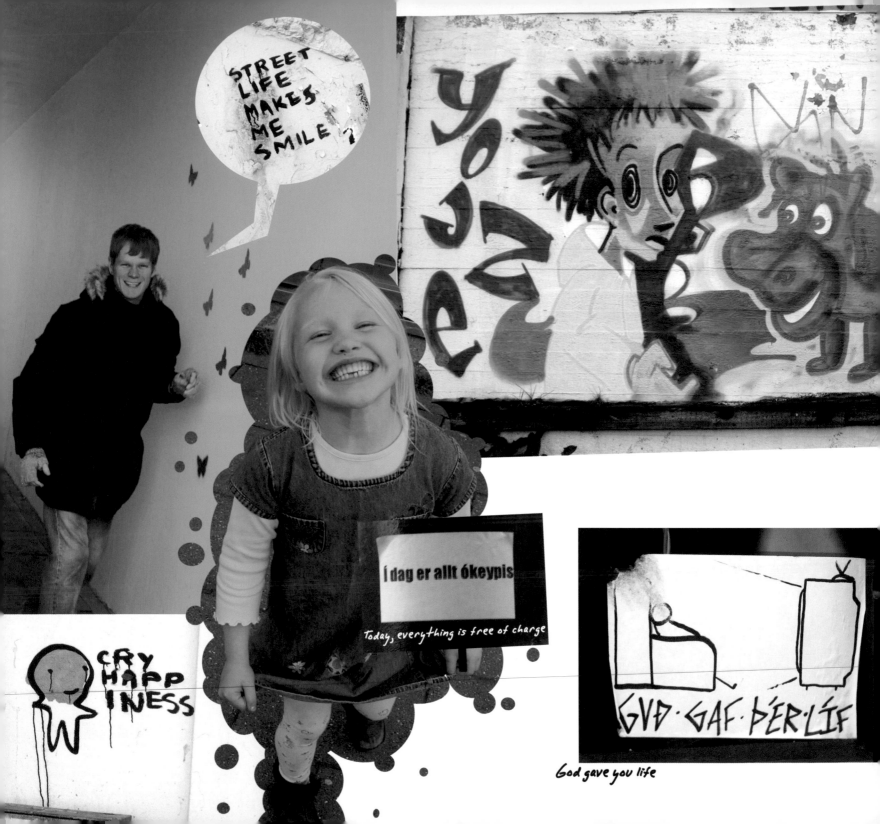

Youze,Oza

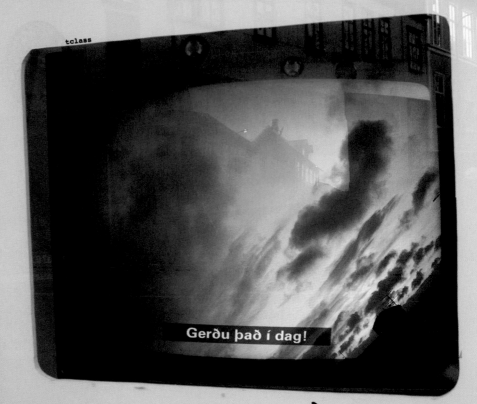

tclass

Gerðu það í dag!

Do it today!

STOP

Furumelur

Dear miss Sofie!
We regret having
kidnapped you.
You can go now.. Sorry
– the burglars

Kæra ungfrú
Soffía!
Við ötluðum
ekki að
Ræna þér
Þú mátt
Fara núna
Fyrigeðdu!
Ræningjarnir

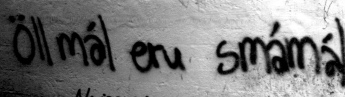

Öll mál eru smámál
No issue is really unmanageable

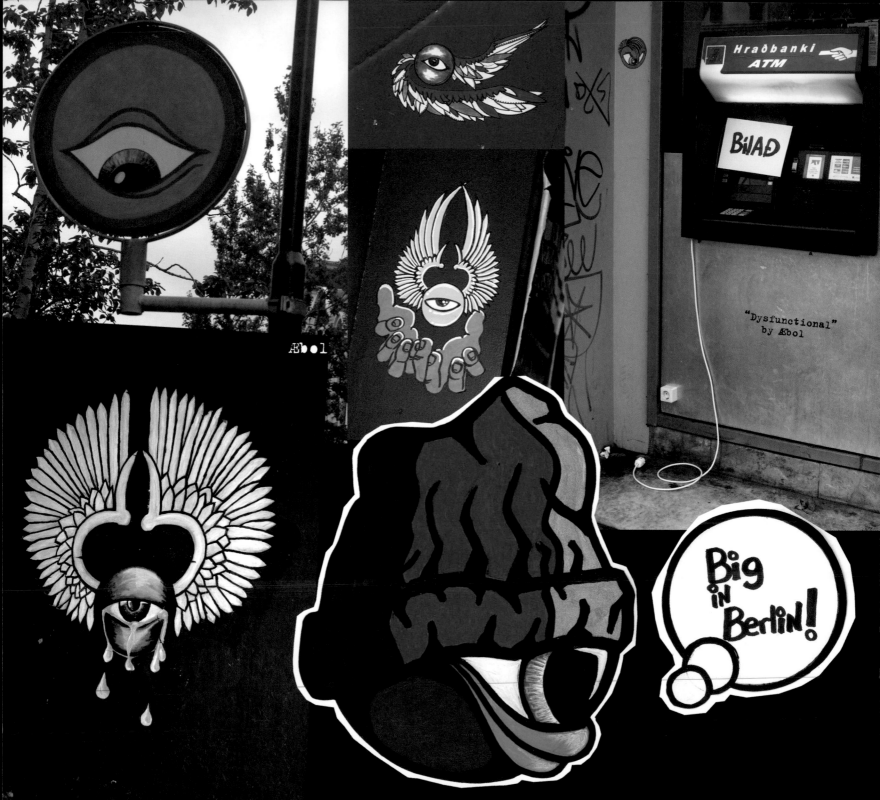

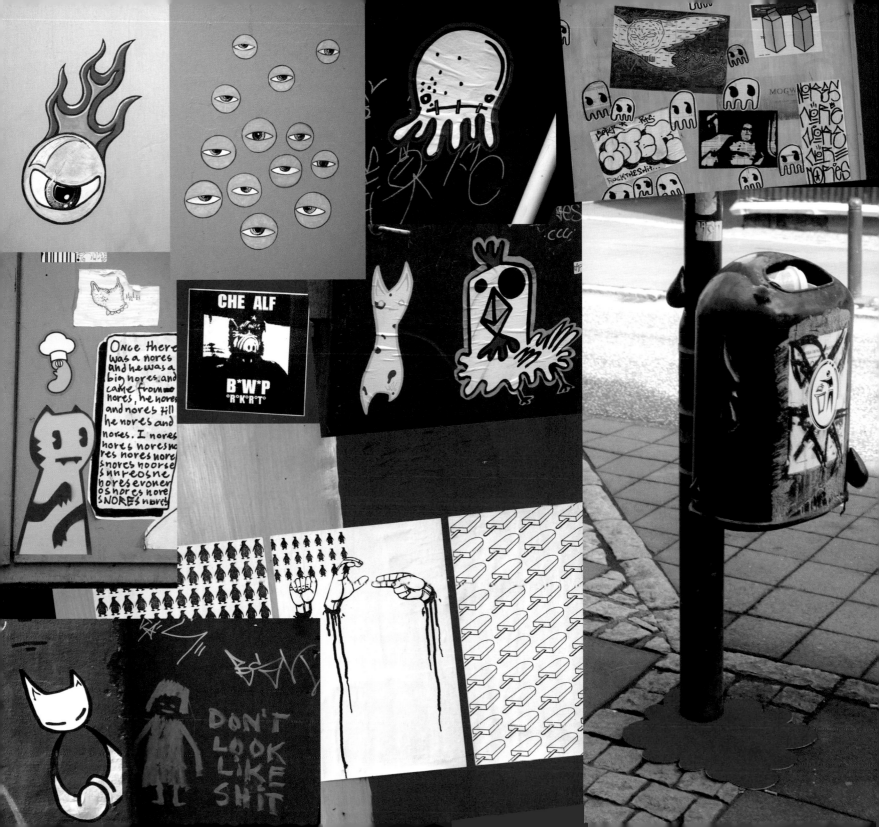

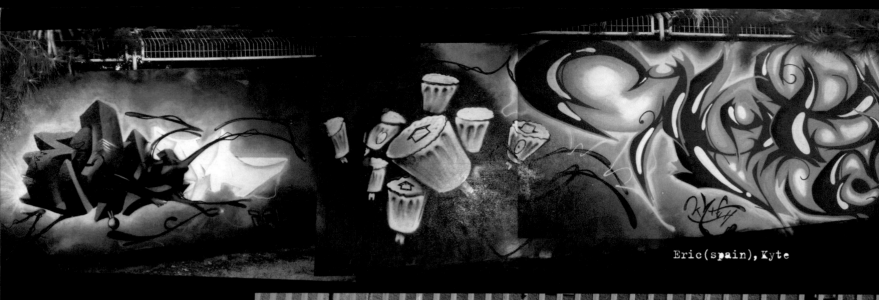

Eric(spain),Kyte

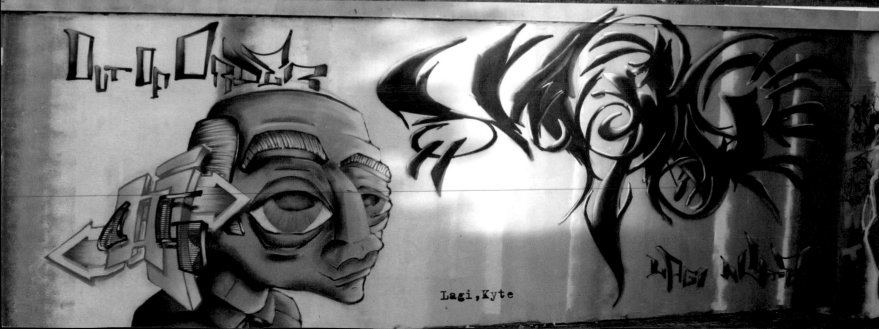

Lagi,Kyte

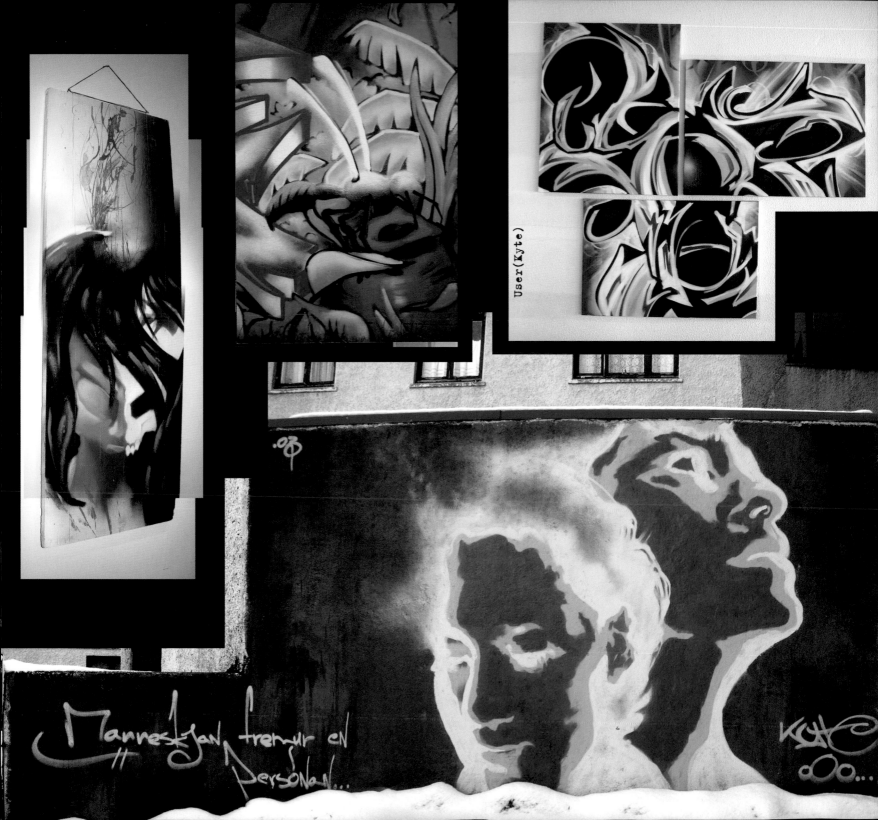

User(Kyte)

.03

Manneskjan tremur en
Personan...

Kyte
ooo...

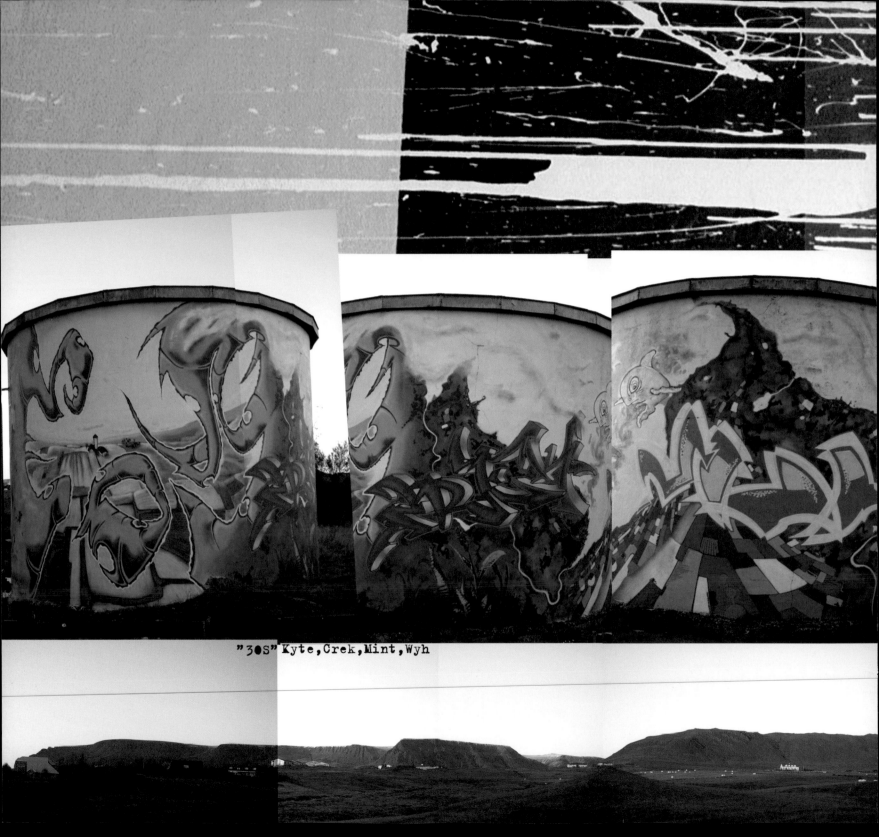

"30S" Kyte,Crek,Mint,Wyh

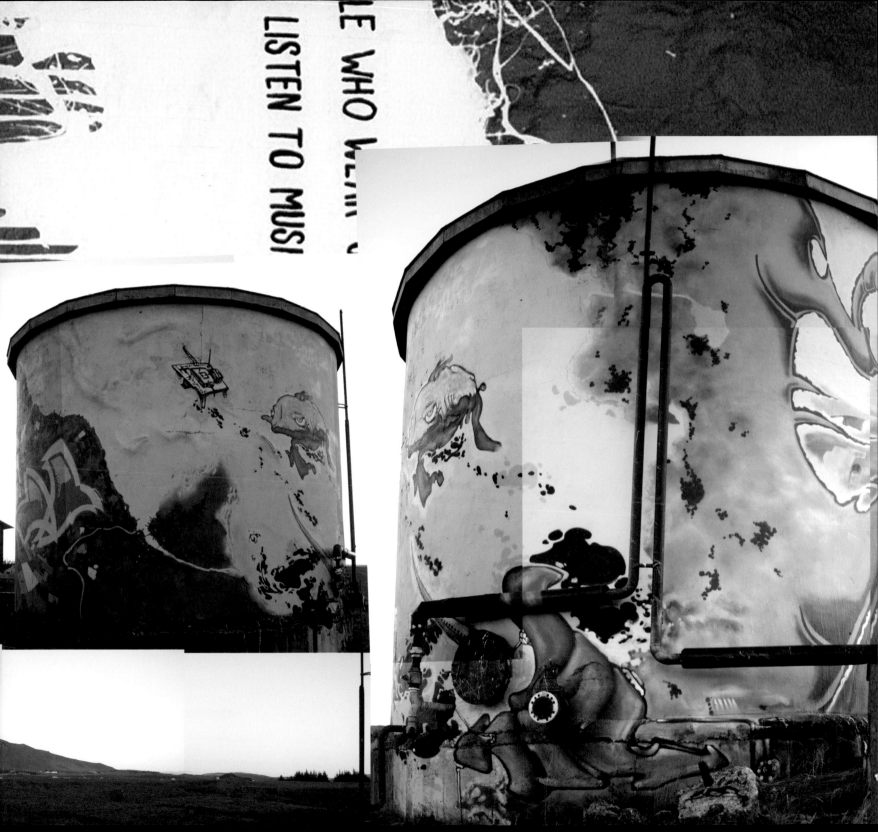

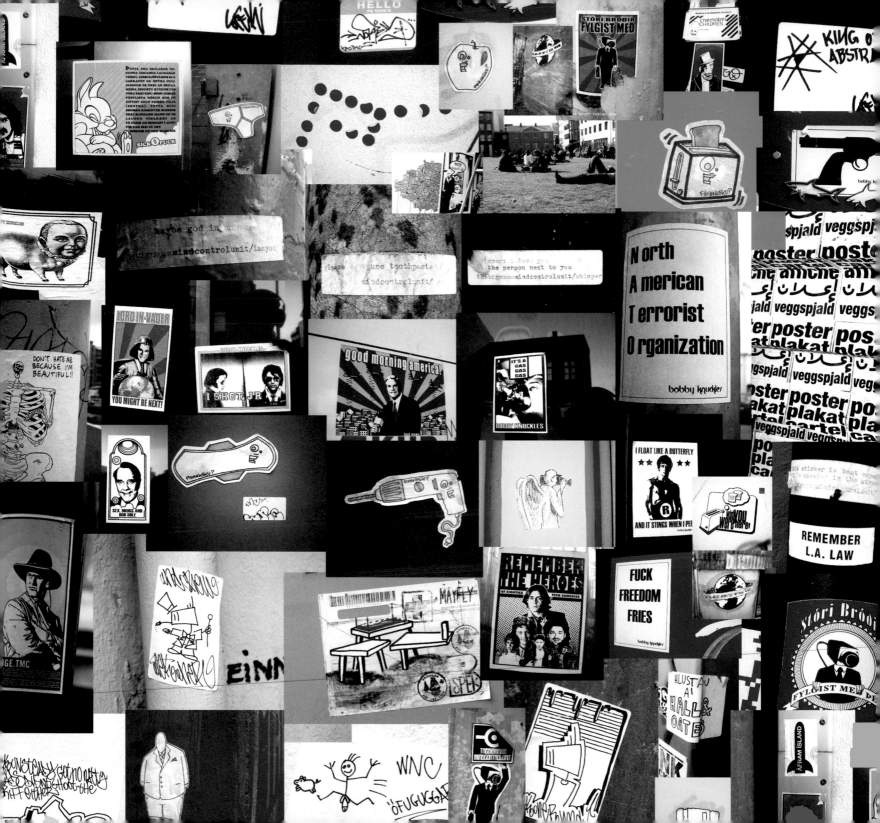

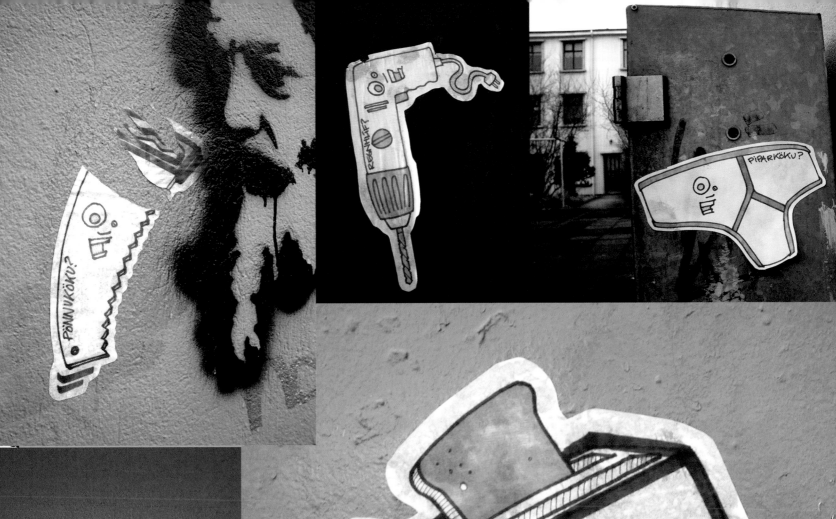
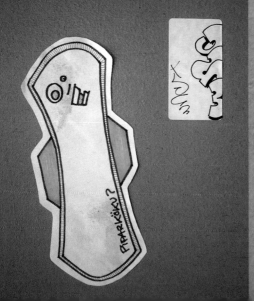
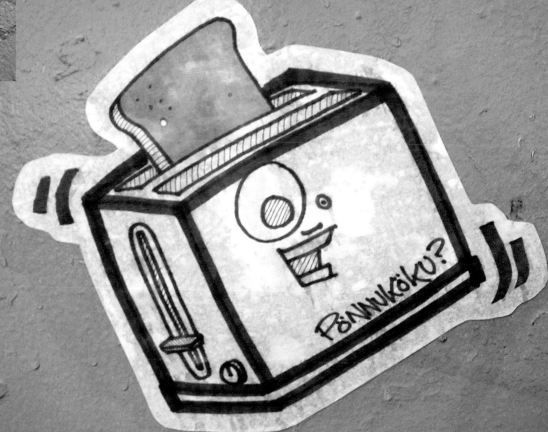

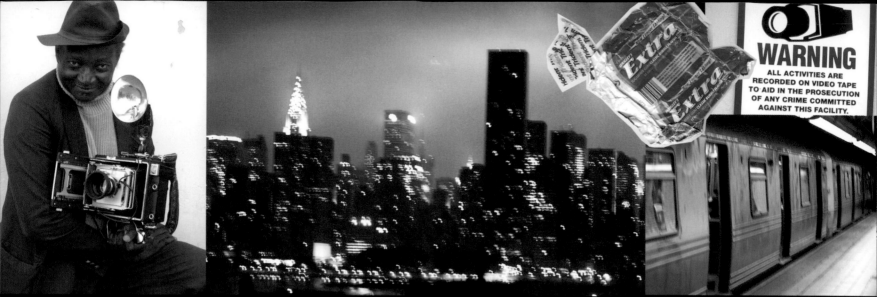

NEW YORK

On a short trip to New York, I was fortunate to meet the artist Michael De Feo. (The flower Guy). We had a nice chat in a café somewhere in Soho. He was generous enough to share some of his work with us, the "Icepickers" on the next spread.

→ THANK YOU MICHAEL!

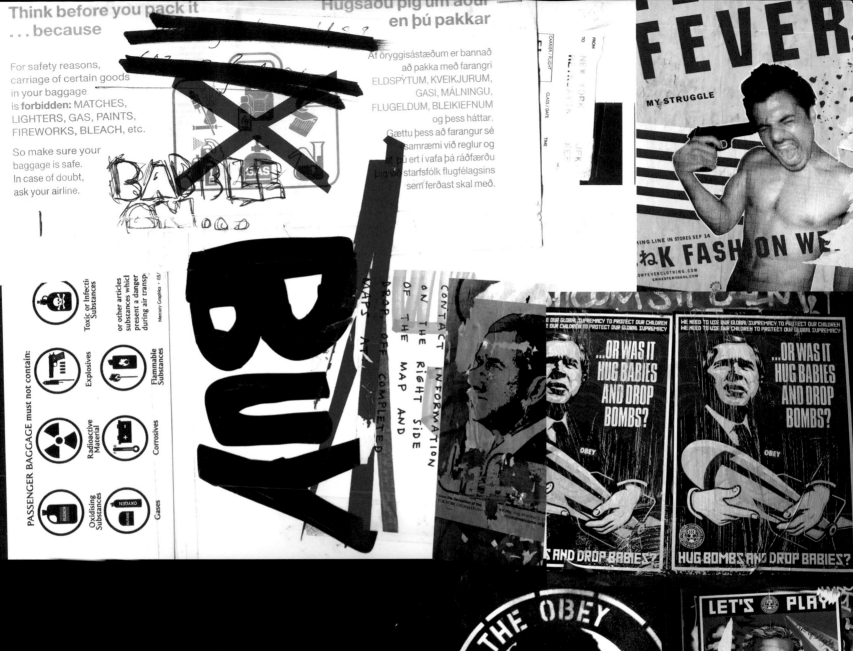
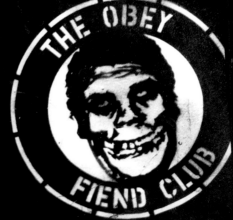
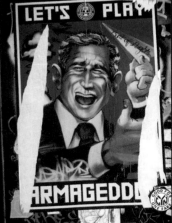

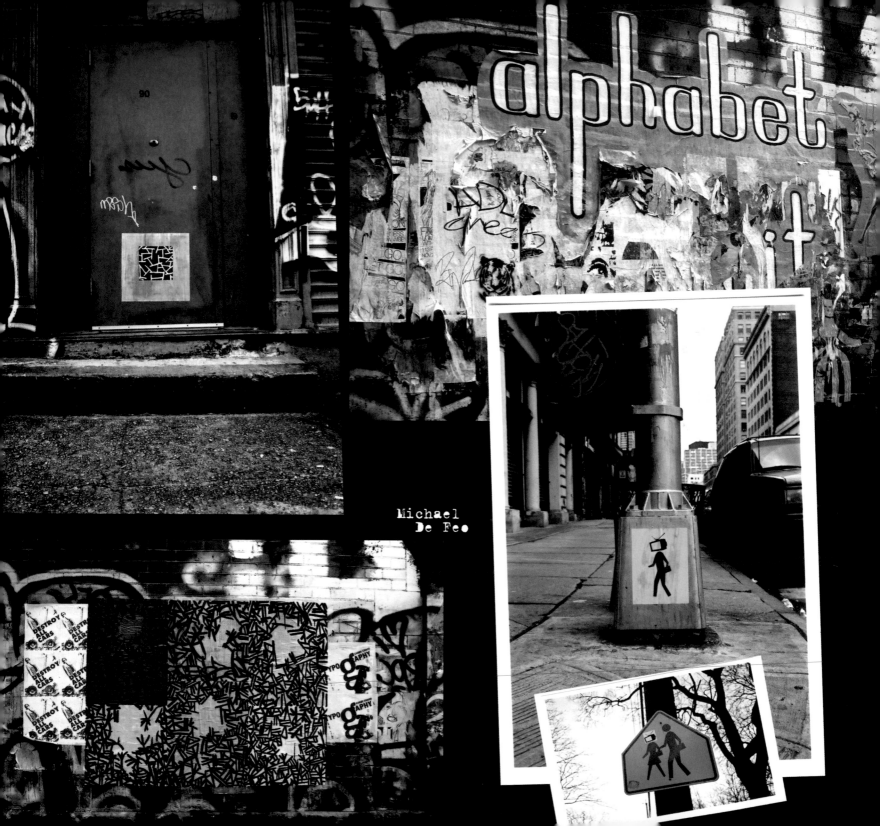

alphabet

Michael
De Feo

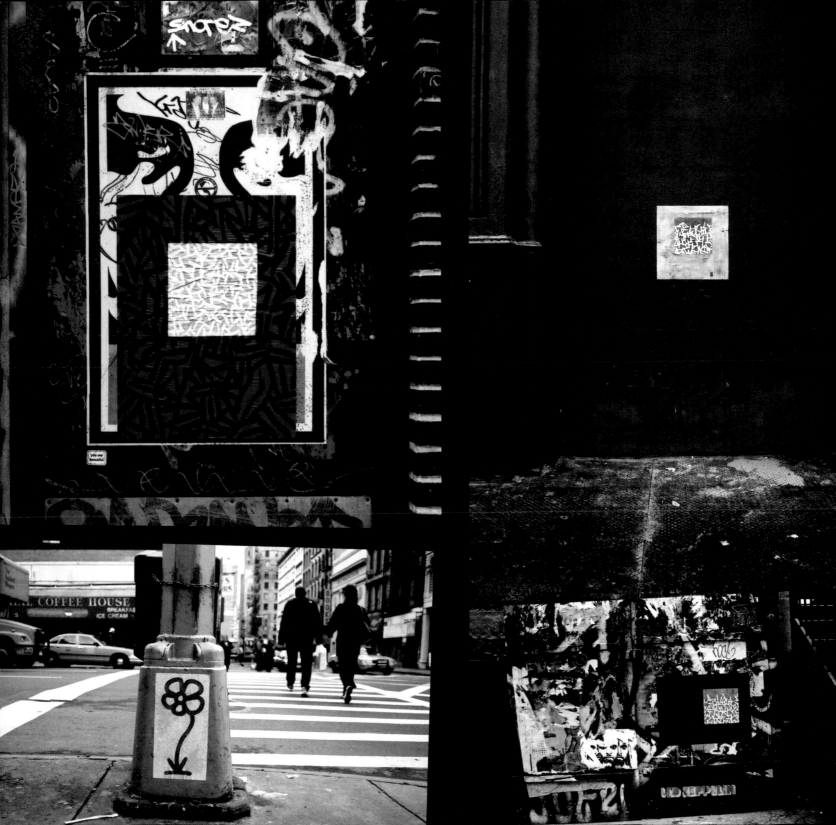

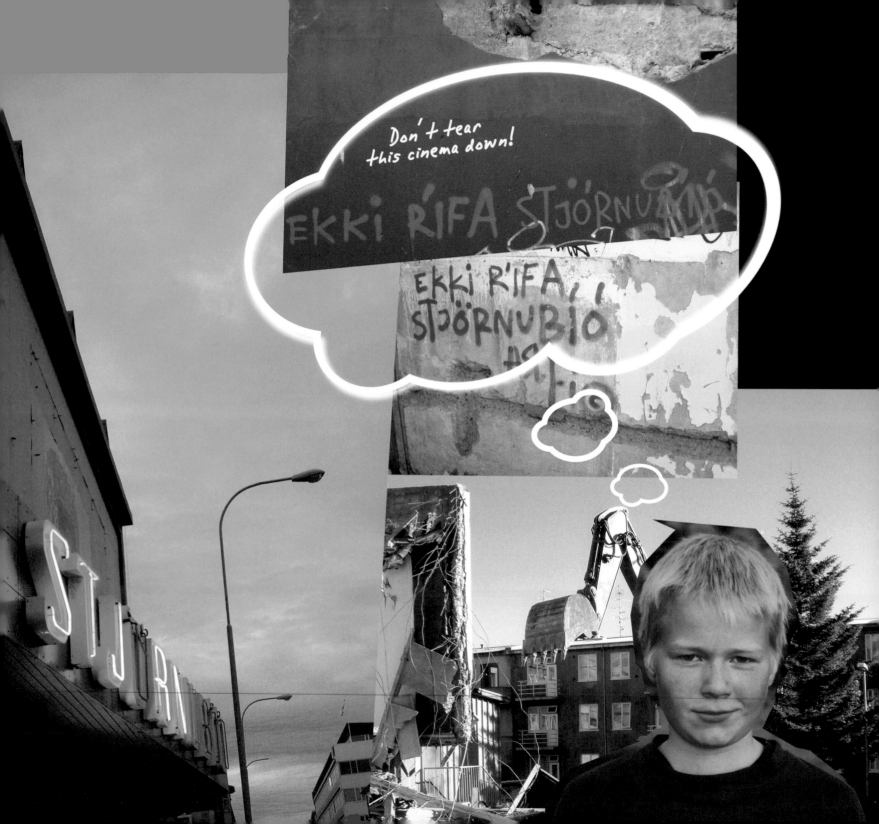

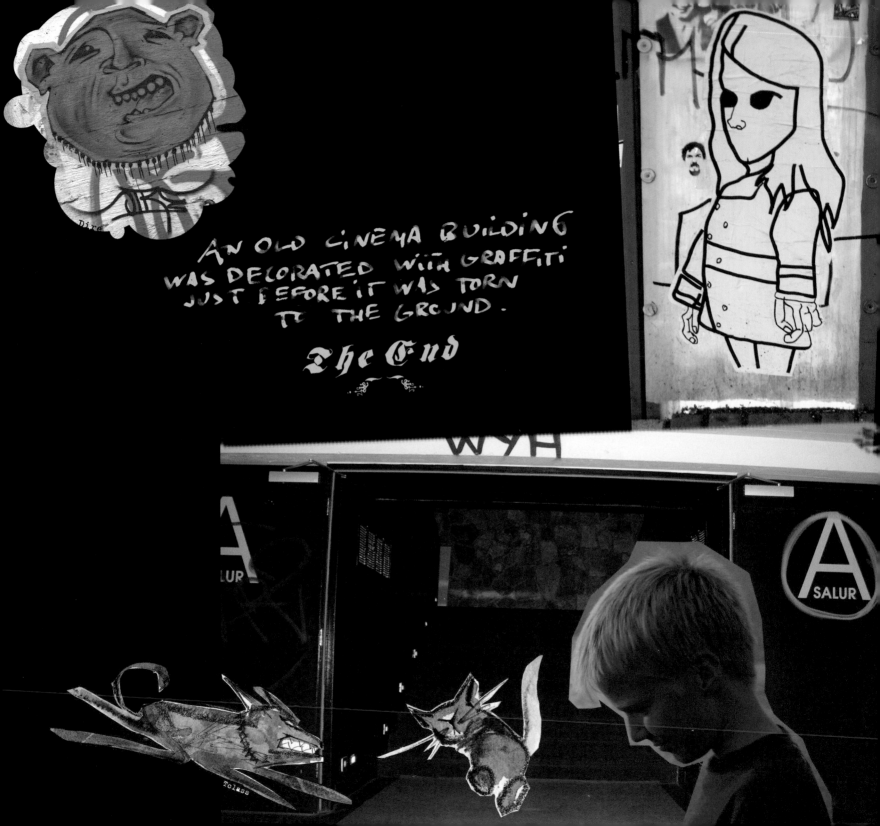

AN OLD CINEMA BUILDING WAS DECORATED WITH GRAFFITI JUST BEFORE IT WAS TORN TO THE GROUND.

The End

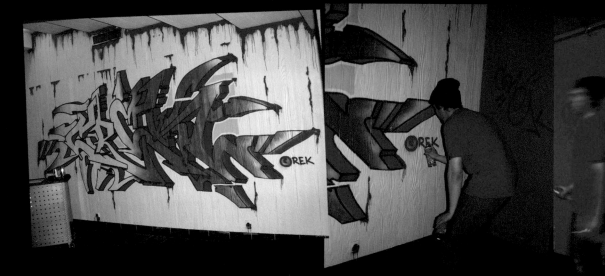
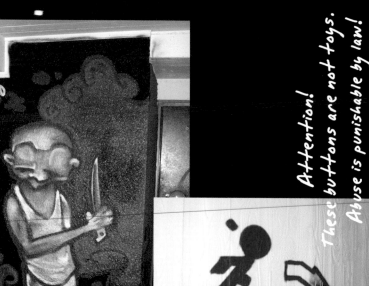
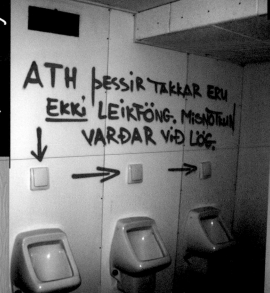

22

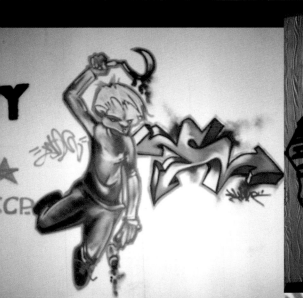

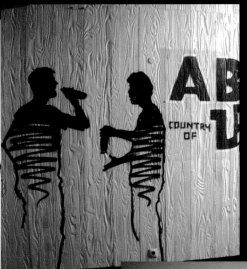

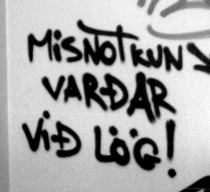

MISNOTKUN
VARÐAR
VIÐ LÖG!

Abuse is
punishable
by law!

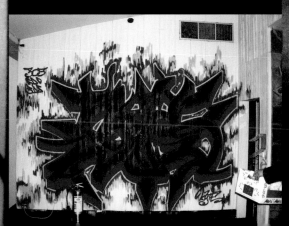

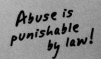

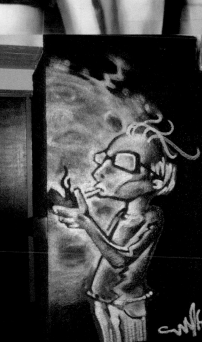

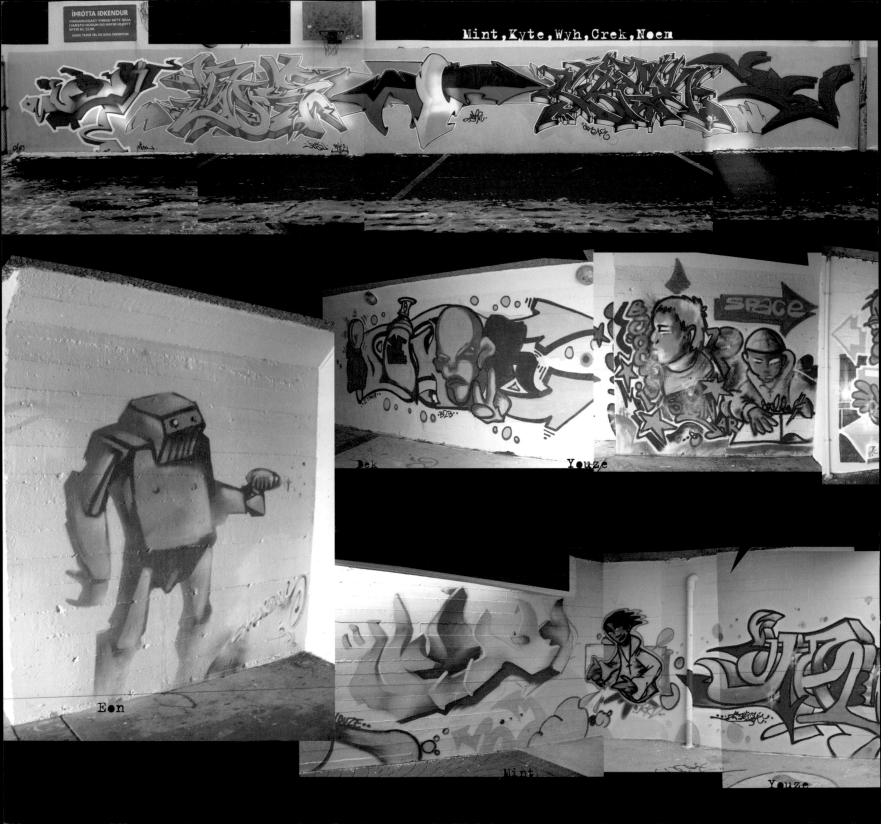

ÍÞRÓTTA IÐKENDUR

VINSAMLEGAST VIRÐIÐ RÉTT ÍBÚA
Í NÆSTU HÚSUM OG HAFIÐ HLJÓTT
EFTIR KL. 22.00.

GANGI YKKUR VEL OG GÓÐA SKEMMTUN

Mint,Kyte,Wyh,Crek,Noem

Dek

Youze

Eon

Mint

Youze

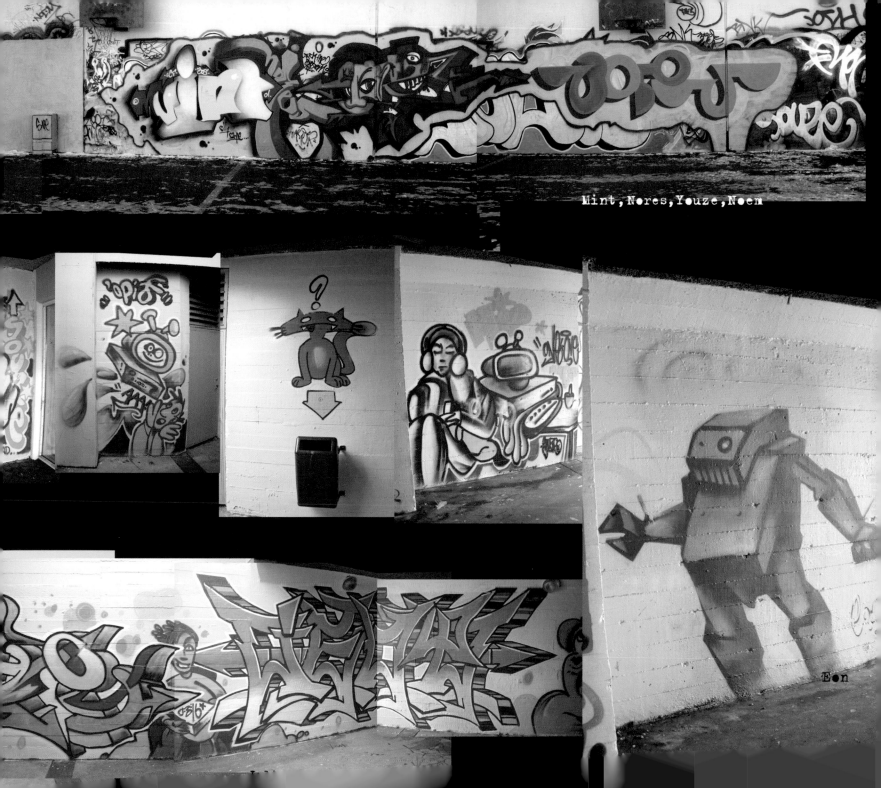

Mint,Nores,Youze,Noen

Eon

LAGIÐ ER STOLIÐ

This tune is stolen

(Iceland's song in the
Eurovision Song Contest)

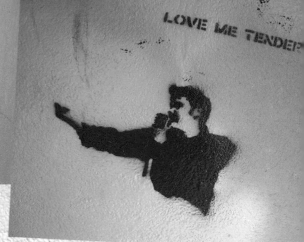

LOVE ME TENDER

My name is Jón and I'm a clone

ÉG HEITI JÓN
OG ÉG ER KLÓN

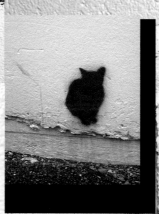

GORILLA REVOLUTIO

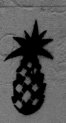

Batman í Reykjavík

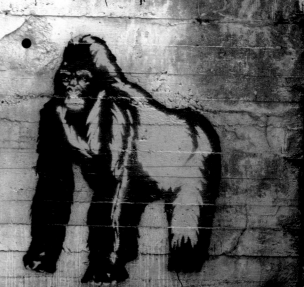

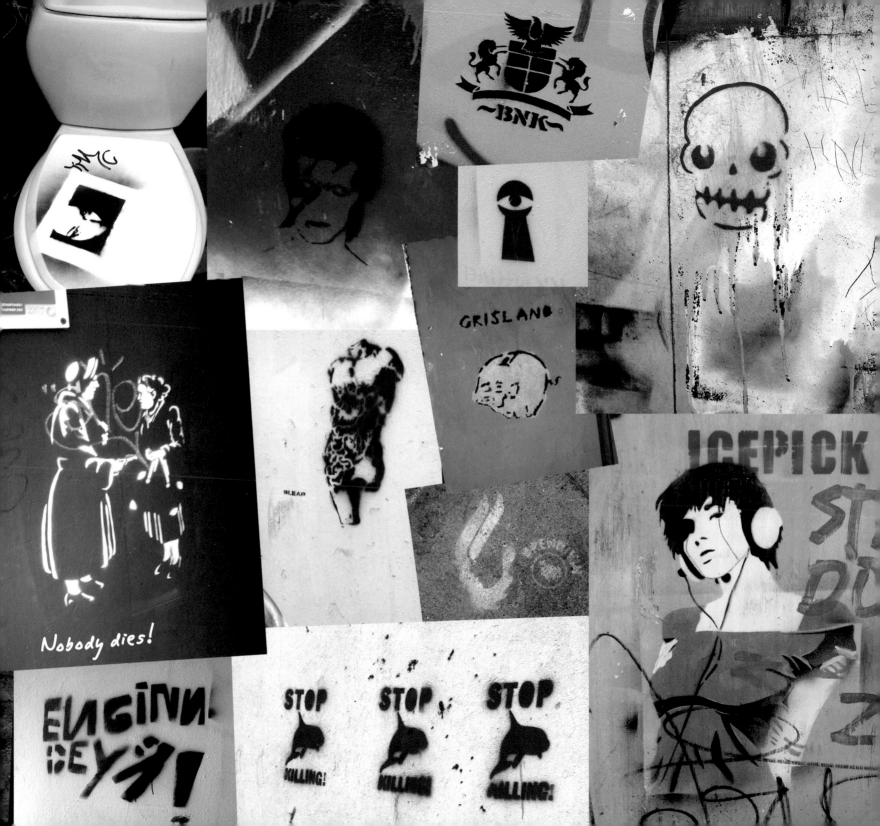

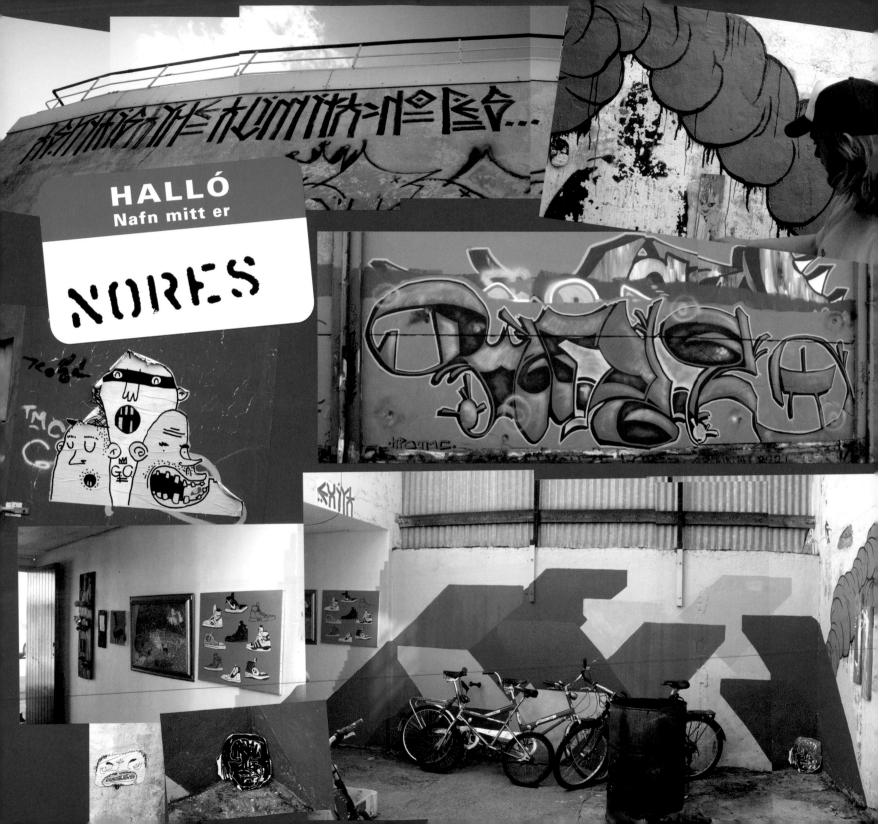

HALLÓ
Nafn mitt er

NORES

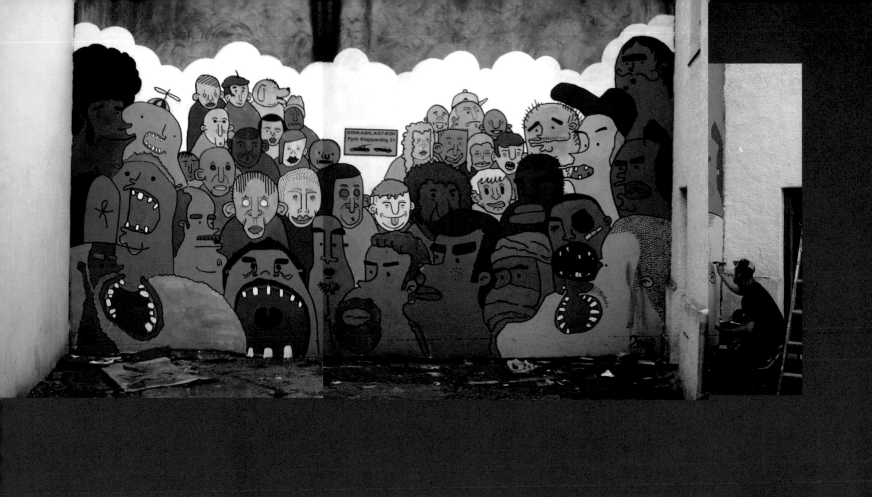

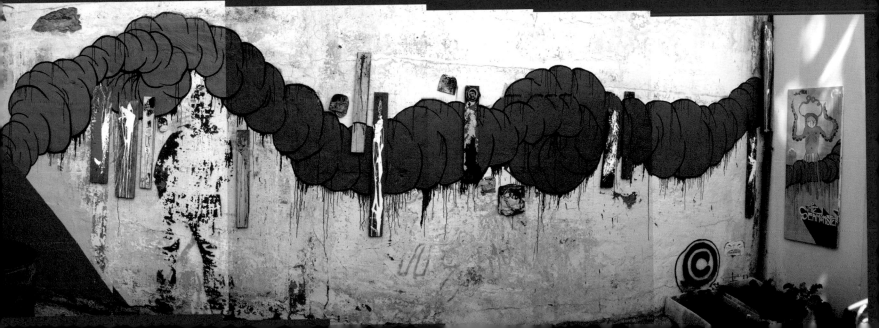

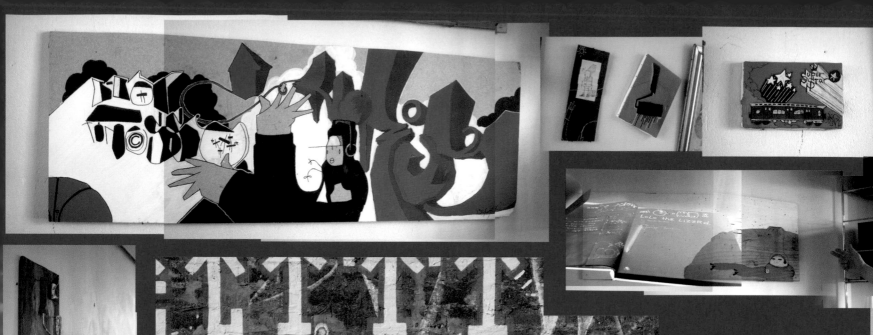

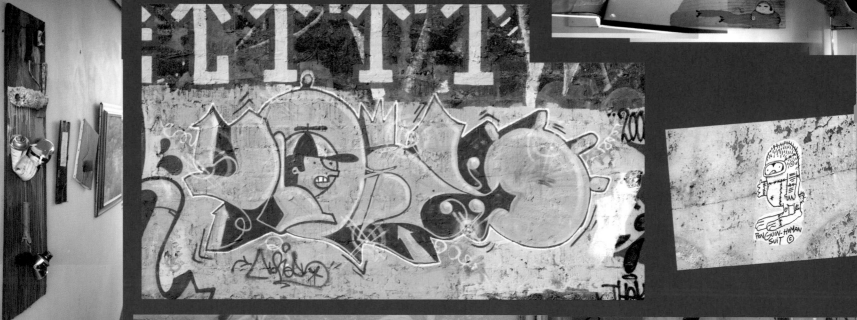

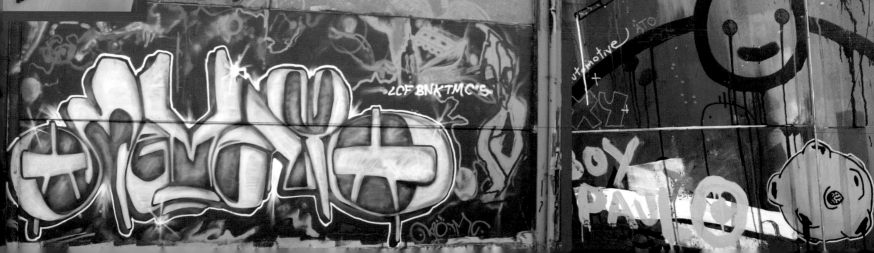

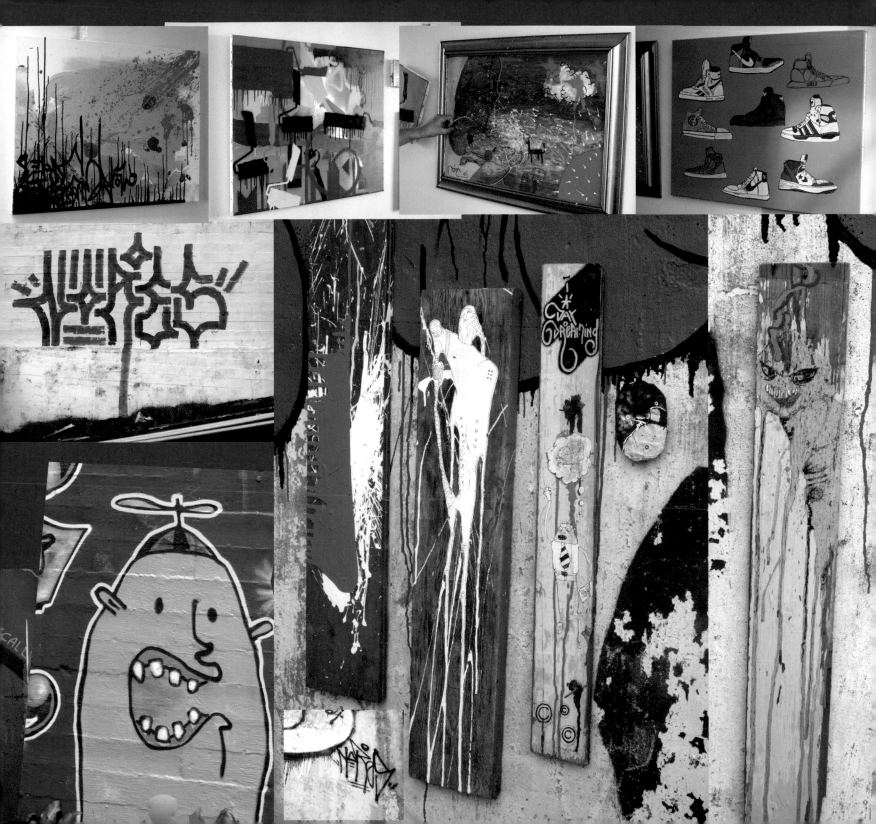

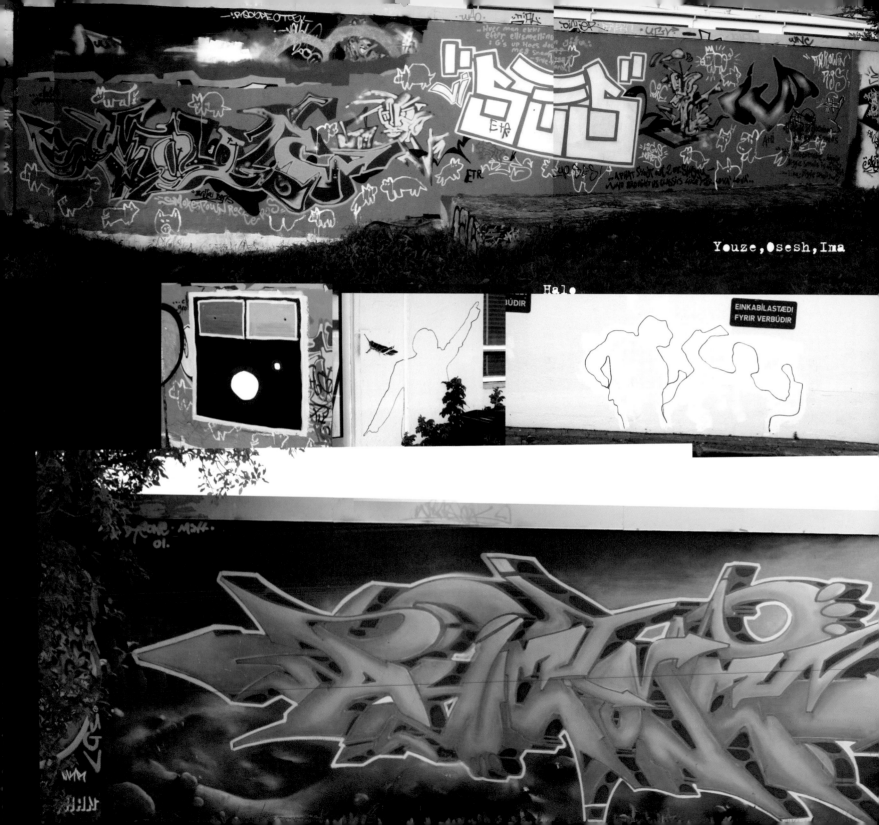

Youze, Osesh, Ima

Halo

EINKABÍLASTÆDI
FYRIR VERBÚDIR

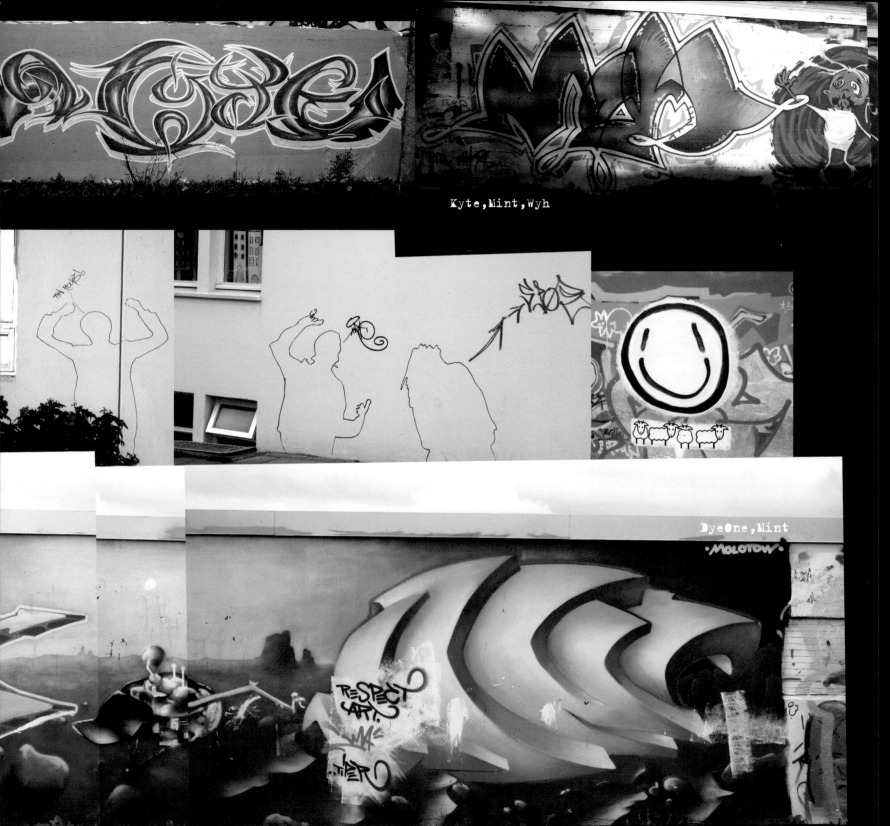

Kyte,Mint,Wyh

DyeOne,Mint

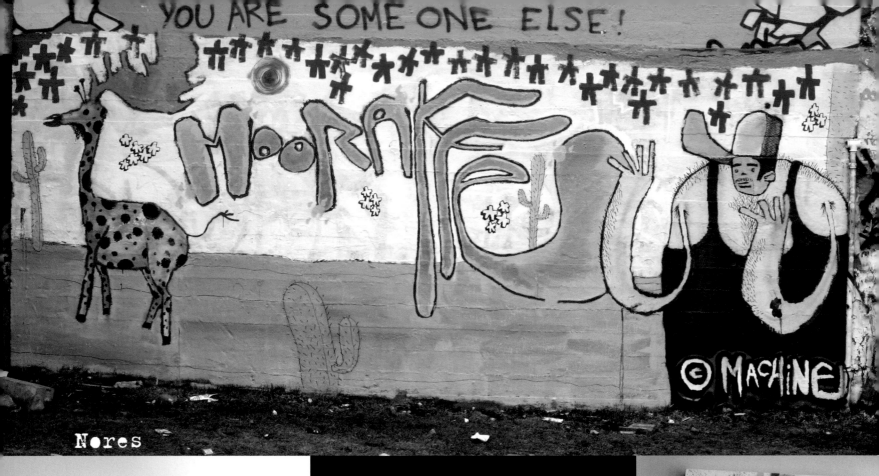

YOU ARE SOME ONE ELSE!

© MACHINE

Nores

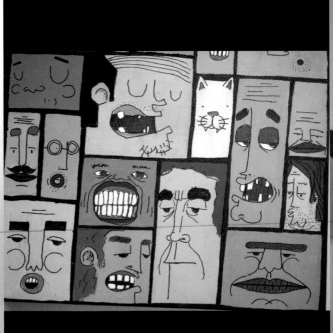

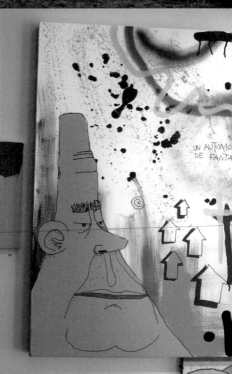

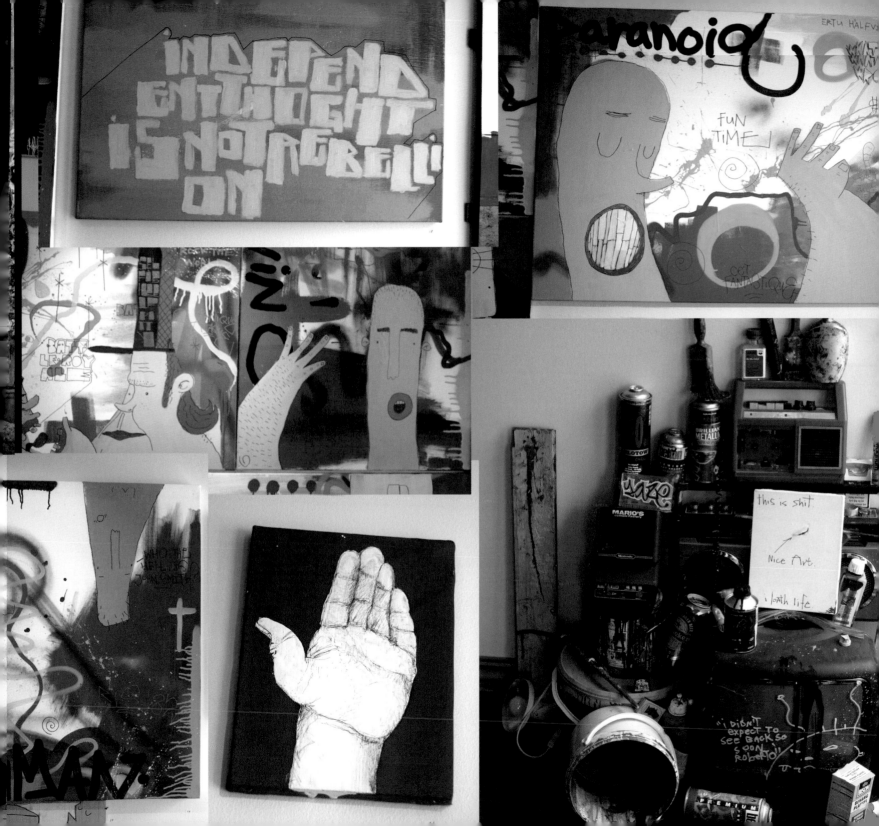

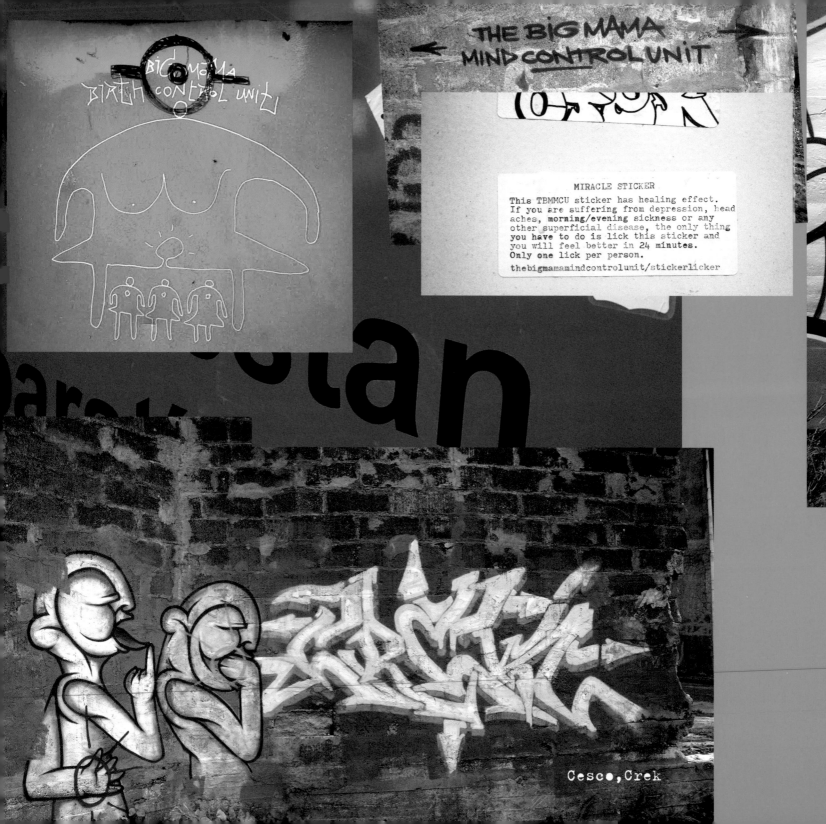

THE BIG MAMA
MIND CONTROL UNIT

BIG MOMMA
BIRTH CONTROL UNIT

MIRACLE STICKER

This TBMMCU sticker has healing effect.
If you are suffering from depression, head
aches, morning/evening sickness or any
other superficial disease, the only thing
you have to do is lick this sticker and
you will feel better in 24 minutes.
Only one lick per person.

thebigmamamindcontrolunit/stickerlicker

Cesco, Crek

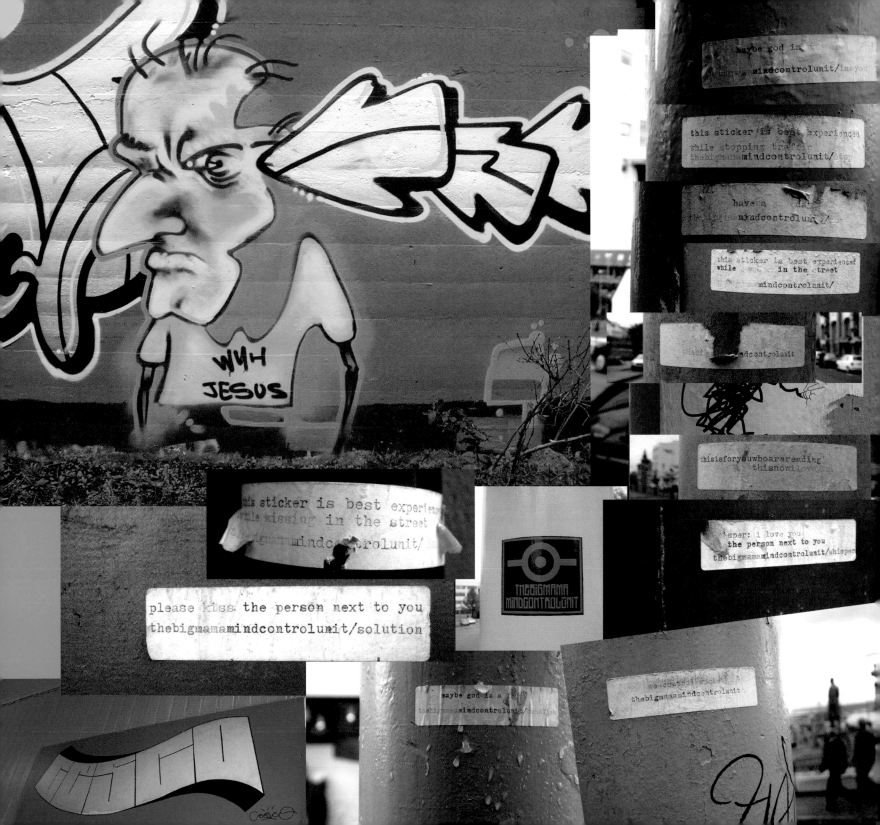

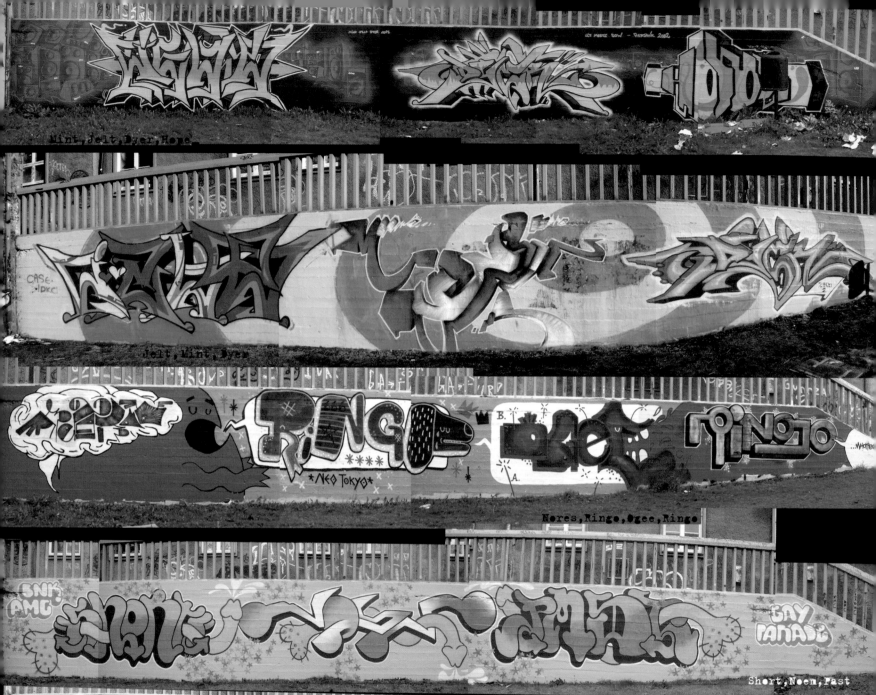

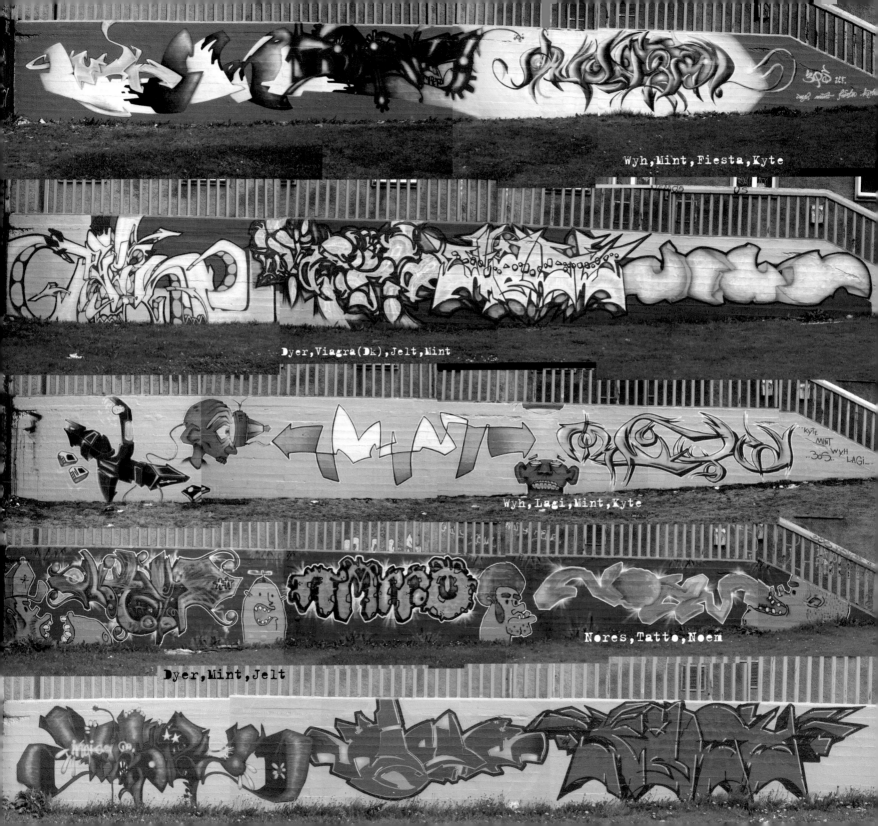

Wyh,Mint,Fiesta,Kyte

Dyer,Viagra(Dk),Jelt,Mint

Wyh,Lagi,Mint,Kyte

Nores,Tatto,Noem

Dyer,Mint,Jelt

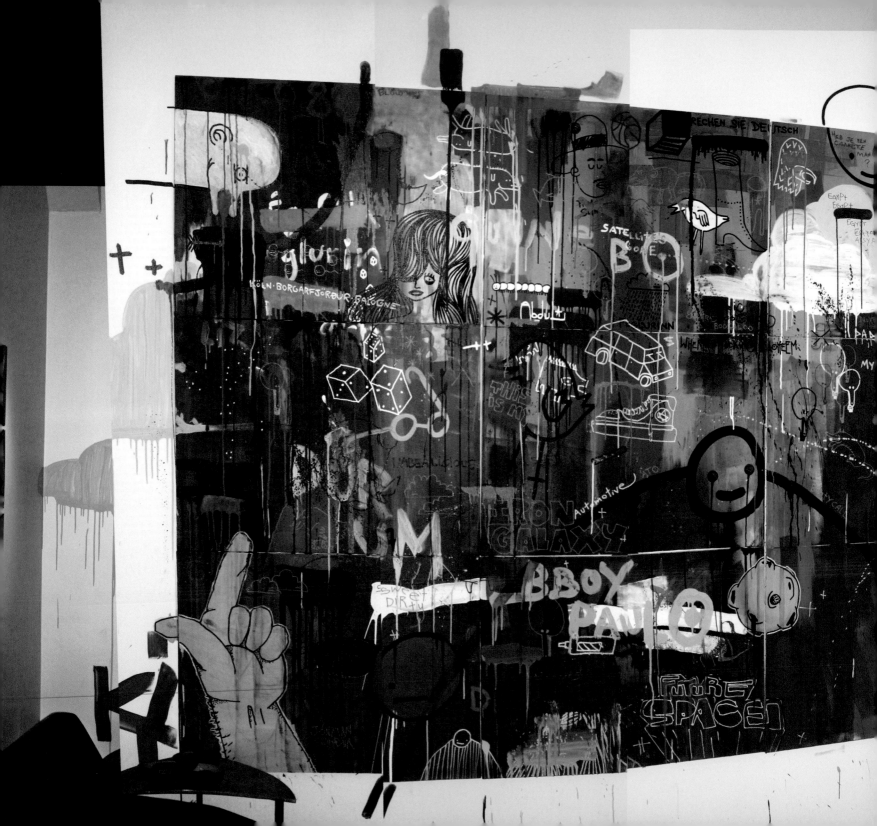

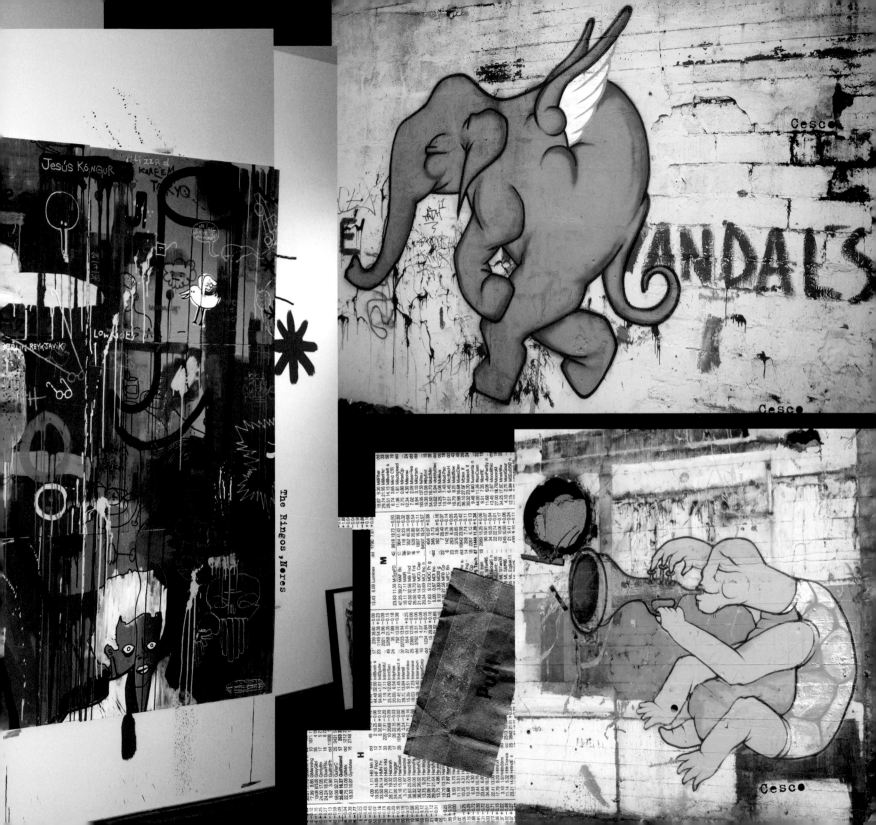

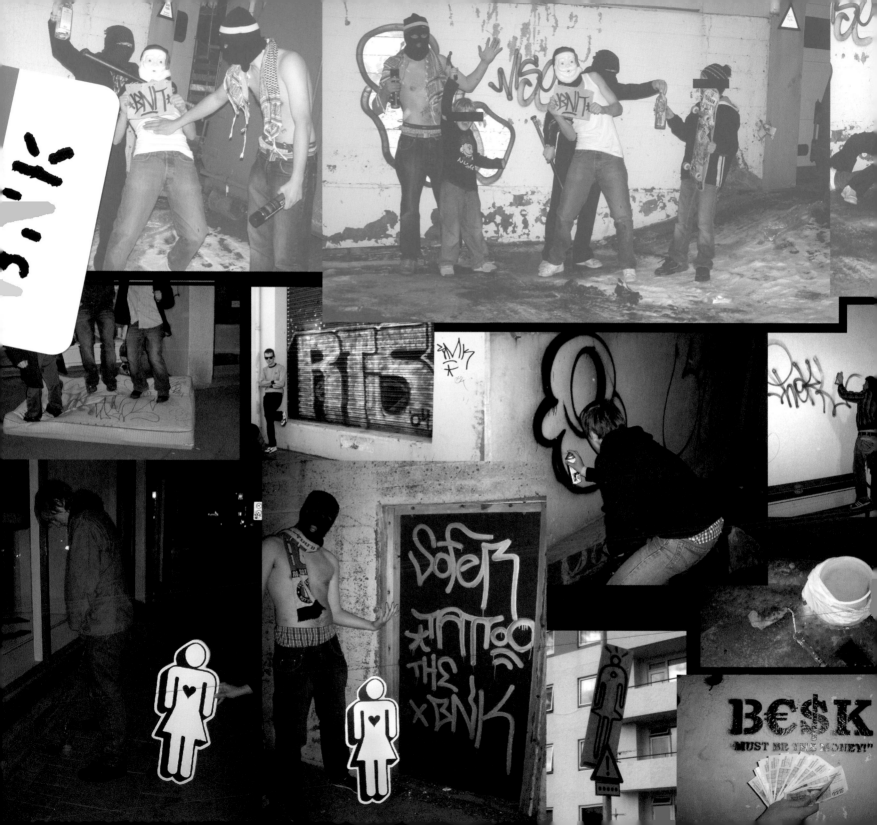

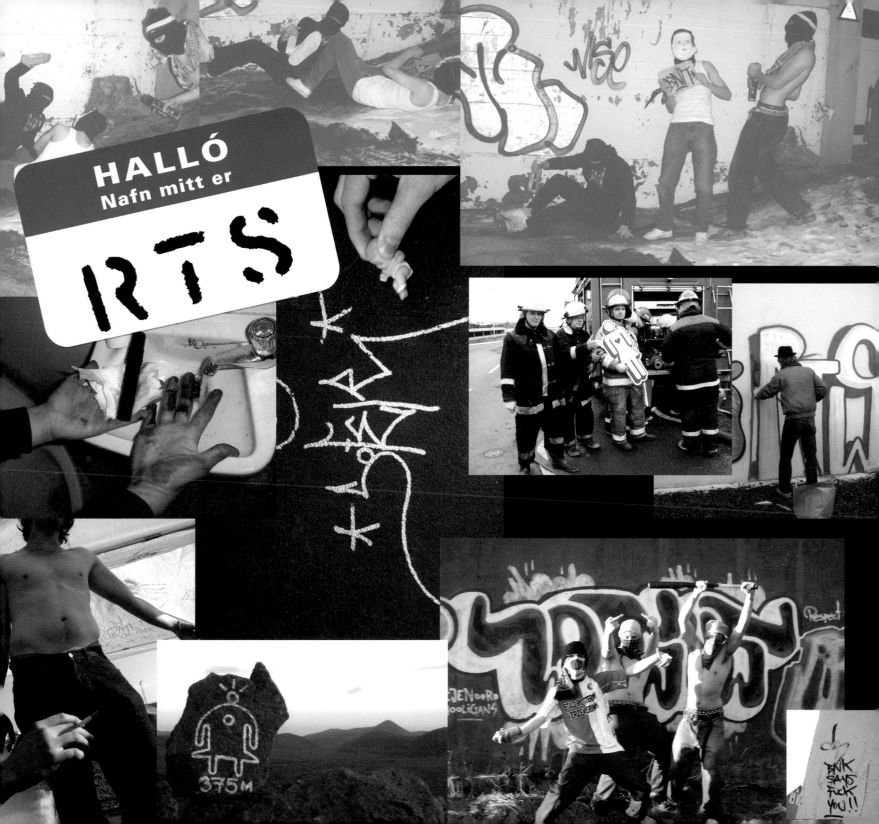

HALLÓ
Nafn mitt er
RTS

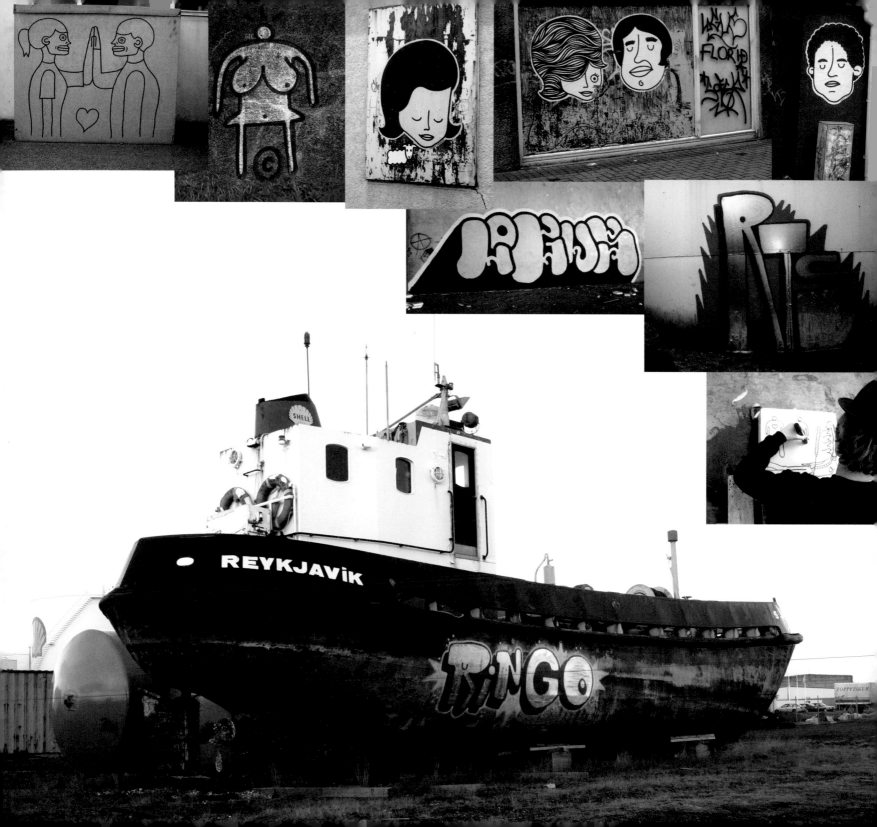

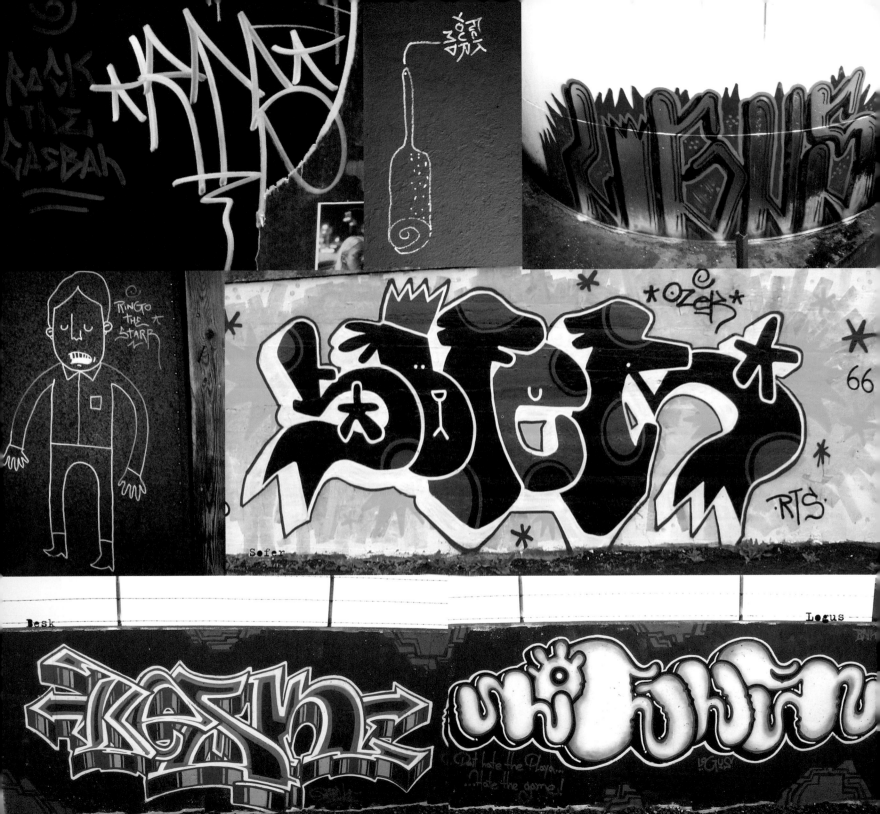

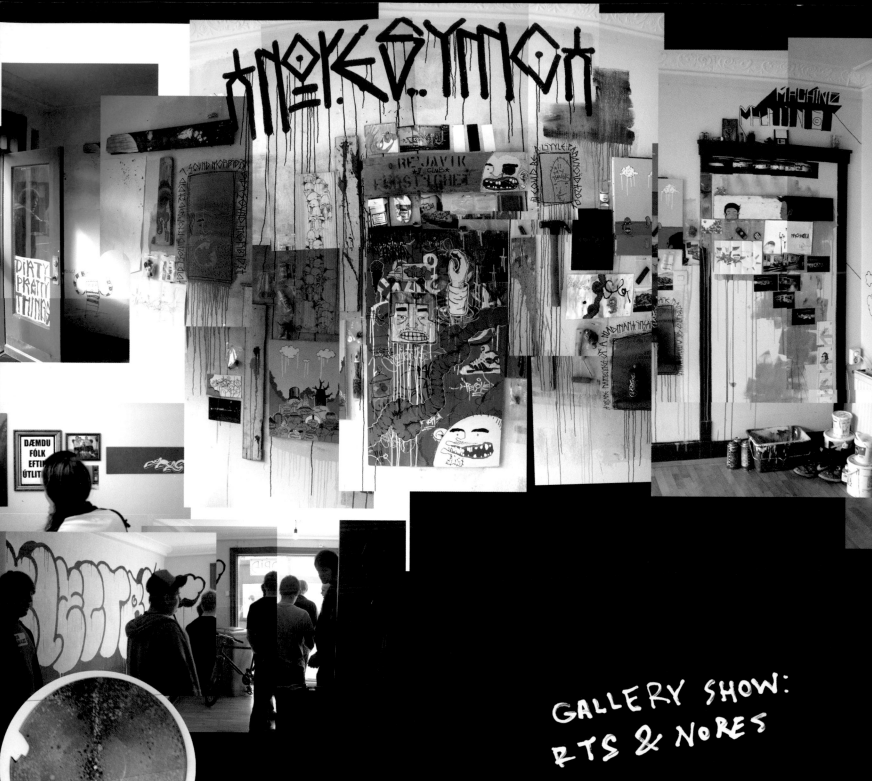

GALLERY SHOW:
RTS & NORES

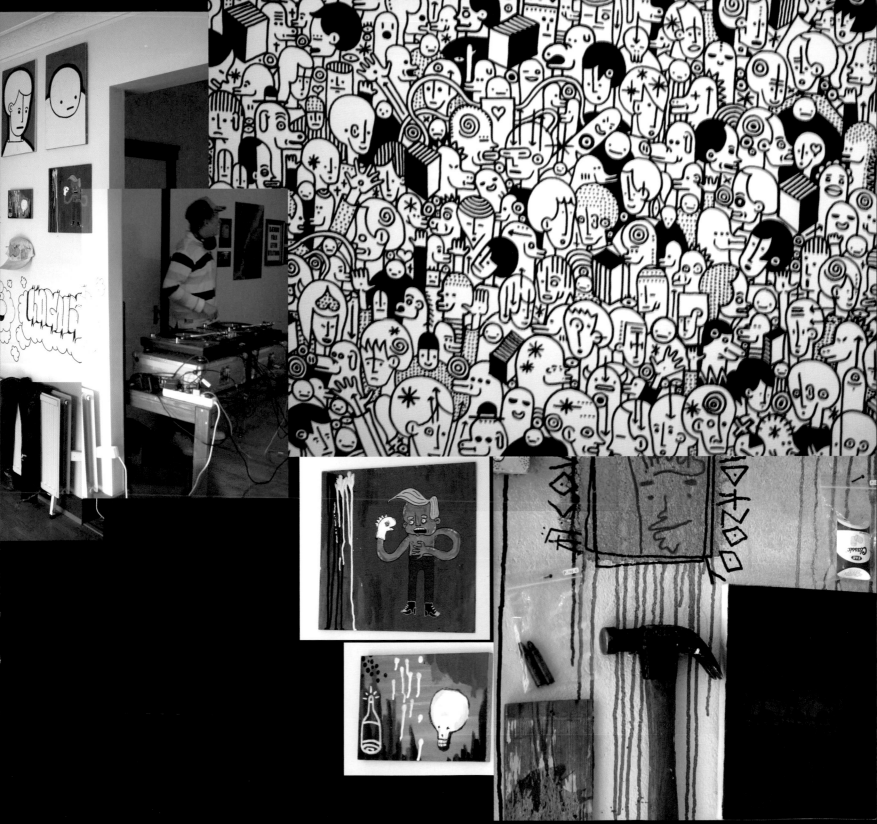

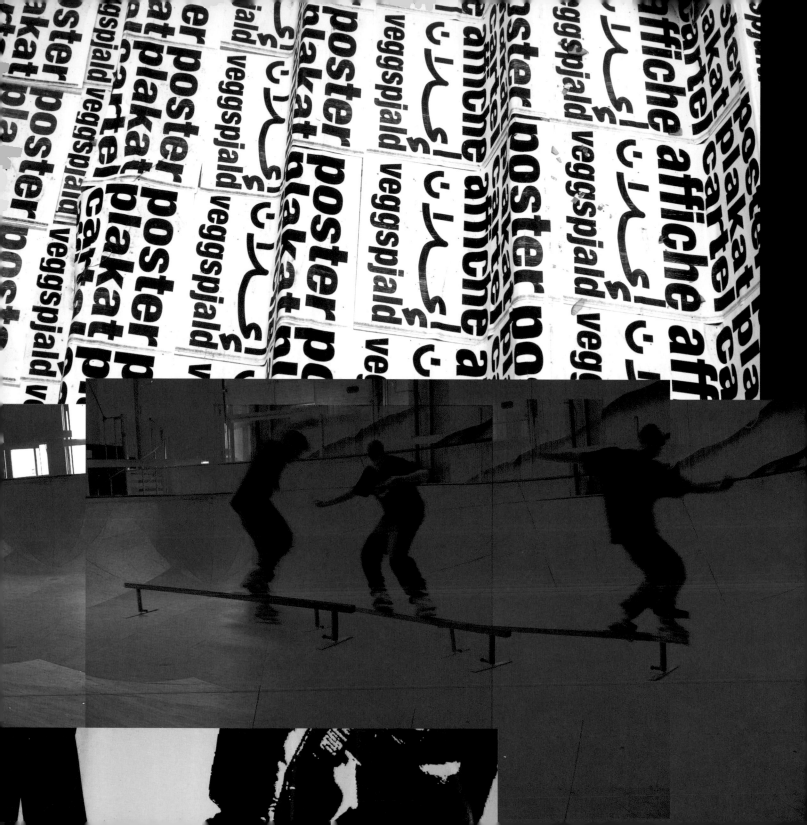

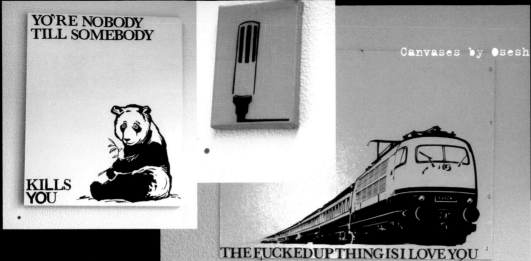
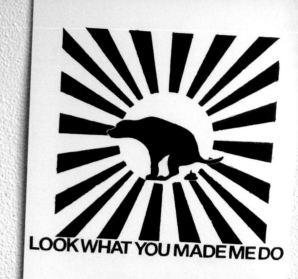
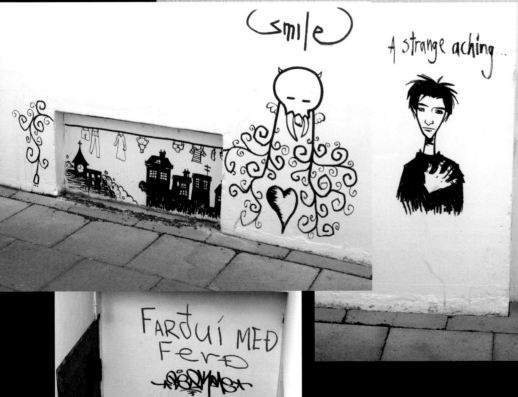
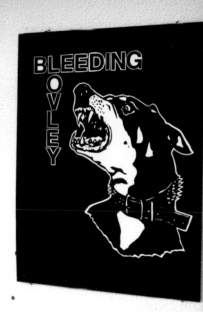
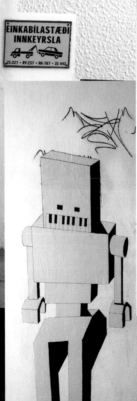

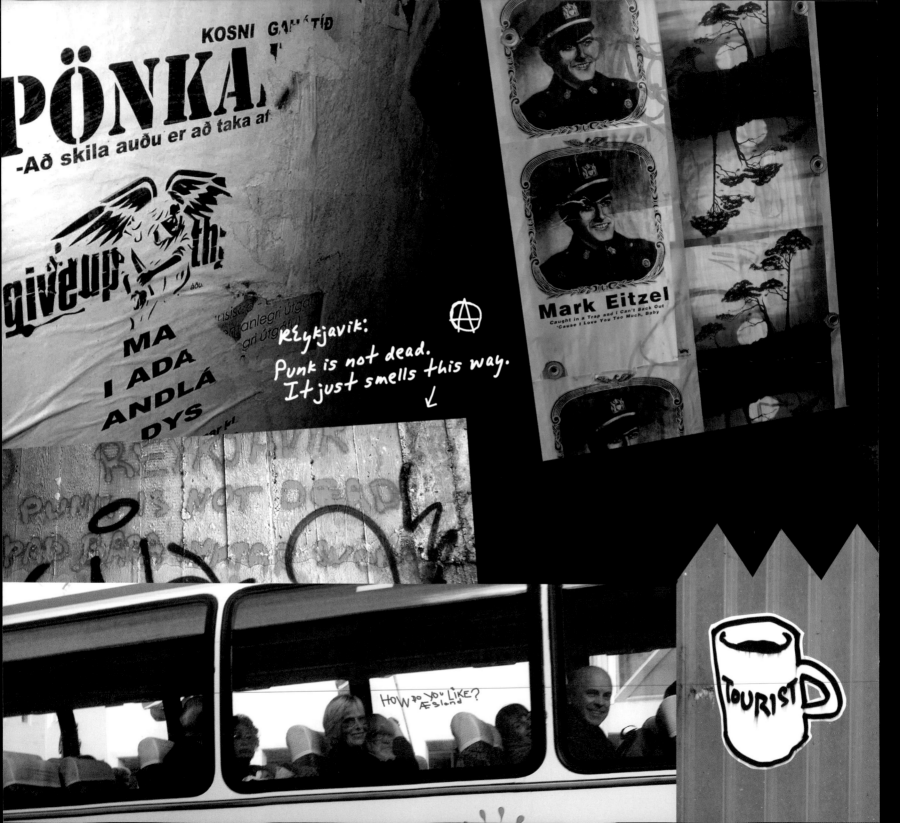

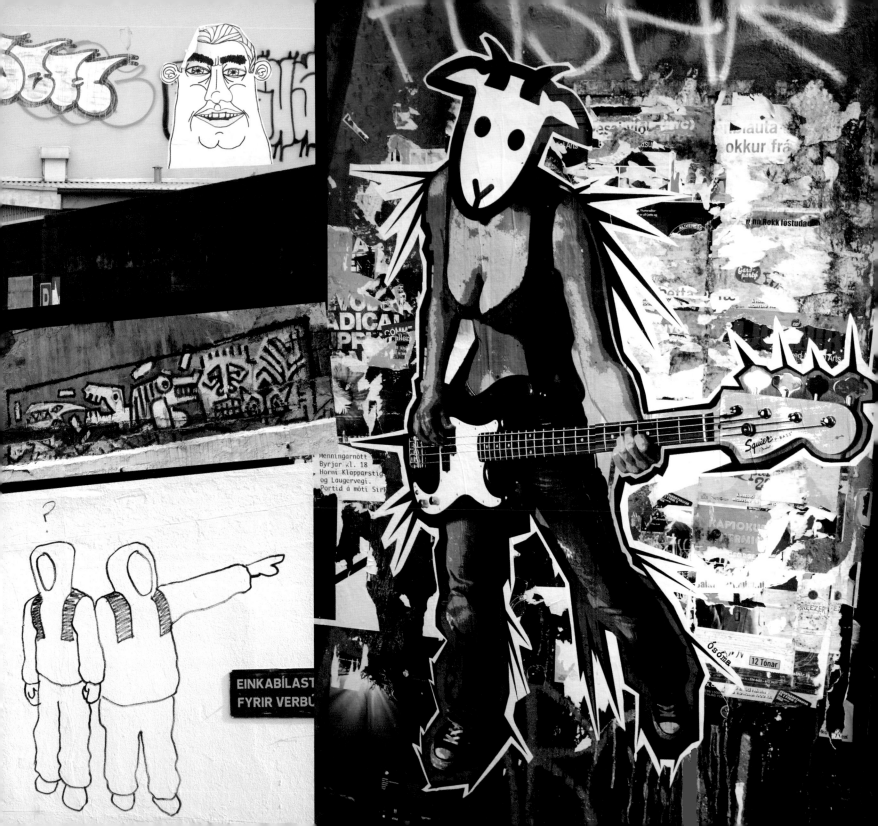

Nafn mitt er

OSESH

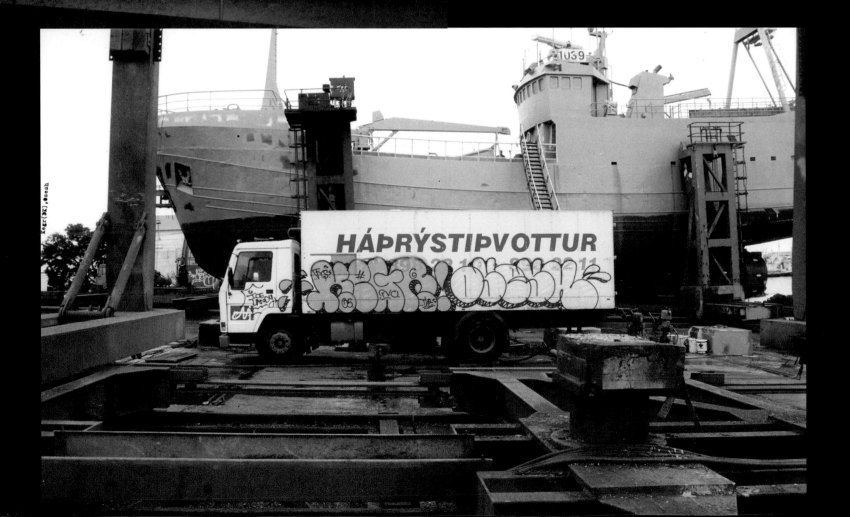

HÁÞRÝSTIÞVOTTUR

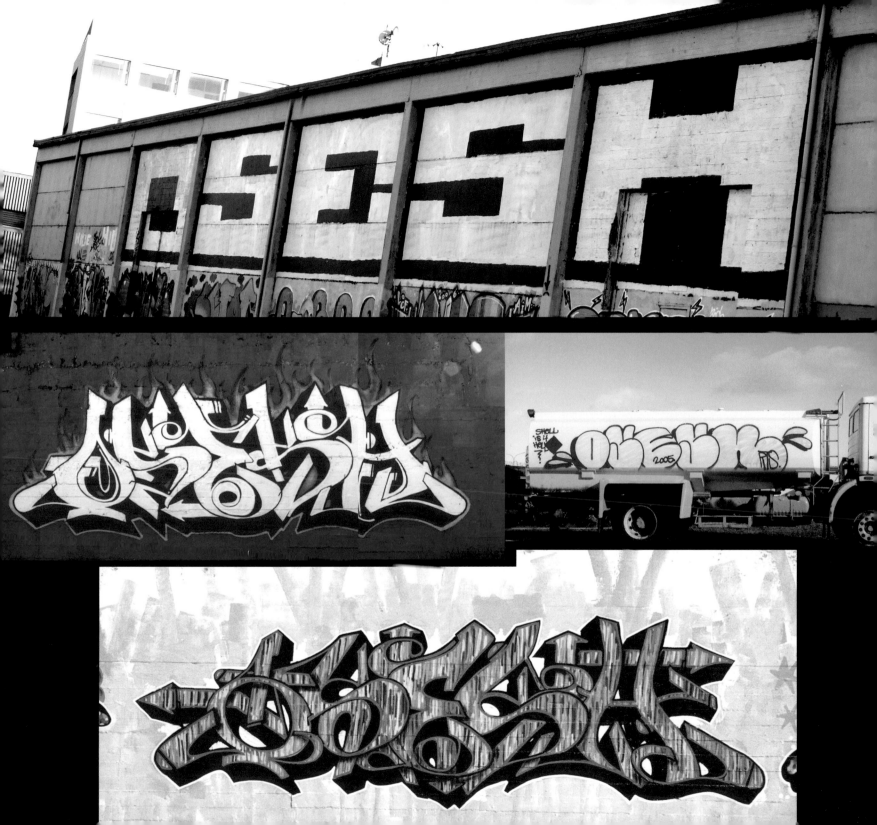

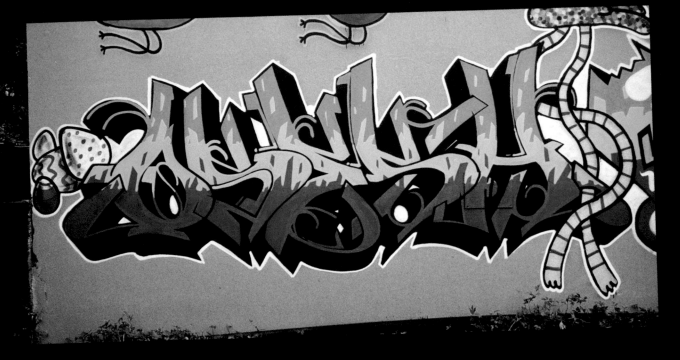

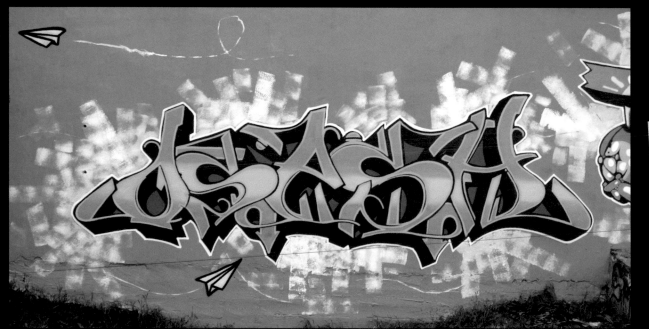

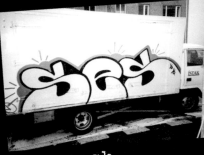

osesh

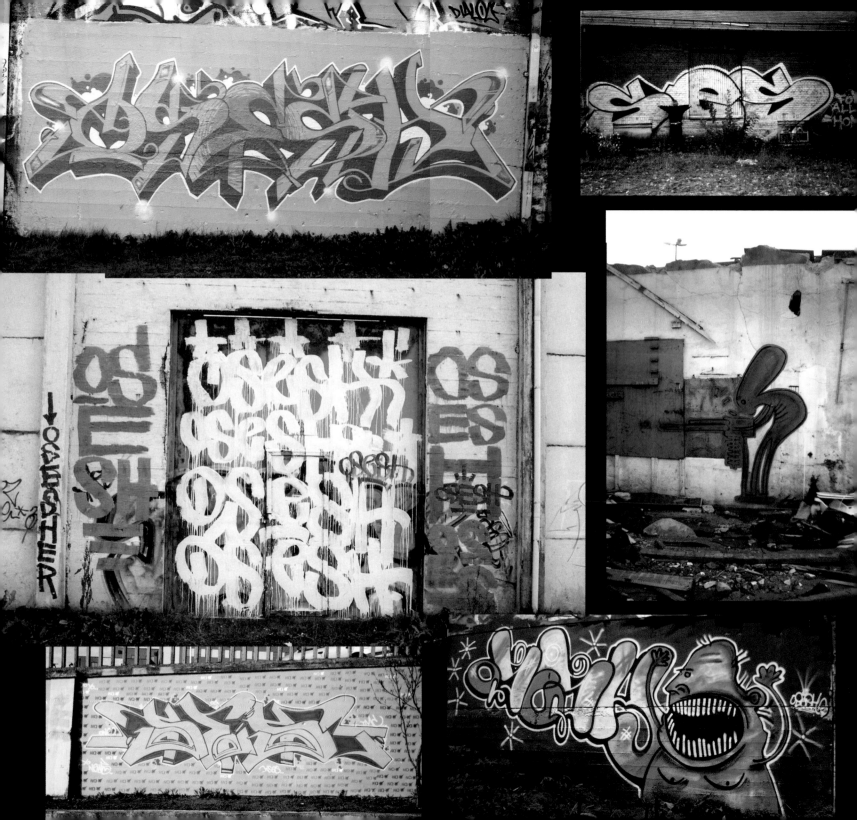

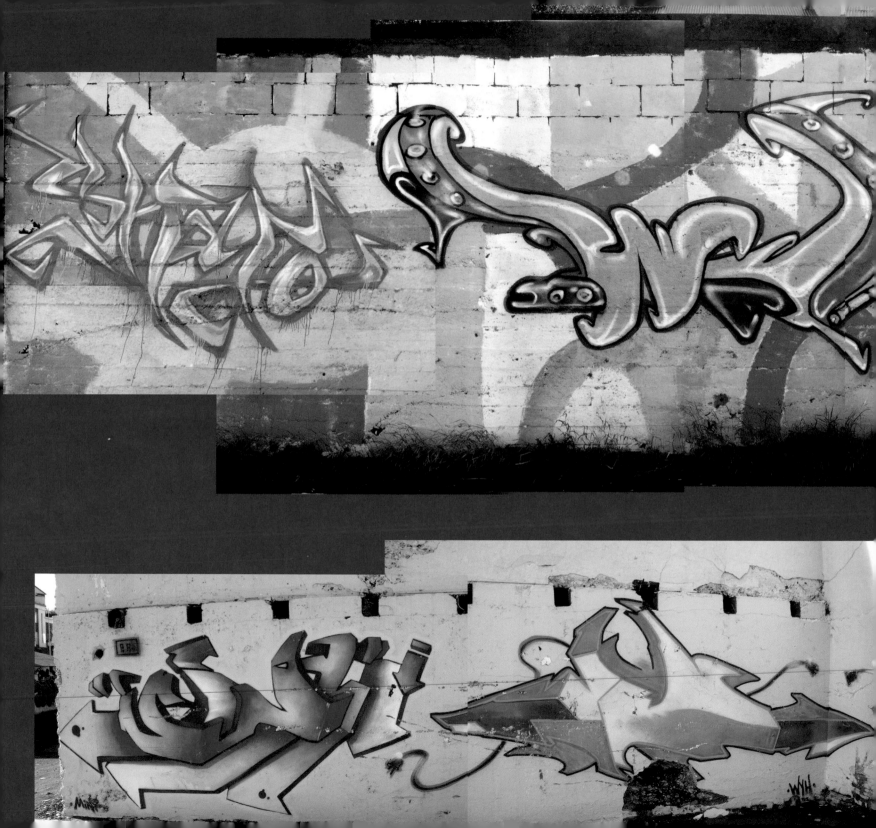

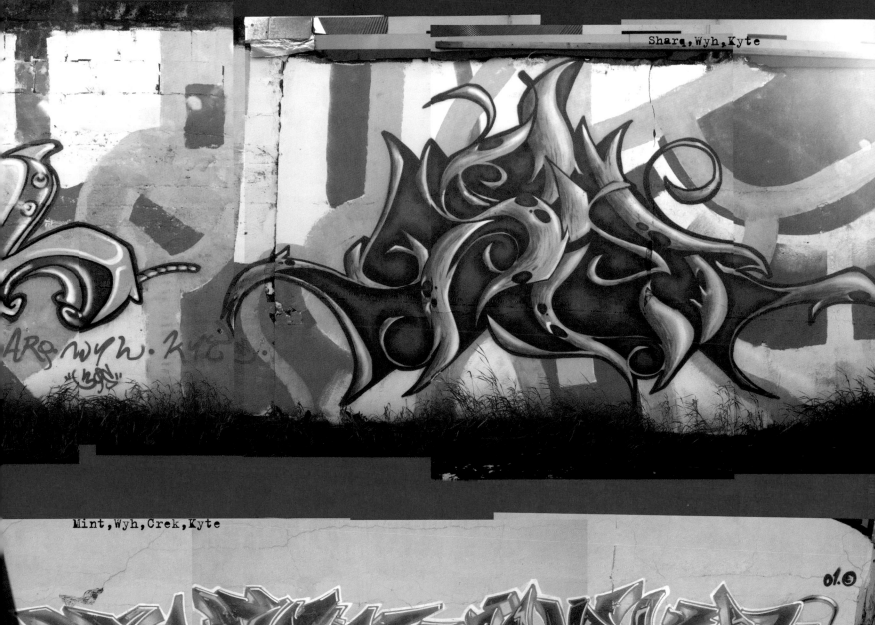

Mint,Wyh,Crek,Kyte

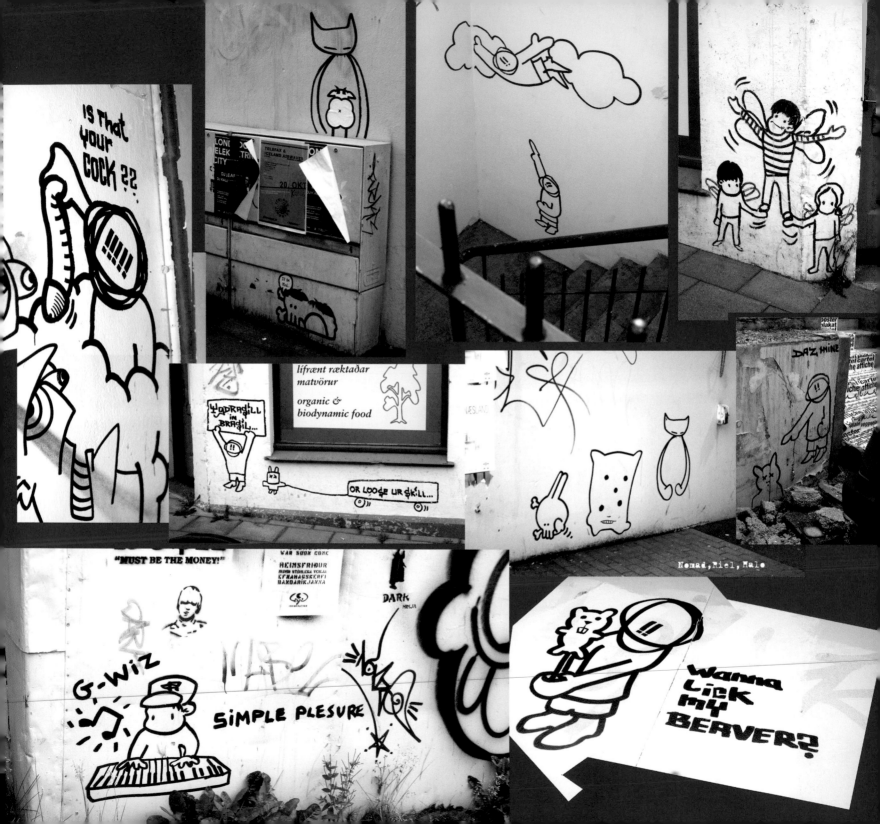

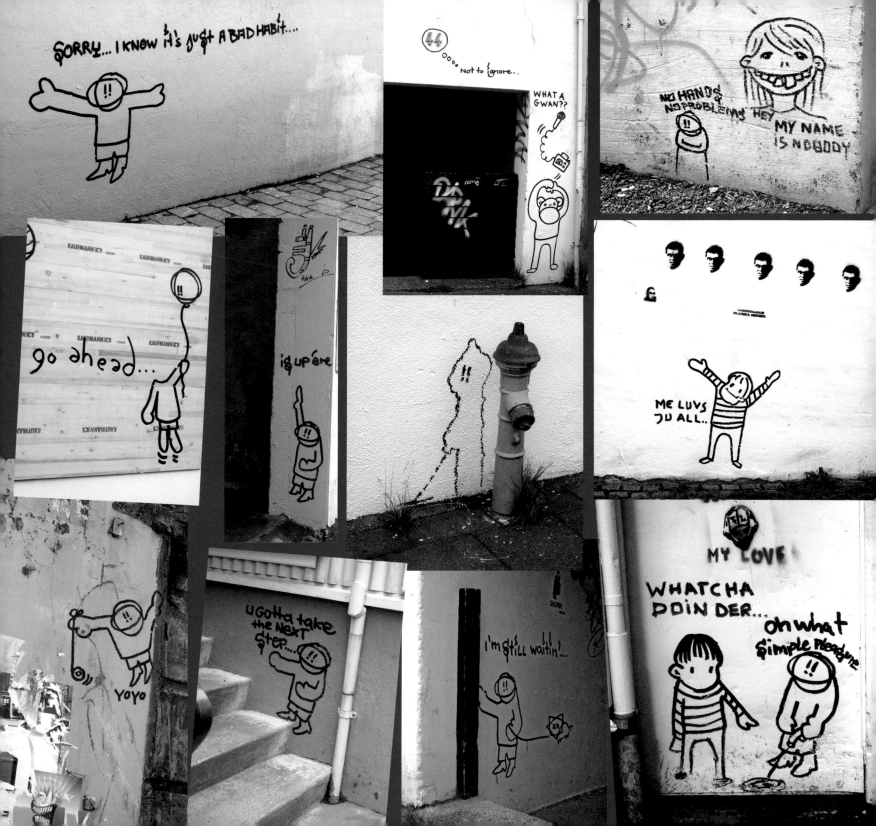

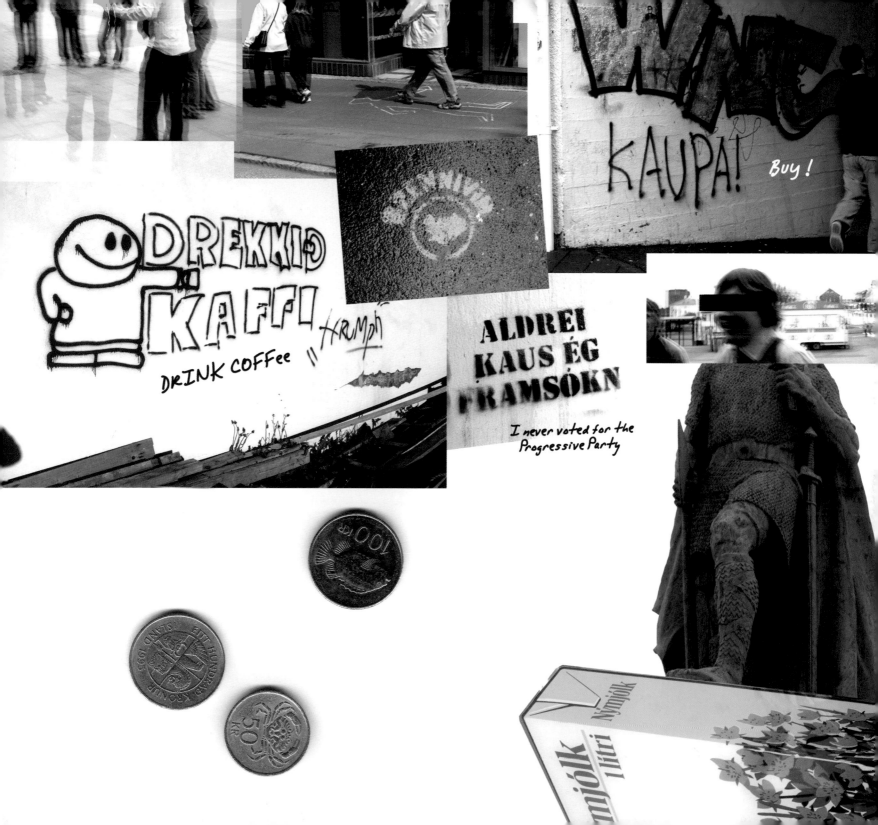

DREKKIÐ KAFFI

Xrumph

DRINK COFFEE

KAUPA!

Buy !

ALDREI
KAUS ÉG
FRAMSÓKN

I never voted for the
Progressive Party

Dear Mr Prime Minister. (David Oddsson, Iceland's ex-Prime Minister)
Our country is so very lucky to have you. You bring us ongoing good fortune.
You've created the perfect tax system. You've created a flawless salary system
and you care so much for the lowest paid and the invalids.
Our health system is top notch and in foreign affairs you govern
on a principle of justice instead of letting self interest rule.
You most certainly give this nation good reason to continue voting for you.
X-D: vote for extending this dream.

KÆRI FORSÆTISRÁÐHERRA

ÞJÓÐIN ER SVO HEPPIN AÐ HAFA ÞIG.
ÞÚ FÆRIR OKKUR ENDALAUST GÓÐÆRI.
ÞÚ SKAPAR FULLKOMIÐ SKATTKERFI.
ÓAÐFINNANLEGT LAUNAKERFI OG LÆTUR
ÞÉR ANNT UM LÁGLAUNAFÓLK OG
ÖRYRKJA. HEILBRIGÐISKERFIÐ ER TIL
FYRIRMYNDAR OG Í UTANRÍKISMÁLUM
LÆTUR ÞÚ RÉTTLÆTISKENND RÁÐA Í
STAÐ HAGSMUNASTEFNU. ÞÚ GEFUR
ÞJÓÐINNI SVO SANNARLEGA ÁSTÆÐU
TIL AÐ HALDA ÁFRAM AÐ KJÓSA ÞIG.
X-D FYRIR DRAUMINN

PouPou

eye INFORMATION

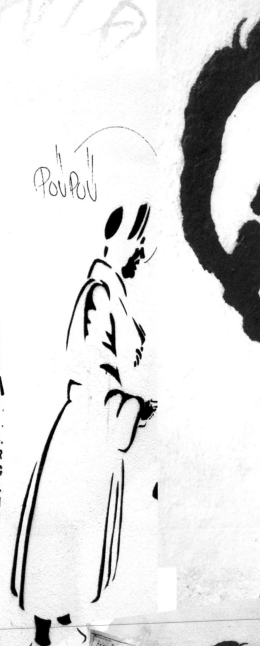

David is lying

DAVÍ LÝGU

TIL AÐ HAL

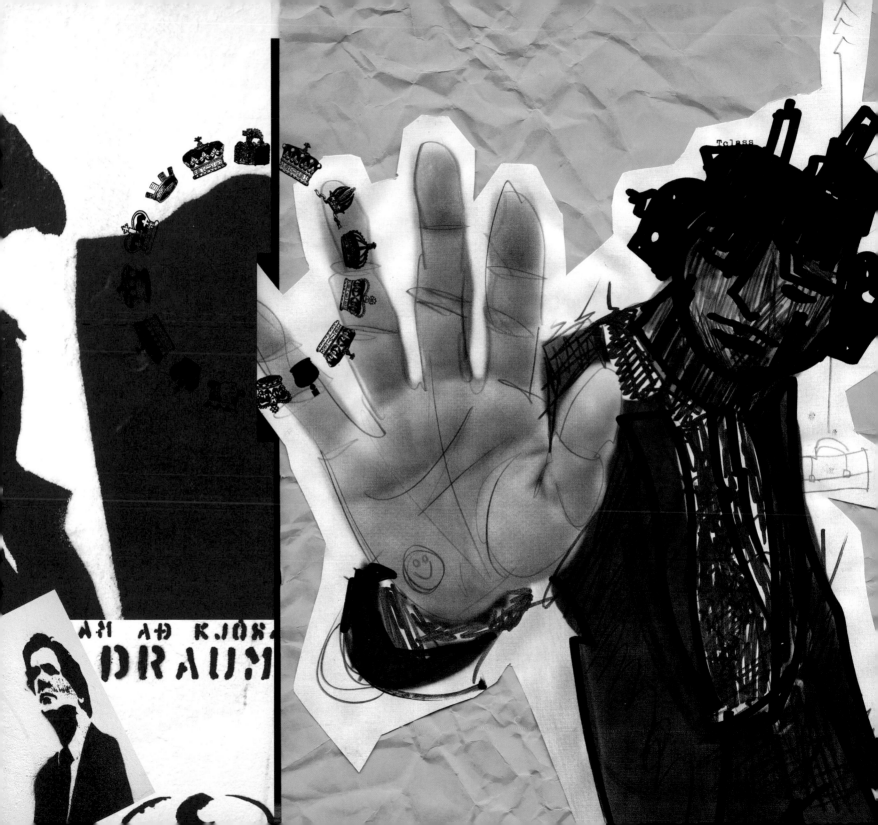

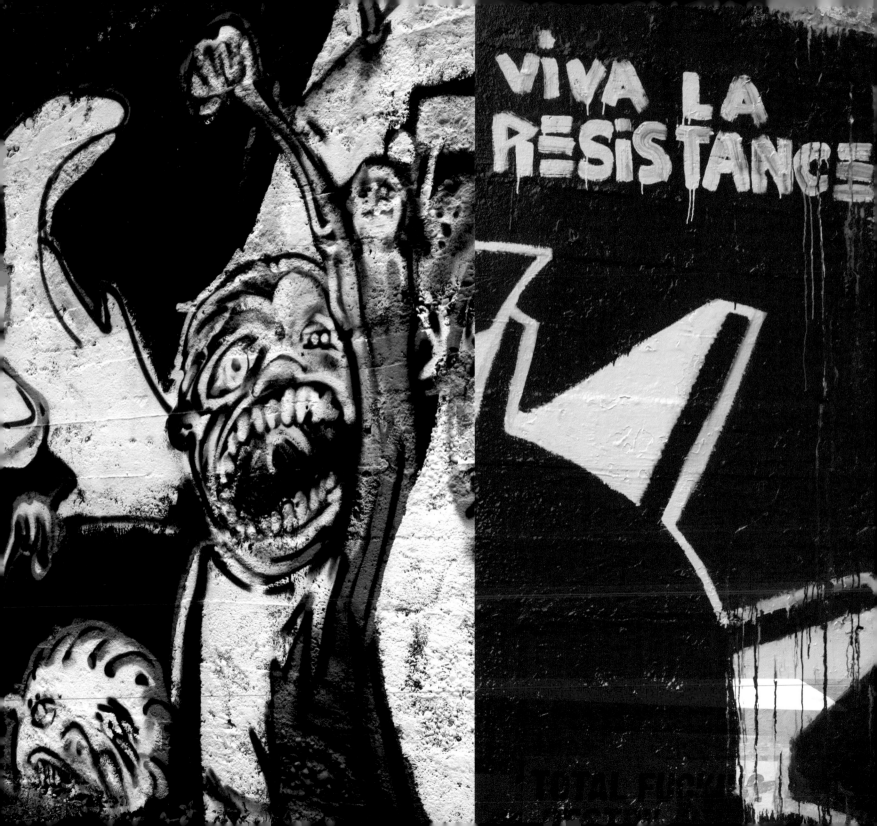

VIVA LA
RESISTANCE

SAY YOU
WANT
A
REVOLUTION

REVOLUTION
IS THE
OPIATE
OF
INTELECTUALS

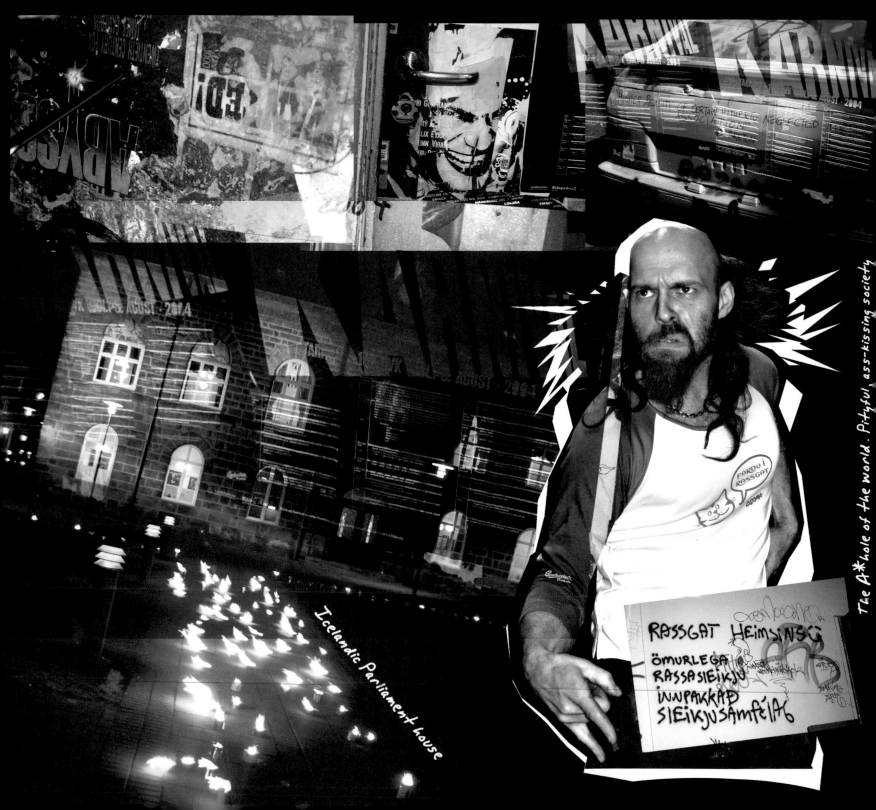

The A*hole of the world. Pityful, ass-kissing society

Icelandic Parliament house

RASSGAT HEIMSINSG
ÖMURLEGA
RASSASlEiKjU
iNNPAKKAÐ
SlEikjusAmfélAg

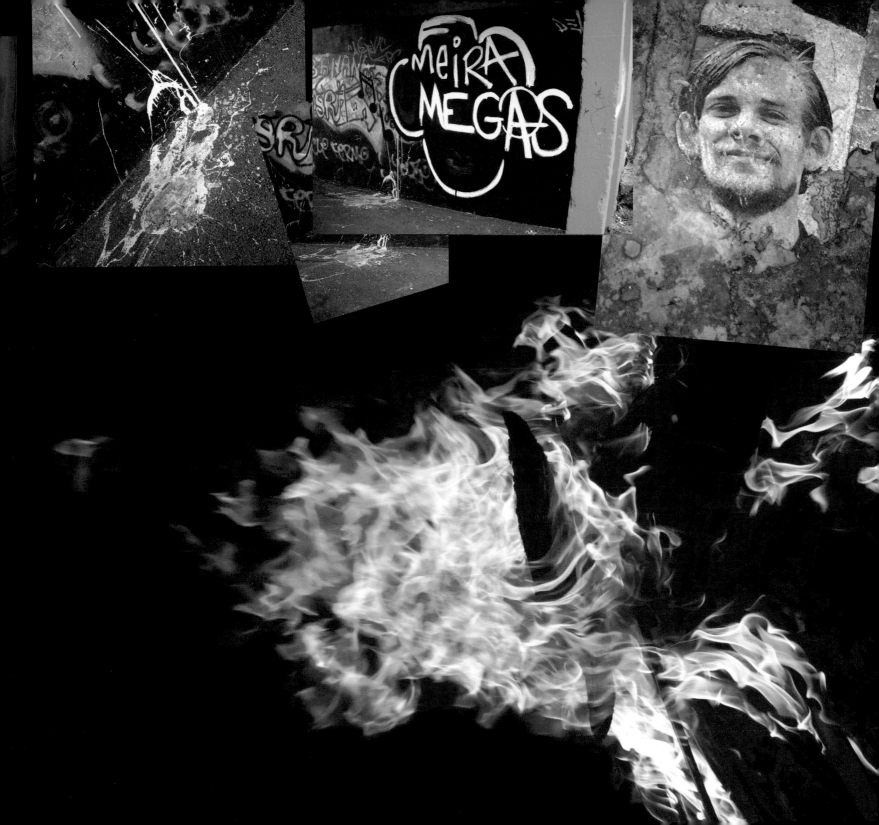

ÁFRAM ÍSLAND ÁFRAM ÍSLAND ÁFRAM ÍSLAND

Go Iceland!

X-D FYRIR DAUÐANN

X-D FYRIR DOLLAR

X-D for Dollars

INFORMATION

SVONA 'A AÐGERA HLUTINA!

That's the way to do it!

Icelanders found the Chemical weapons

SVEINN HERMANNSSON
ÁRNI JÓHNSEN
STURLA BOÐVARSSON / FRIÐRIK
VILHJALMUR VILHJÁLMSSON
ALFR EÐ ÞORS TEINSSON
GUÐVERÐUR A. STEFÁNSSON
JÓN BALDVIN HANNIBALDSSON
MAGNÚS THORODDSEN
GUÐMUNDUR MAGNÚSSON

Banana Republic!

ISLENDINGAR
FINNA EFNAVOPN

*Agent of the
Icelandic Army*

UMBODSMADUR
ISLENSKA HERSINS

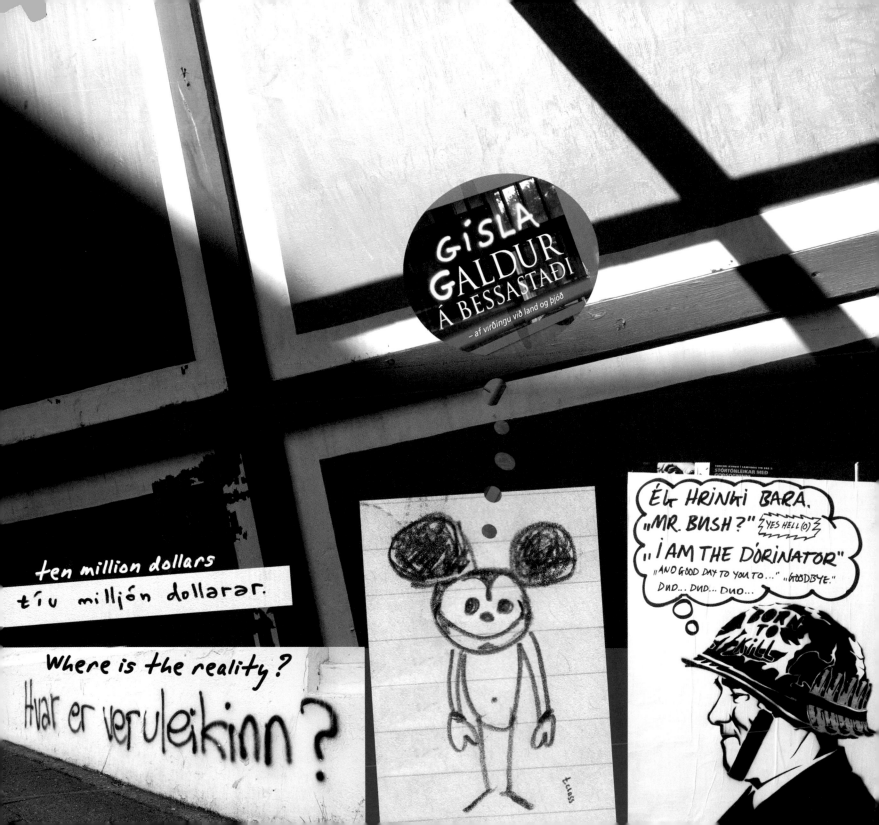

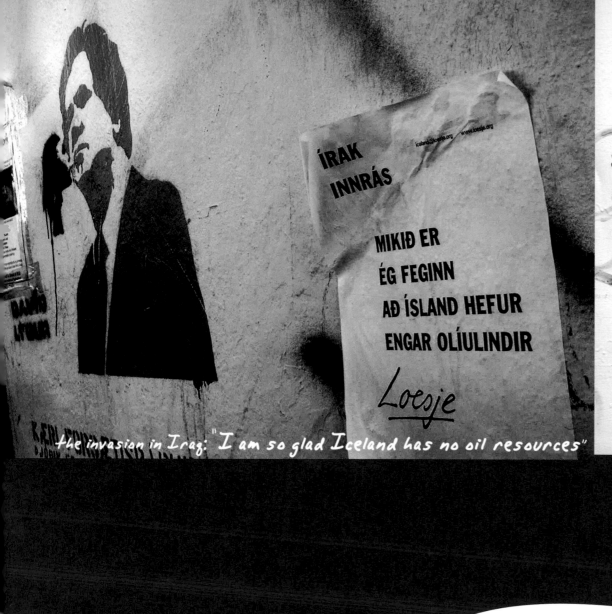

ÍRAK
INNRÁS

icelend@loesje.org www.loesje.org

MIKIÐ ER
ÉG FEGINN
AÐ ÍSLAND HEFUR
ENGAR OLÍULINDIR

Loesje

the invasion in Iraq: "I am so glad Iceland has no oil resources"

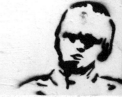

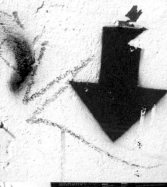

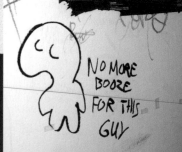

NO MORE
BOOZE
FOR THIS
GUY

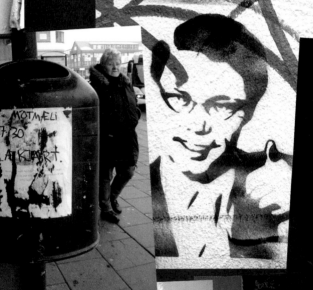
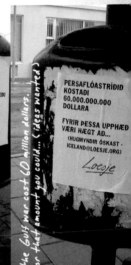

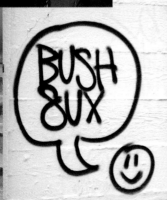

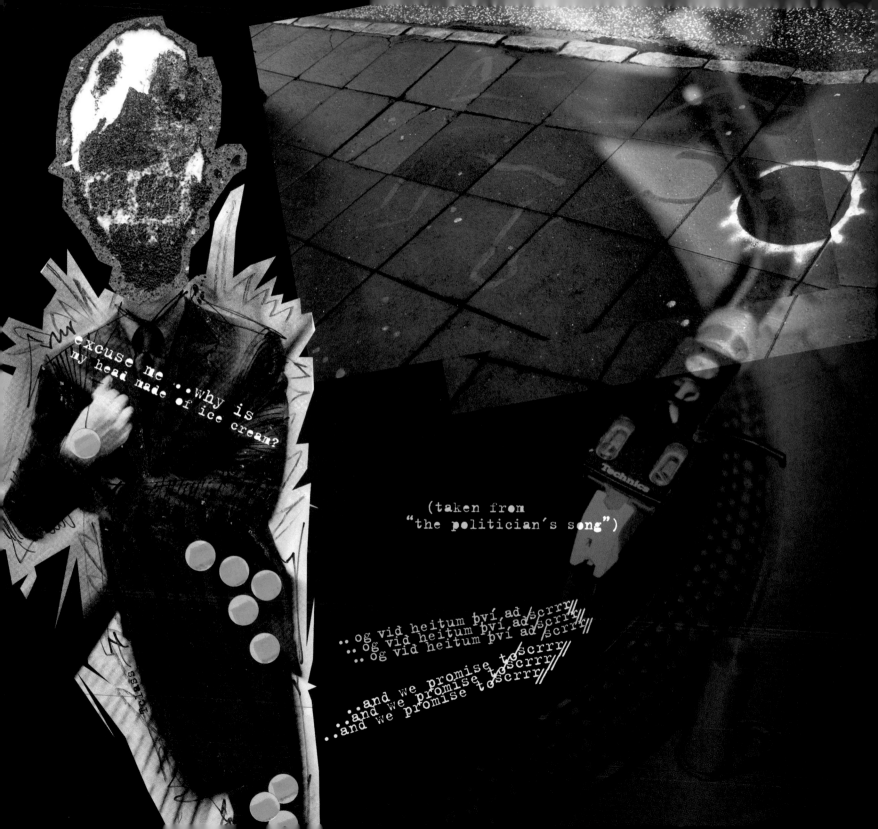

excuse me ..• why is
my head made of ice cream?

(taken from
"the politician's song")

.:• og við heitum því að scrrr
.:• og við heitum því að scrrr
.:• og við heitum því að scrrr

...and we promise toscrrr
...and we promise toscrrr
...and we promise toscrrr

llvirkjun

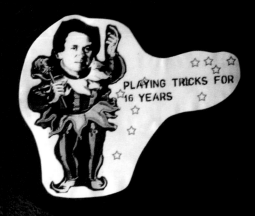

PLAYING TRICKS FOR 16 YEARS

twist and shout

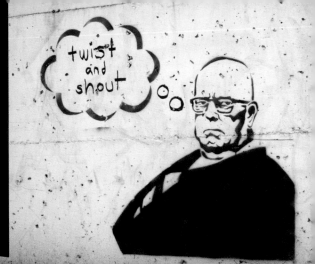

David Oddson (ex Prime Minister)

DREKKJUM VALGERDI EN EKKI ISLANDI

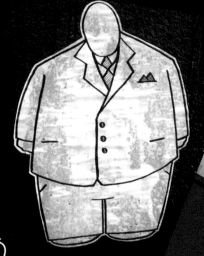

↑

"Let's drown the Minister of Industry, not our country." (on plans on building Power Plants)

Vorhátíð Listaháskó...

Listaháskólans 2003

WASH YOUR WOES AWAY

NIDUR MEÐ DAVÍÐ

CAPITALISM IS AFRAID OF LOVE

REGGÍA ROKK

Down with David.. (ex Prime Minister)

X-D for "Death"

X-D FYRIR DAUÐANN

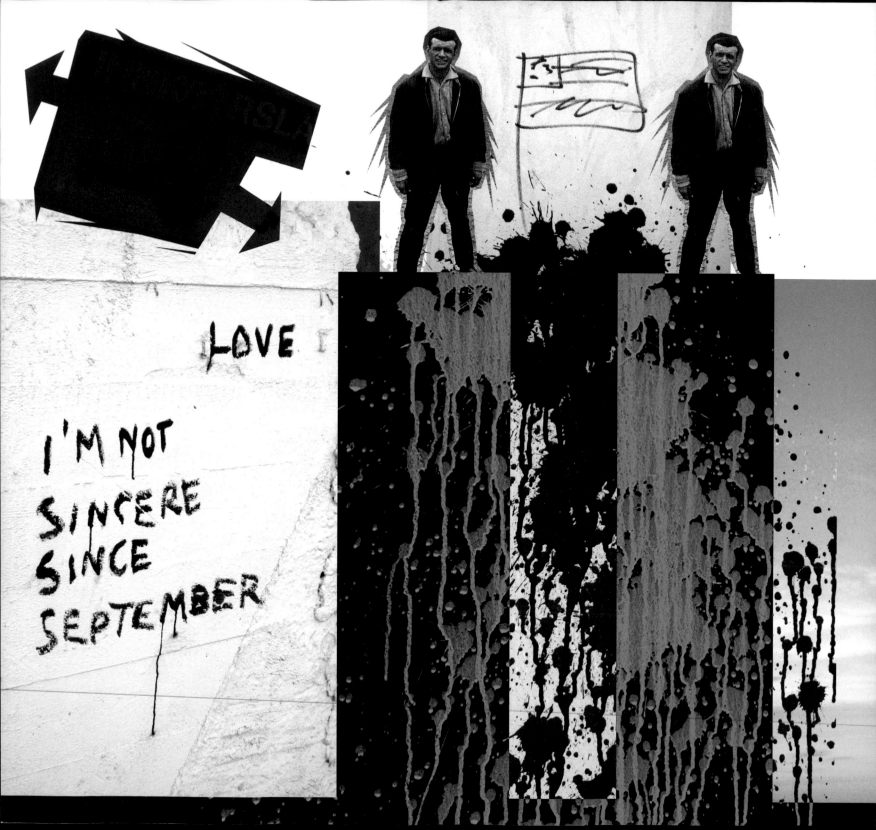

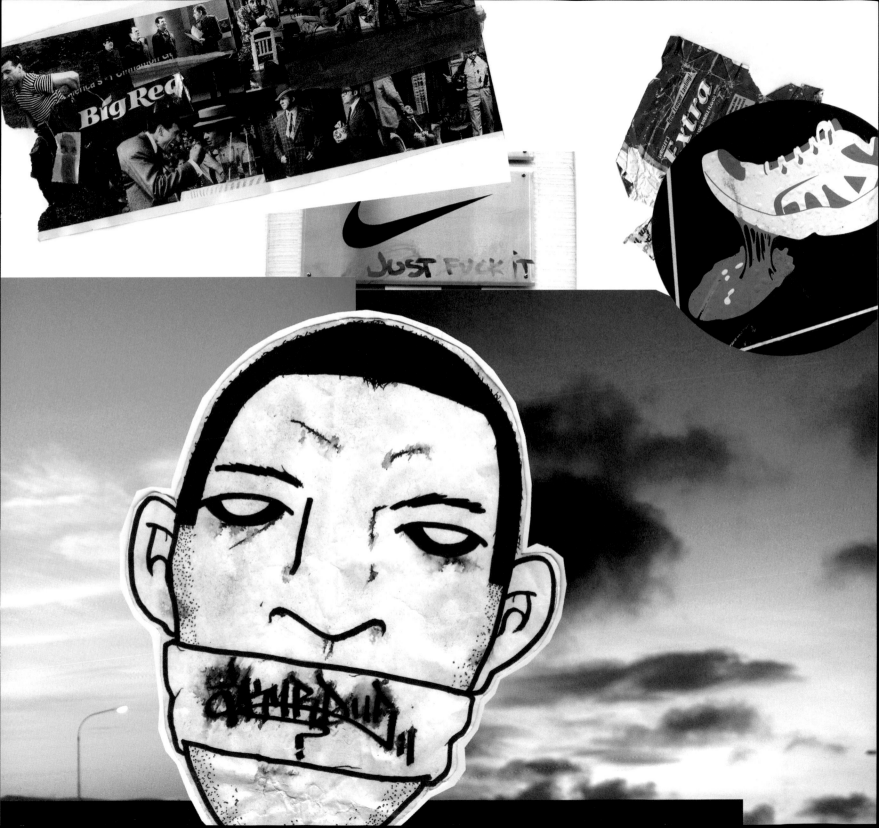

DESTROY
EVILNESS
EMBRACE
HAPPINESS

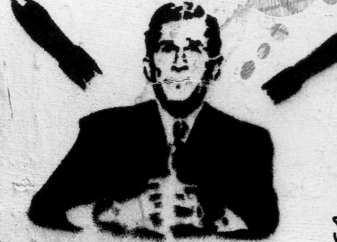

! LOOKOUT !
WAR SOON COME.

HEIMSFRIÐUR
MUNDI STÓRLEGA VEIKJA
EFNAHAGSKERFI
BANDARIKJANNA

World peace would weaken the USA
Economical base enormously.

eye
INFORMATION

MÓTMÆ
17:30
LÆKJAR-
TORG-I

Not in our name !

EKKI I OKKAR NAFNI

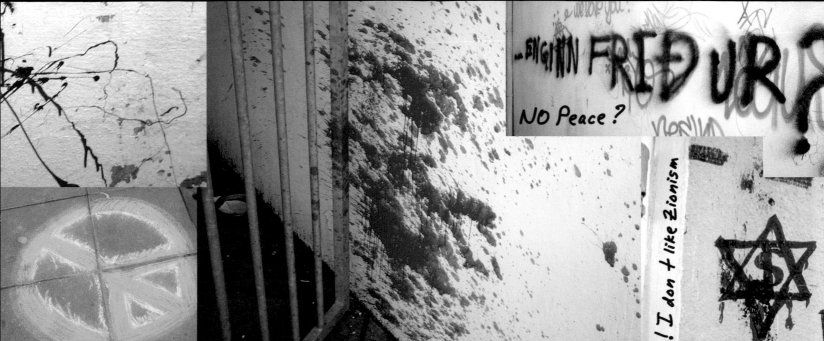

...ENGINN FRIÐUR?!

NO Peace ?

Mr. David Oddson! I don t like Zionism

David Oddsson!
MÉR LÍKAR EKKI
ZIONISMI

This nation demands the governments active opposition agains the upcoming invasions of Iraq! 79% of the people are agains attacks

ÞJÓÐIN KREFST ÞESS
AÐ RÍKISSTJÓRNIN SÝNI
VIRKA ANDSTÖÐU
VIÐ FYRIRHUGAÐAR
ÁRÁSIR Á ÍRAK!
79% ÞJÓÐARINNAR ER MÓTFALLINN ÁRÁSUM Á ÍRAK

eye
INFORMATION

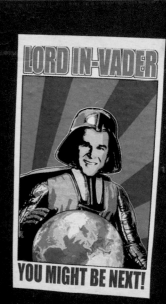

LORD IN-VADER

YOU MIGHT BE NEXT!

www.NIKEWAGES.ORG

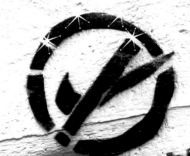

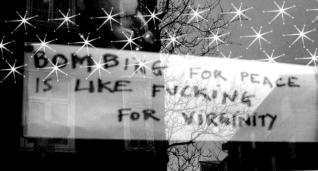

BOMBING FOR PEACE IS LIKE FUCKING FOR VIRGINITY

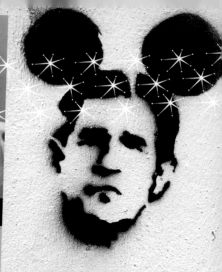

...UM EKKI BARNAPRÆLKUN

Don't support child labour

GIMP
↓

BIN LADEN WITH A BASOUKA COMIN A GET YA!

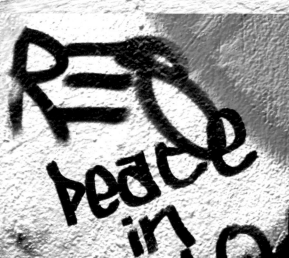

RED
peace in IRAQ

No VIOLENCE

Destuction

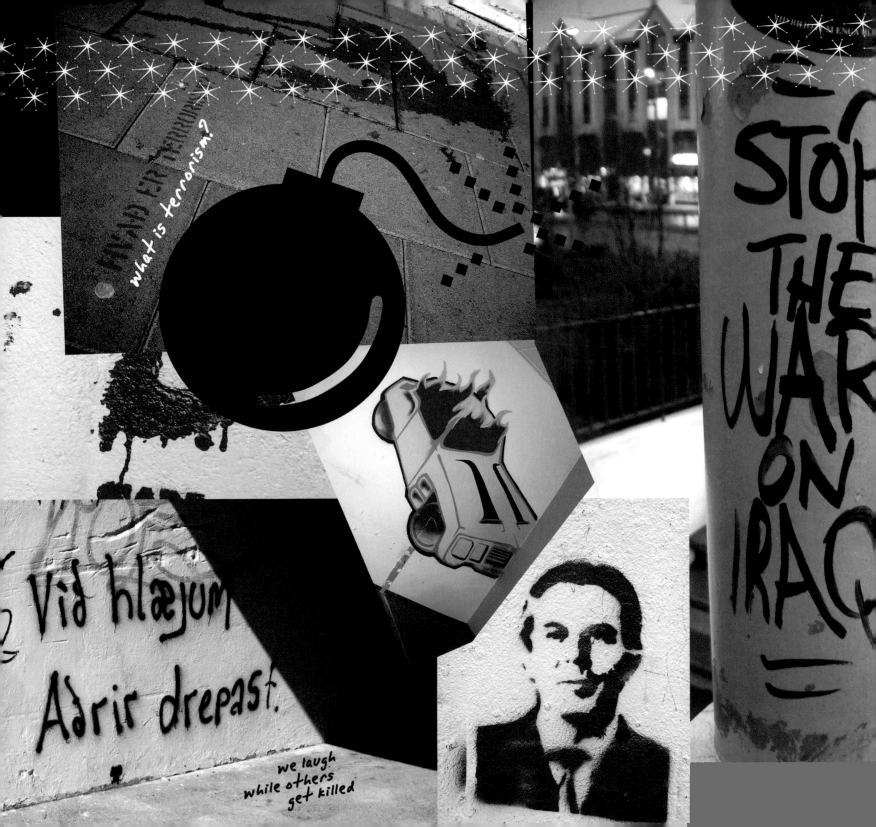

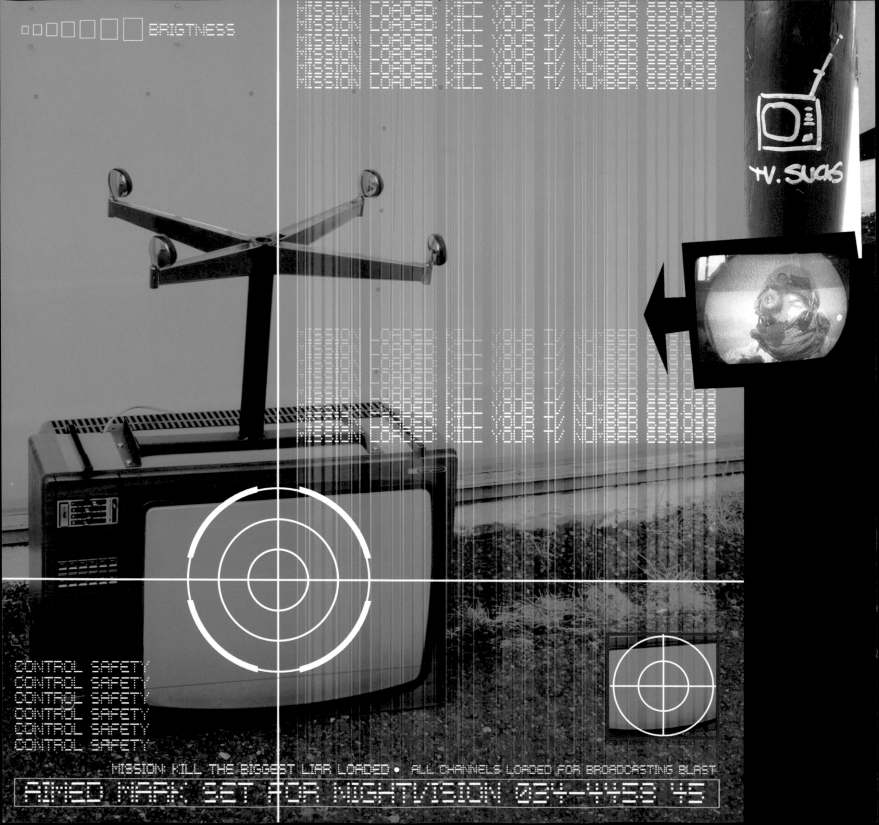

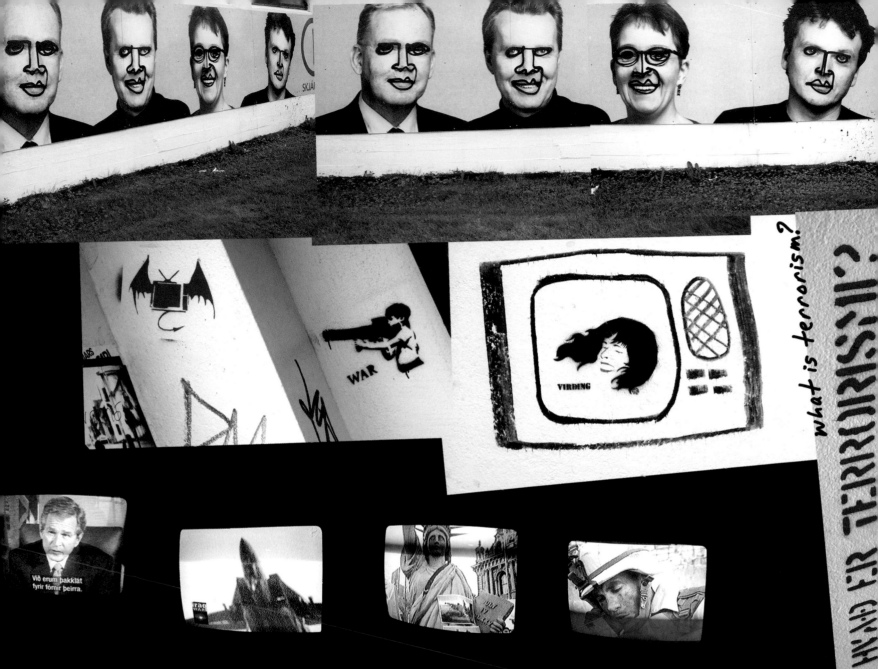

HVAÐ ER TERRORISMI?

what is terrorism?

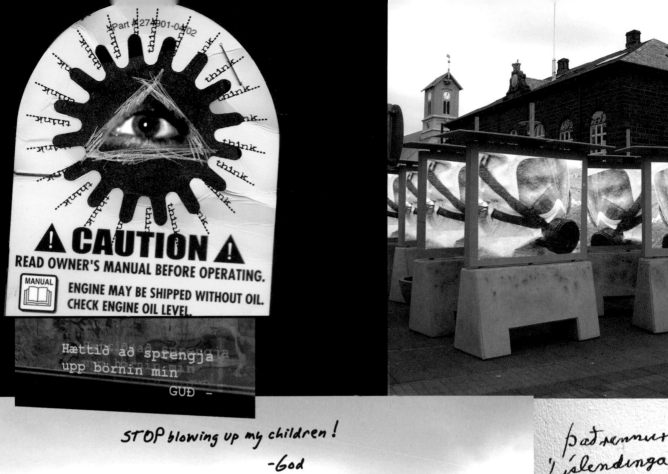

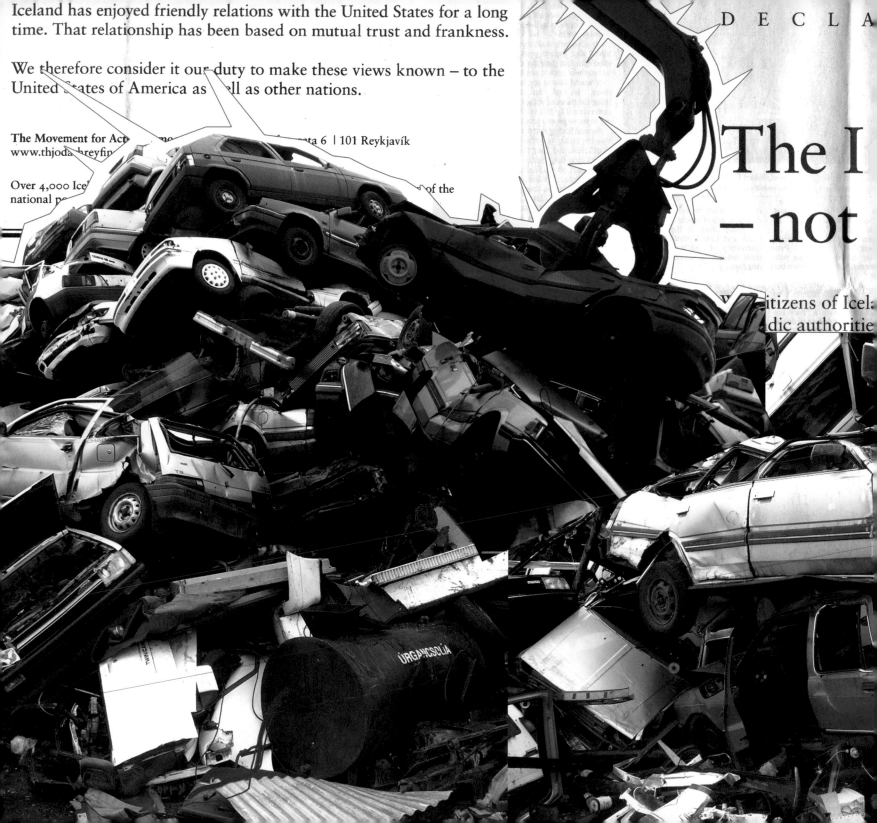

Iceland has enjoyed friendly relations with the United States for a long time. That relationship has been based on mutual trust and frankness.

We therefore consider it our duty to make these views known – to the United States of America as well as other nations.

The Movement for Act ... ta 6 | 101 Reykjavík
www.thjoda breyfin

Over 4,000 Icel ... of the
national pe

DECLA

The I
– not

itizens of Icel:
dic authoritie

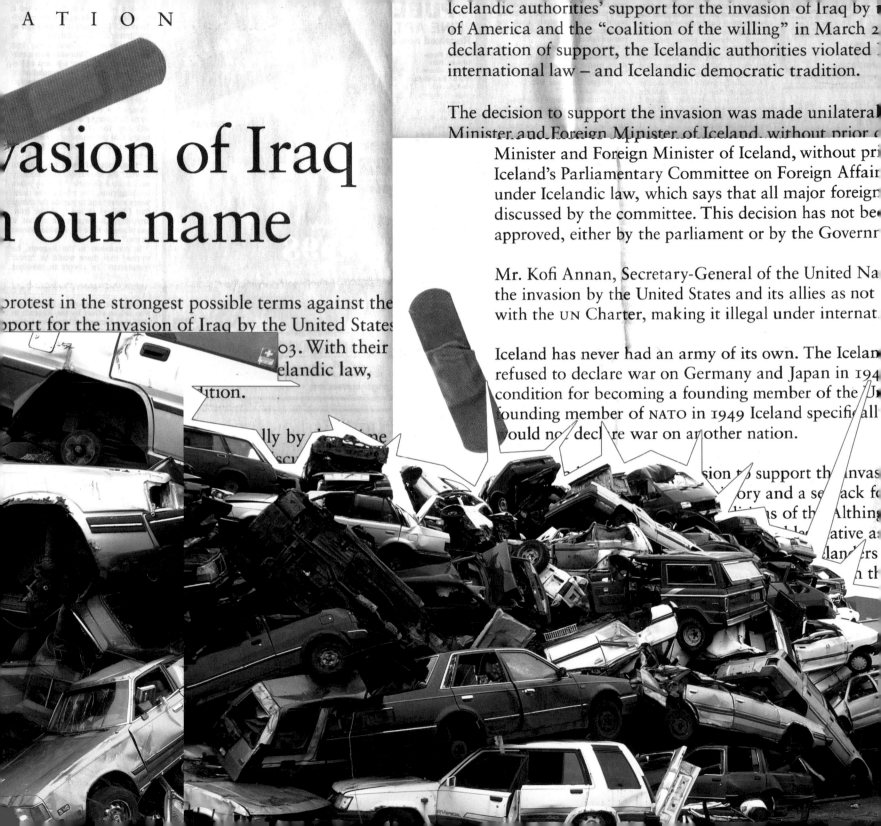

A T I O N

vasion of Iraq
n our name

protest in the strongest possible terms against the
pport for the invasion of Iraq by the United States
03. With their
elandic law,
ution.

lly by the time
sc

Icelandic authorities' support for the invasion of Iraq by
of America and the "coalition of the willing" in March 2
declaration of support, the Icelandic authorities violated
international law – and Icelandic democratic tradition.

The decision to support the invasion was made unilateral
Minister and Foreign Minister of Iceland, without prior
Iceland's Parliamentary Committee on Foreign Affair
under Icelandic law, which says that all major foreign
discussed by the committee. This decision has not bee
approved, either by the parliament or by the Governr

Mr. Kofi Annan, Secretary-General of the United Na
the invasion by the United States and its allies as not
with the UN Charter, making it illegal under internat

Iceland has never had an army of its own. The Icelan
refused to declare war on Germany and Japan in 194
condition for becoming a founding member of the U
founding member of NATO in 1949 Iceland specifi all
ould no decl re war on another nation.

sion to support th invas
ory and a se ack fo
s of th Althin
ative a
lan ers
th

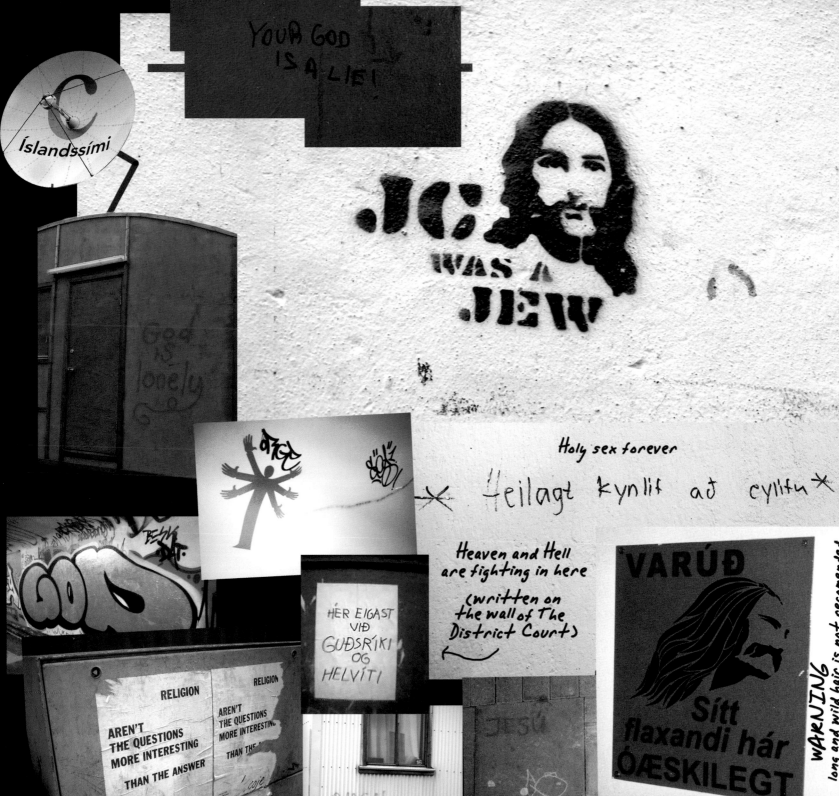

STOP DRIVING START WALKING!

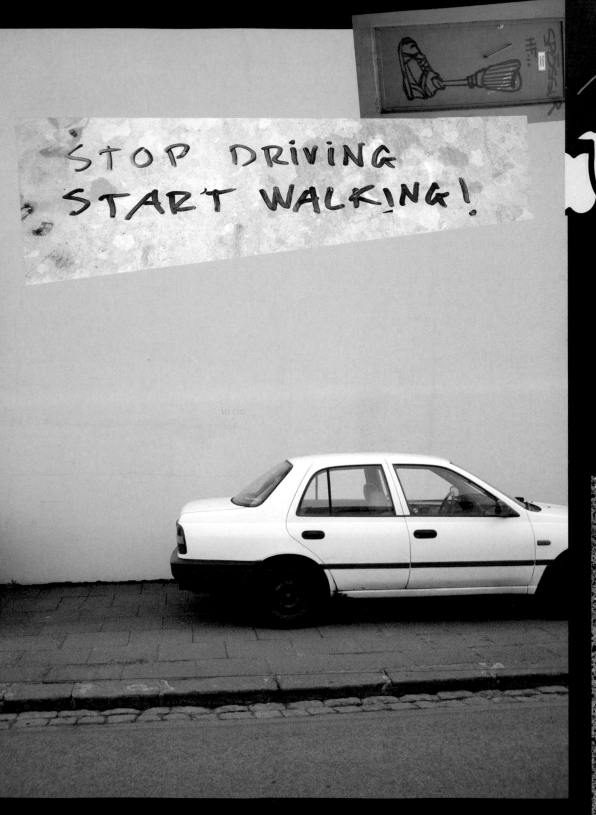

Halldór Ásgrímsson getur valdið hægfara og kvalafullum dauða

H.Á. (then Prime Minister) can cause slow and painful death

the Bird Flu is very dangerous to you and the ones near you

Fuglaflensa er mjög skaðleg fyrir þig og þá sem eru nálægt þér

Naive

Love is an addiction Dont start loving

Ást er mjög ávanabindandi, byrjaðu ekki að elska

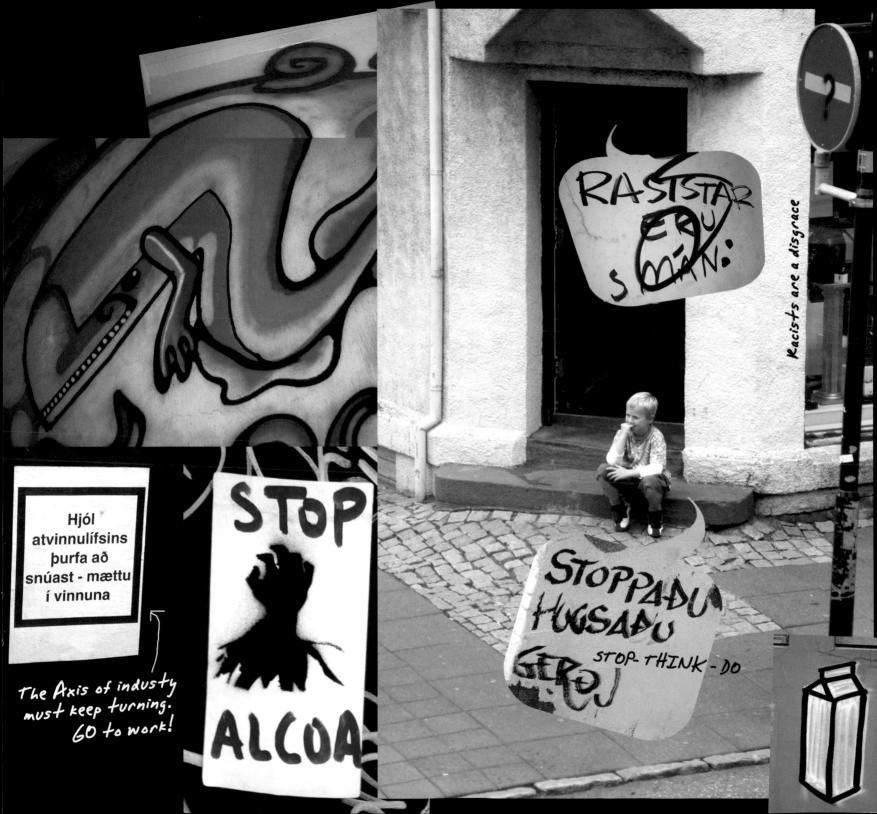

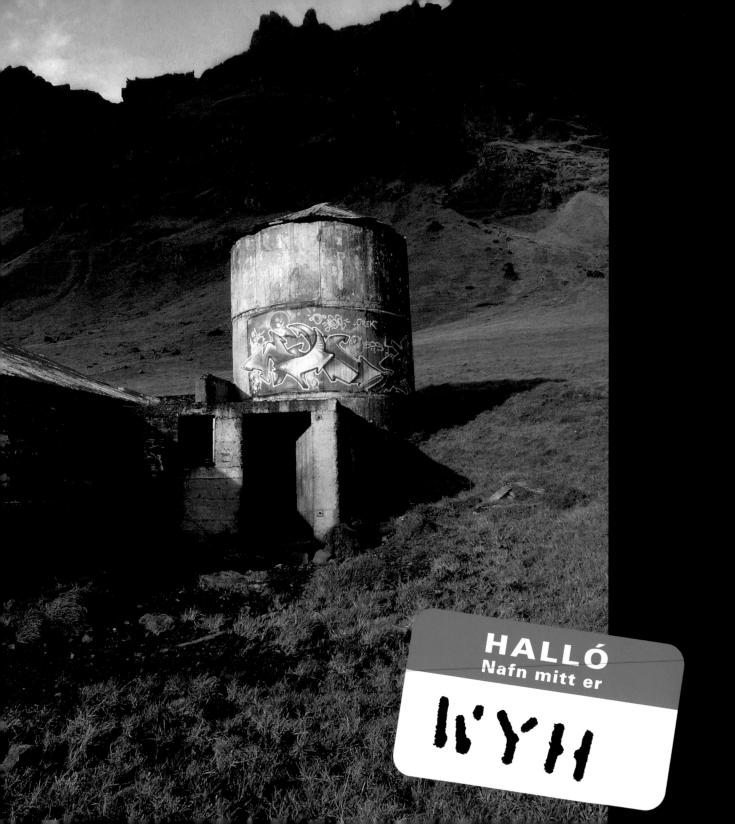

HALLÓ
Nafn mitt er

ÍYH

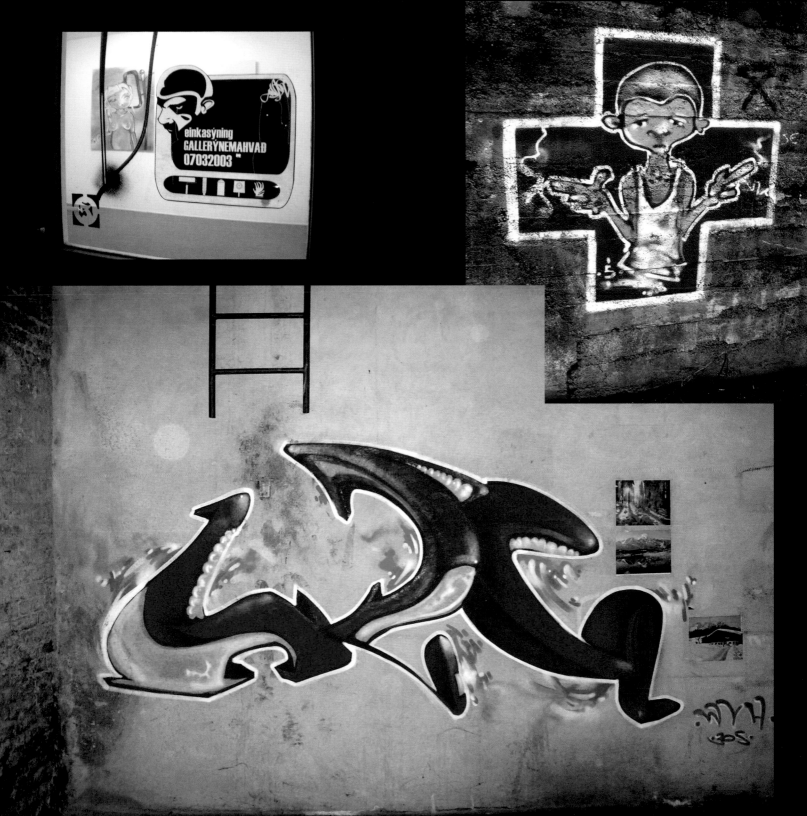

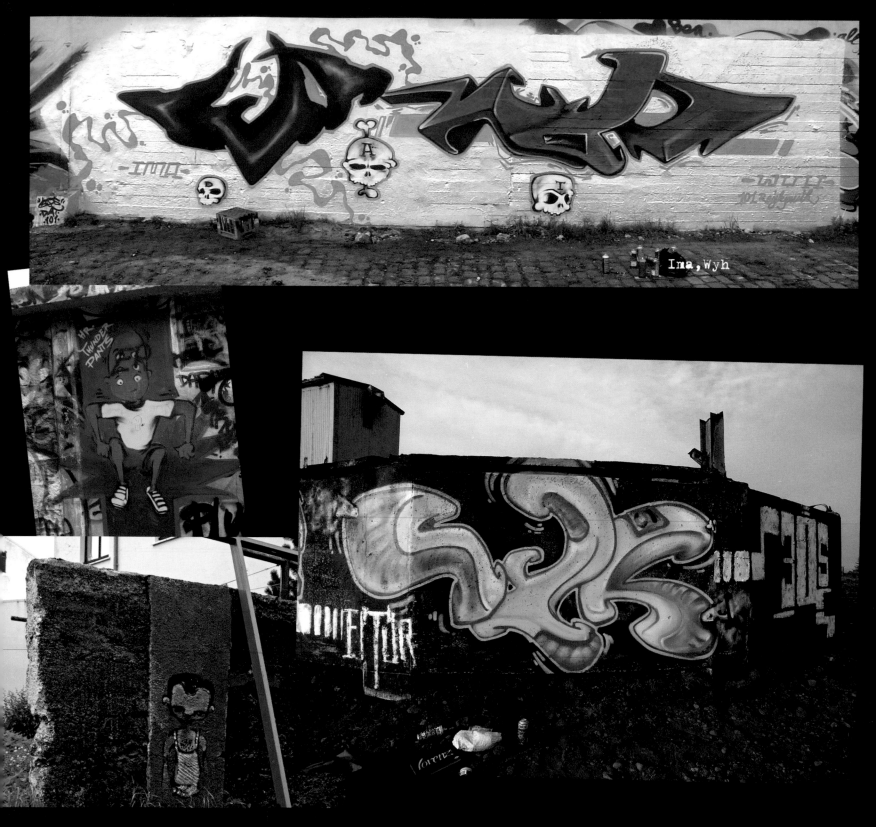

Ima,Wyh

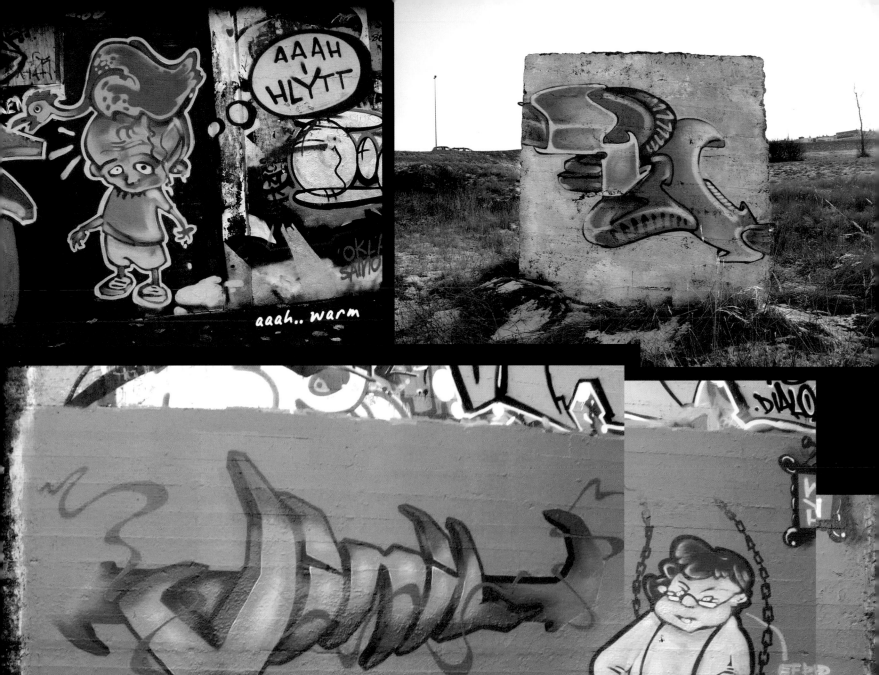

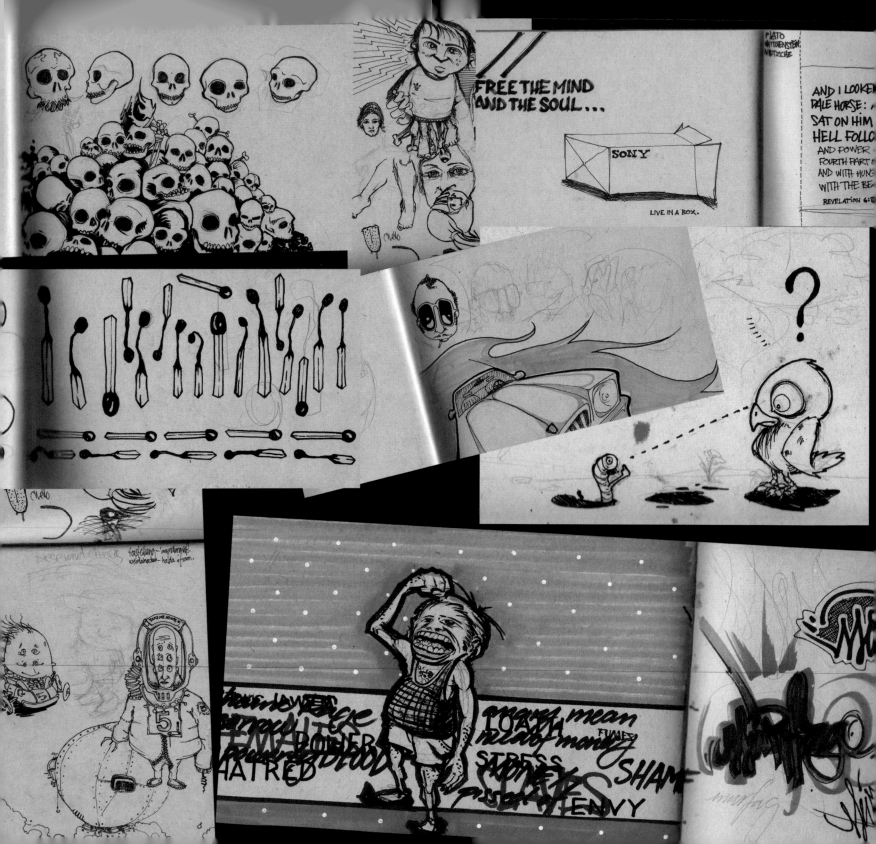

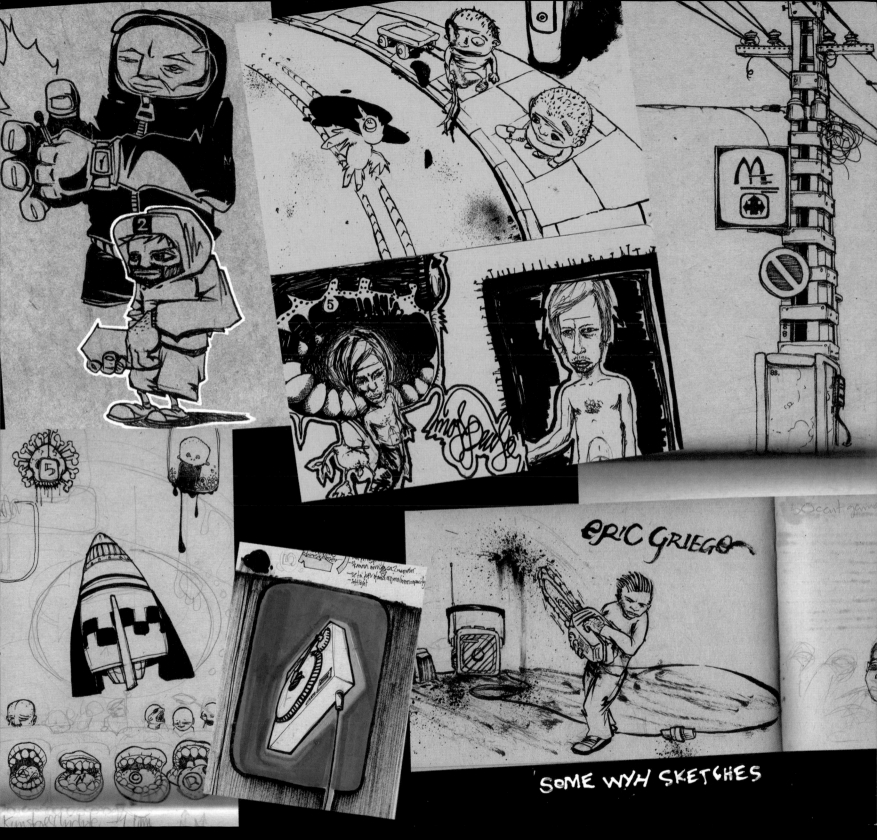

ERIC GRIEGO

SOME WYH SKETCHES

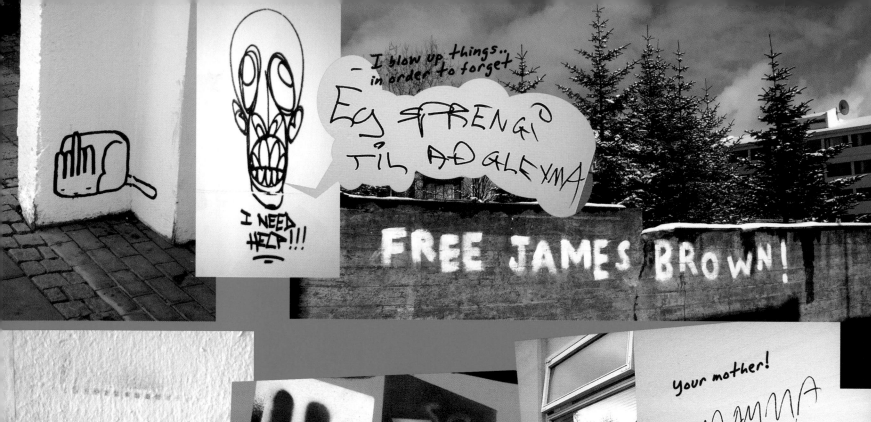

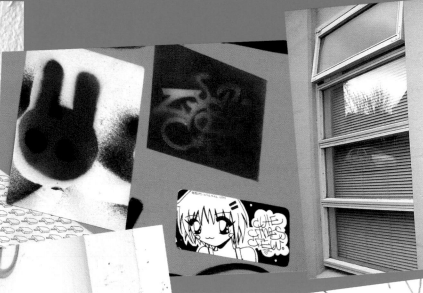

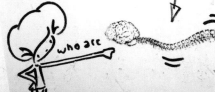

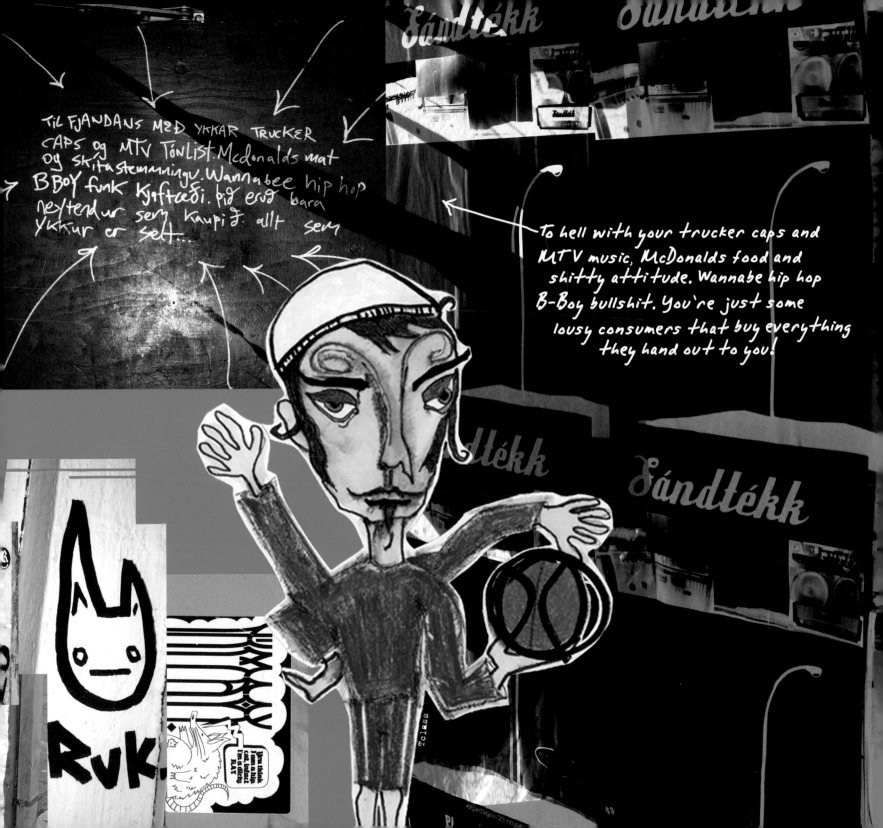

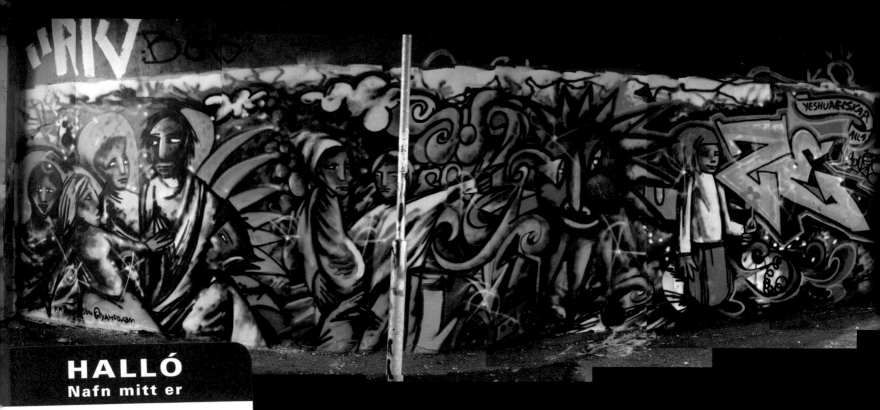

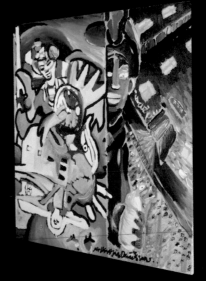

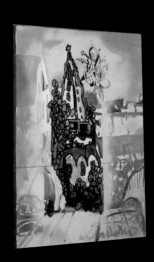

HALLÓ
Nafn mitt er

YOUZE

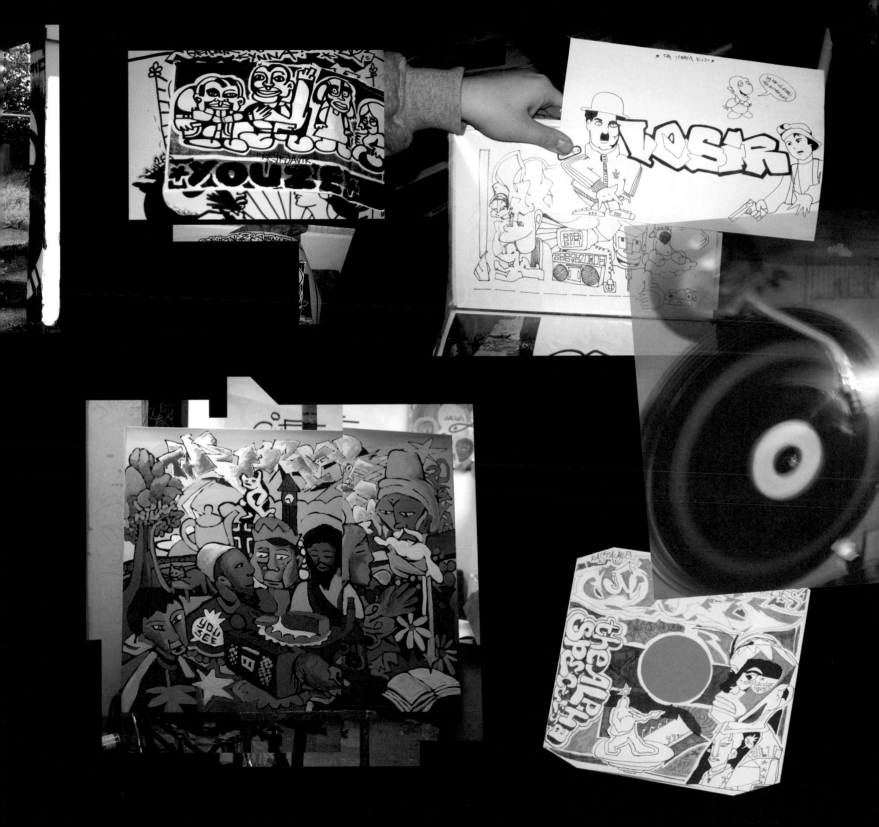

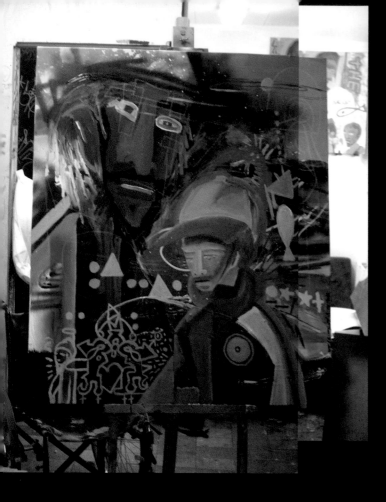
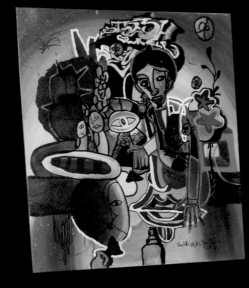
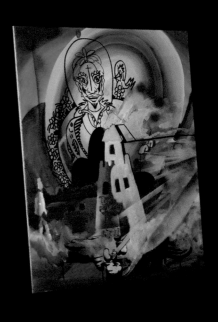
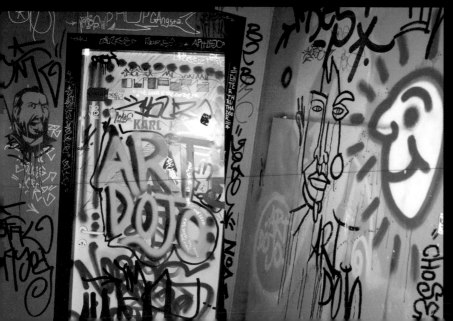
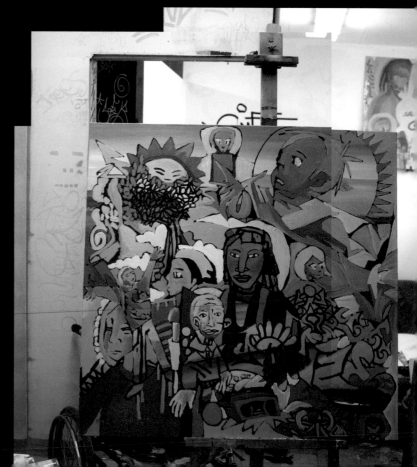

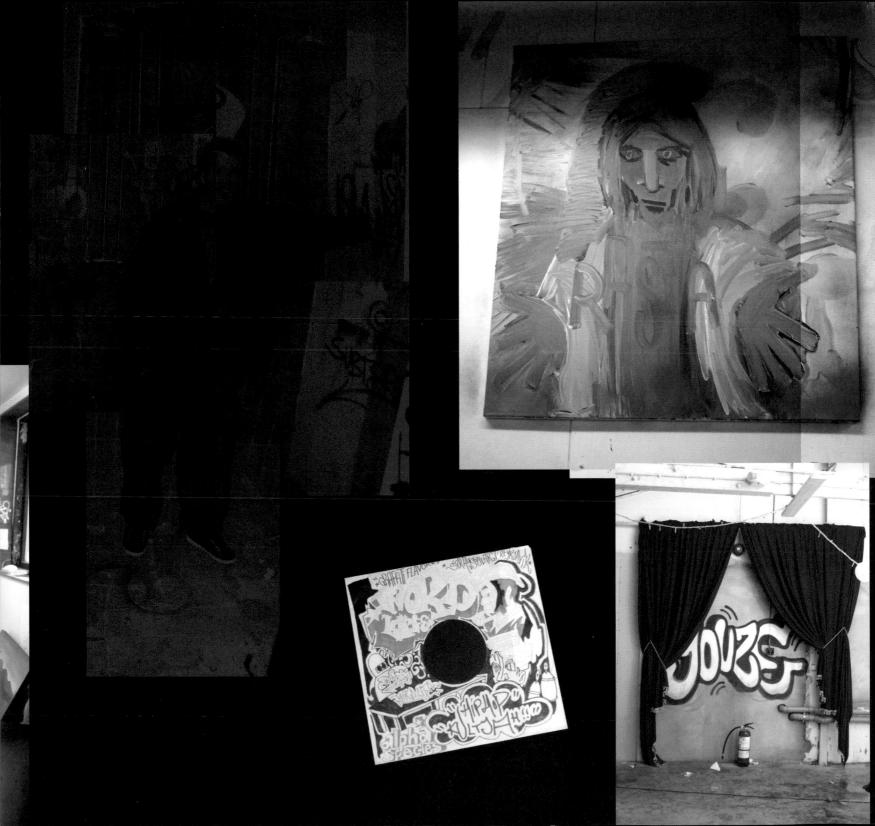

"ORLOF Travel Bureau
"GULLFOSS"
LISBON SHORE EXCURSION

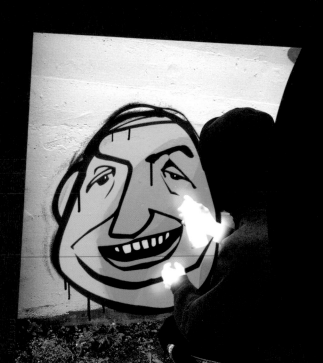

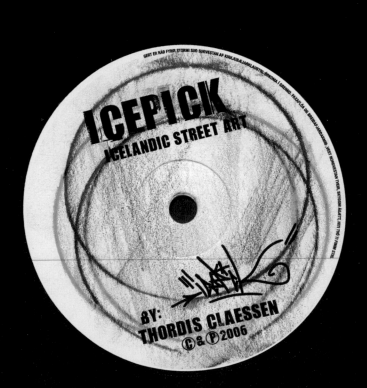

ICEPICK
ICELANDIC STREET ART

BY:
THORDIS CLAESSEN
© & ℗ 2006

Modern-day heroes in popular culture will rely less on muscles than on brains – and computer know-how. _Meet the new man. He works out... to counter or plastic surgeon. He feels no need to He's attentive to his wardrobe. And he might well patronise a male be apologise for his commitment to self-preservation, pampering and pe ... desirability is ... applicants and club members are screened by intelligence aptitude. The ... fashion industry Diana archetype will prove a compelling alternative to the ultra-thin 16 ye ... e clinics, focuses plastic surgery clinics will feel more approachable than ever. _Watch fo ... wealthier classes, becoming as accessible as gas stations are today.

ADULT

thordis claessen

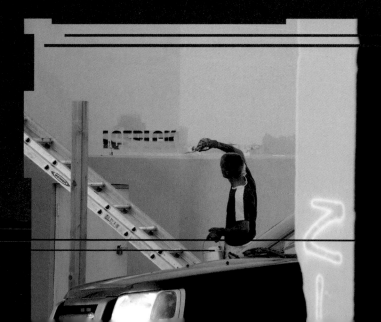

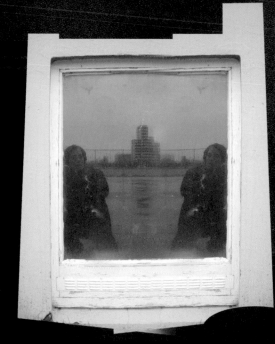

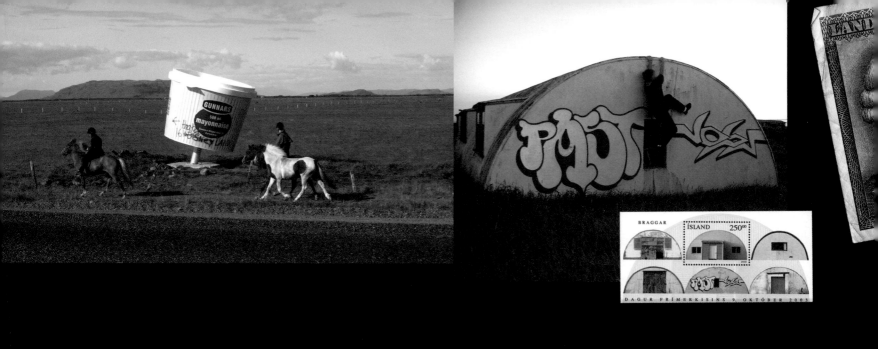

ICE PICK
Acknowledgements.

THANK YOU'S

1000 ÞÚSUND ÞAKKIR:

MY DEEPEST GRATITUDE
TO ~~THE MAN~~ MY FRIEND WHO MADE
THIS POSSIBLE; RÚNAR ÓMARSSON.

MY BROTHERS & SISTER
+ PARENTS ♡
HENNÝ MÍN.
GULLI ÓSÓMAVINUR MINN,
SIGGI SVANBERGS. DVD MASTA,
KATA ODDS AF HIMNUM,
, HELGA ÞORVARÐAR SKÁLDKONA
Í SAN FRAN. OG ALLT HENNAR YNDIS
LEGA FÓLK. NONNI MINN, SIGRÚN ERLA &
ÓSÓMA KINDIN, FJÖLSKYLDAN DAVIÐ MÍN Á GÖRÐUM
NINNA & GYLFI, EYRÚN & FLÓKI (EG ER
ENNÞÁ MEÐ DIKTAFÓNINN), M. DE FEO!,
DAVID LOPES & GINKOPRESS,
BADDY, JUICYFRUIT, HARRI, HABBÝ OG
HVÍTAHÚSIÐ. ATLI & BRYNDÍS F. PÓSURNAR
TRISTAN MANCO — FOR THE USEFUL TIPS.
JÓI Í GÖNGUNUM ☆

☆ FIRST AND FOREMOST TO THE PEOPLE
WHO HAVE MADE THE WORK ON THE STREETS,
CONTRIBUTED X-TRA PHOTOS AND GIVEN TIME
TO THIS PROJECT. AND EVEN MADE
A SACRIFICE.. "[BLÓÐ]"

→ ÓSÓMA

→ NIKITA CLOTHING
ICELANDAIR ←

ADDITIONAL PHOTOS
FROM:

WYH, KYTE, BOBBY K, RTS * BNK
ATOM, KEZ, NOEM, OSESH,
SÚRKÚLA, M.DE FEO,
30S, JÓI 'Í GÖNGUNUM'
LOGUS, SOFER, HALO.
ÁSL. SNORRA; (PICT. OF THORDIS)
NAFNI, SIGGA, FANNEY (OLD FAMILY PHOTOS)

FRONT COVER FIGURE
BY: SÚRKÚLA
ICE PICK TAG LOGO
BY: KEZ

CONTACTS:

WWW.ICEPICKBOOK.COM * INFO@ICEPICKBOOK.COM
WWW.THORDIS.COM
WWW.OSOMA.IS

WYH: STEINI@FRONT.IS * WWW.FOTOLOG.COM/WYH_ONE
KYTE: EL.KYTE@GMAIL.COM * FLICKR.COM/PHOTOS/EL_KYTE
YOUZE: YOUZEONE@YAHOO.COM
ATOM: WWW.PIXELSON.NET * ATOM@PIXELSON.NET
KEZ: WWW.GRAFFITI.ORG/KEZ * KEZONE@GMAIL.COM
CREK/LAGI: ARNIGRETARS@GMAIL.COM * MYSPACE.COM/LAGSI
DYER: DYERUNO@GMAIL.COM

CHECK OUT:

WWW.FOTOLOG.COM/OZEK
/NOEM
/DURUM
/3RDWORLD
/ALERTOLEUM
/SLEEPWALKERS
/ELEKTRARORRR
/HORNY_LO
/EL_MINTOS
/KAYTHIRTYFIVE

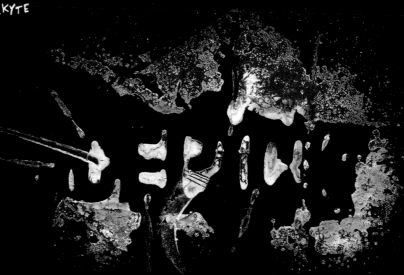